20
FIGURE PAINTERS
AND HOW THEY WORK

20 FIGURE PAINTERS AND HOW THEY WORK

FROM THE PAGES OF *AMERICAN ARTIST* EDITED BY SUSAN E. MEYER

WATSON-GUPTILL PUBLICATIONS/NEW YORK
PITMAN PUBLISHING/LONDON

First published 1979 in New York by Watson-Guptill Publications,
a division of Billboard Publications, Inc.
1515 Broadway, New York, New York 10036

Published in Great Britain by Pitman Publishing Ltd.,
39 Parker Street, London WC2B 5PB
ISBN 0-273-01367-X

Library of Congress Cataloging in Publication Data
Main entry under title:
20 figure painters and how they work.
 Includes index.
 1. Human figure in art. 2. Humans in art.
3. Painting—Technique. 4. Painting, American.
I. Meyer, Susan E. II. American artist.
ND1292.T83 757'.092'2 [B] 78-21148
ISBN 0-8230-5489-6

Manufactured in Japan

First printing, 1979

193258

INTRODUCTION

Always a vital subject for the artist, the human figure has presented a rich source of expressive possibilities. The twenty painters selected for this volume represent a diverse range of creative men and women who interpret the subject in a variety of ways, demonstrating the full potential of the figure as a source of inspiration to contemporary artists.

For some painters the figure itself provides a challenging subject for objective depiction: Artists see in their models a subject to be portrayed as it presents itself. Portrait painters such as John Howard Sanden, Marcos Blahove, Margery Ryerson, for example, strive to capture the essence of their subject in a portrait. Andrew Sanders, in looking for a similar goal, prepares numerous drawings and sketches before he obtains what he senses is the most truthful representation of his subject. While Philip White places his subjects in an environment and works to obtain an accurate, detailed description of his model, Alice Neel is concerned more exclusively with the *internal* aspect of her subject, indifferent to matters of physical likeness, preferring instead to capture the psychological features she finds most compelling.

Other artists find in the figure a vehicle for describing a culture, a way of life, a social frame of mind. Barkley Hendricks depicts the black culture he sees around him in the United States; while Paul Collins—who traveled to the other side of the earth to paint a way of life in Africa—reveals a different portrait of black society. Ann Leggett ventured to Mexico to paint the Zinacantans; William Sharer and Ned Jacob depict the life and land of the Southwest Indian; Sue Ferguson Gussow and Ruth Egri focus primarily on the female figure as a means of expressing their concern with women in society; while Henry Casselli and Harvey Dinnerstein tend to divide their time painting intimate portraits of their families and depicting a way of life that has deeper social implications. Eugene Dobos and Murray Stern use the figure symbolically: Dobos conveys an amusing comment on a serious thought by his exaggerated distortions of the human form; Murray Stern depicts football players in order to express symbolically his horrified reaction to man's tendency to inflict violence upon man.

Finally, there are those artists who are attracted to the structure of the human form because of the purely formal considerations—color, design, and composition—offered by the figure. Rosemarie Beck and Philip Pearlstein, for example, paint the figure almost as if it were a still life, uninterested in the psychological or symbolic characteristics of their subject. Both greatly influenced by the Abstract Expressionists, they have nevertheless arrived at very different points: Beck is most fascinated by paint and with the interplay of one color pattern with another; Pearlstein, on the other hand, portrays the figure in an almost photographically realistic fashion, yet his concerns are equally taken with the juxtaposition of pattern, line, and color. Cornelis Ruhtenberg also employs the figure as a means of organizing space, but she is inspired not by Abstract Expressionism, but the traditions of Oriental painting.

While the figure represents one of the most difficult subjects to paint or draw, it continues to remain one of the most enduring challenges for artists who seek a personal means of self-expression.

Susan E. Meyer

CONTENTS

20
FIGURE PAINTERS
AND HOW THEY WORK

ROSEMARIE BECK

BY LORRAINE GILLIGAN

ROSEMARIE BECK's apartment is startling for the number of books lining its walls and its air of ordered simplicity, which is in marked contrast to her paintings. Beautiful landscape studies and preparations for her *Orpheus* and *Tempest* series of paintings fill the walls.

Curiously, Beck, who has remained a private person in the midst of an aggressive New York art world, categorizes herself as an abstract painter. How can this literate woman, who has obviously been inspired in her choice of subject matter by the books vying for space in this apartment and who paints recognizable objects, consider herself an abstract painter?

In this seeming contradiction may be the thread running through Beck's work. Her studio contains numerous interpretations of the *Orpheus* theme peopled with contemporary men and women. The story of Orpheus, a Greek myth, is one of a man whose prowess could enchant man and beast. When he played the lyre and sang, no one could resist him. Among those who succumbed to his spell was a maiden, Eurydice. She became his wife only to be tragically lost from him by a viper's sting. Orpheus was heartbroken and decided to go down to the world of Death, seek out Eurydice, and bring her back. On his journey down he enchanted all who were obstacles to finding his beloved. The gods permitted Orpheus to take Eurydice upon one condition: that he would not look back at her as she followed him, until they had reached the upper world. Thus Orpheus led the way back, longing to see Eurydice. As he stepped into the daylight, he turned to her. It was too soon, and in an instant she was gone, crying farewell. Yet his journey of hope and sorrow remains eternal.

A familiarity with the myth may heighten the emotional impact of Beck's paintings, but her intent is not to illustrate certain passages of the myth—or any story—for that matter. Her goal is quite different: "In paintings," she comments, "the great rule, if indeed there is any one that is primary, is simply that you always think in the language of painting. Nothing else will do. To the untutored, it's a foreign language that creates reality: the painter's reality. Hence, the more abstract the language, the greater the objective reality. In short, the drama is always in plasticity: Every stroke is form-making, not merely form-filling, and, whatever else it may be, it's very specifically an essay on painting."

But Beck is not interested in writing a book about art every time she paints; her goals have always been modest. As a young woman studying the violin at Oberlin College in Ohio, she found that some of her most rewarding moments occurred when she was making quick sketches of people and surroundings. After graduation from Oberlin, Beck moved to Woodstock, New York, where she lived and painted for a number of years. Here, among other painters, she was able to develop a sense of what separated the dedicated artist from the dilettante.

Beck came to New York to study at Robert Motherwell's school. Her reflectiveness has given her a tolerant understanding of those early days: "When I was younger, it was easier to paint. One belonged to a group or coterie where you could stay on the fringe and feel somewhat revolutionary." Her identification with a group of artists was not one of personal relationships but of sharing a sense of dedication about a way of painting and expression.

The "revolutionary Beck" was caught up in the spontaneous assertion of the artist's will on the canvas as embodied in the Abstract Expressionist movement. Her early works from this period show the influence of Abstract Expressionists Phillip Guston and Bradley Walker Tomlin in particular. She says, "I learned to become a painter by studying Cubism, by learning to transform form. I used many of Guston's and Tomlin's strategies." The security of identifying with a group of painters permitted Beck to be influenced and to share in certain trends that allowed a vital stage of development. But identification is a phase to be gone through, not a niche in which to remain: "If you are talented, you imitate and you feel a sense of power that really isn't your own."

Right: *Orpheus and Eurydice,* (large detail) 1975, 30 x 24. Courtesy Genesis Galleries, Ltd. Here the central area of the picture is enlarged to allow for a closer look at Beck's brushwork. Photos Geoffrey Clements, Staten Island, New York.

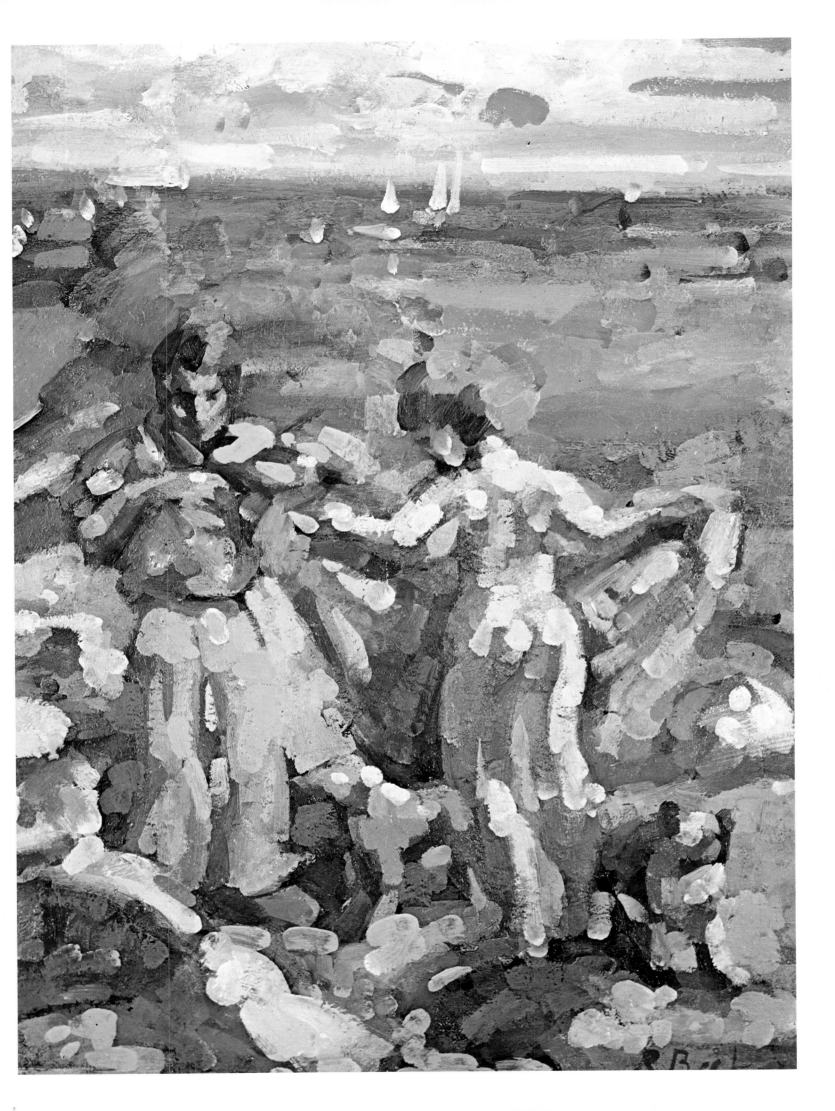

Right: *Orpheus and Eurydice V,* 1971, oil, 30 x 42. Collection the artist.

Below: *Study for Orpheus and Eurydice,* 1970, oil, 18 x 24. Courtesy Genesis Galleries, Ltd.

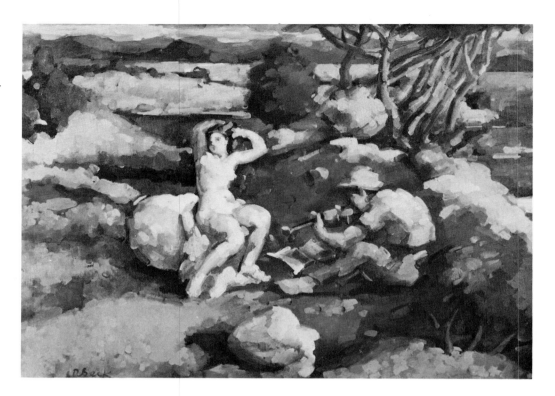

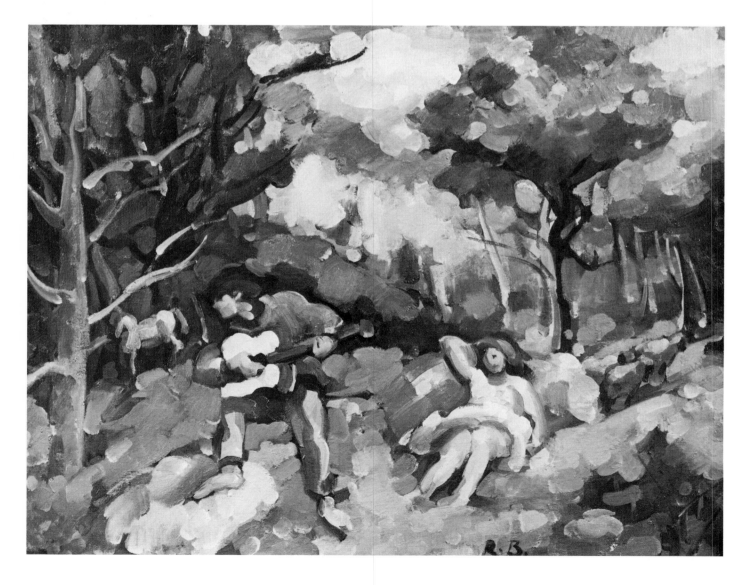

By the early 1950s Beck discovered that the drama of the period no longer appealed to her: "The magic had gone out of many of my generation, and I had a feeling of repetition in my work. The more I painted in the abstract vein, the more dissatisfied I became. I had a feeling that the abstract subject had less and less substance and that soon it would vanish away." Dating from this period is a large self-portrait in which Beck's features appear to be either crystallizing or disintegrating. The work is a seminal piece, a departure from abstract depiction to a reference of the real world; a walking away from and a timid greeting to, synthesized in one painting.

The choice to no longer embrace Abstract Expressionism and to commit herself to a more realistic mode forced Beck to confront problems that were uniquely her own: As an abstractionist Beck was able to imitate and be influenced by the artists around her. By venturing into Realism, Beck had to rely on her intuition to answer important questions. What would be her subject matter? How would she compose it? Would she work indoors or out? How much would her imagination enter into a work? And how would she feel about the final results? Would she like her painterly interpretation of the outside world?

Here was her opportunity to blossom into an artist with her own character, her unique self. Not only was her departure from abstract art an effort to refresh herself, it was an area she was drawn to more than she dared to admit: "Once I put my foot in the stream, I didn't come out. I've been there ever since." Like the stimulating moments sketching at Oberlin, her attraction to Realism was a secret part of herself that was finally acknowledged.

Beck, who has taught painting in various institutions throughout the years, found her role as a teacher helpful in supporting her decision to embrace Realism: "I found teaching useful. I couldn't teach people to be abstract painters, but rather to develop a sensibility to discern what was necessary for them to progress. This helped to reconfirm my own decision. The main thing in my contact with my students was to talk about the issues of painting, to be conscious of its paradoxes, and to allow them to gain a confidence from practice that is guided."

While teaching may have led to an affirmation in the choice of her direction, her circle of artist friends was silent and puzzled. American painting of the 1950s is generally characterized as a period of nonrepresentational subject matter, as exemplified by richly painted and gestural works of Jackson Pollock and Willem deKooning and the more introverted, quiet sensations of Mark Rothko and Clyfford Still. Beck's decision to follow a path of realistic portrayal courageously recognized and accepted her need to depart from a style of painting that had become unfulfilling to her.

The advantages and limitations of her new direction became apparent. The choice of a theme, whether it be based on women preparing their toilets, two lovers, or more literary choices such as the Or-

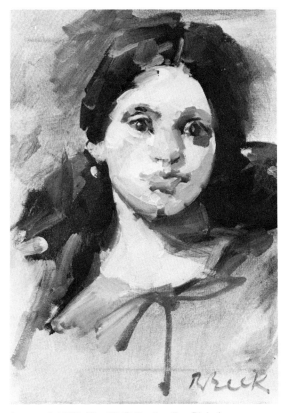

Janna, oil, 1968, 16 x 12. Collection Rus Pinieri.

pheus or *Tempest* themes, presents its own restrictions. They force the imagination to invent, exploring ways of presenting a theme.

Beck usually starts with an invented composition and uses reality as a reference for clarifying and refining her work. She considers her work to be more conceived than a composite of studies from life. It is important for Beck to "constantly refurbish the imagination and not to constantly use poses directly from life."

Beck's world gives the same priority to people as to still life: "I want to be able to tell myself that this shape is behind this other shape; it has a bottom and sides. I want to be clear about the parts as well as the whole, to separate them, as it were. And I am now convinced that if the anguish of paradox is not somewhere felt—the paradox of a patch of paint being also a hand or an apple—we are still hungry; there is not enough food for the mind."

Looking around Beck's apartment, one cannot help but feel in good company among loving couples: women preparing for an evening of unknown adventure, pensive men and women situated in carefully constructed environments.

The aloneness sets in when she walks into her studio every morning to work. Her studio is on the floor below her apartment, and although it is small, she feels it as an improvement after years of working in her apartment. The two windows in the room face the dismal gray facade of a popular daily publication. The windows are clouded with the grime of the city, and Beck depends upon a single fluorescent fixture rather than having a studio too strongly lit. A large easel is set up by the window, and, close by, an enamel-topped table serves as a palette. Brushes are neatly arranged atop an unused fireplace, and paints and tools are organized on the shelves lining the wall. The studio space is wide open and free of clutter.

Oil painting's rich, sensuous quality appeals to Beck and is her preference. She works on stretched, sized canvas, her paintings ranging in size from small to large works of 5 or 6 feet. Beck's own physical ability to handle a painting determines the maximum size she is willing to use.

"When I have time—usually in my studio—I paint thinly and build up the painting. If I'm outdoors, I usually paint quickly and apply the paint heavily," she comments. Her palette is arranged according to

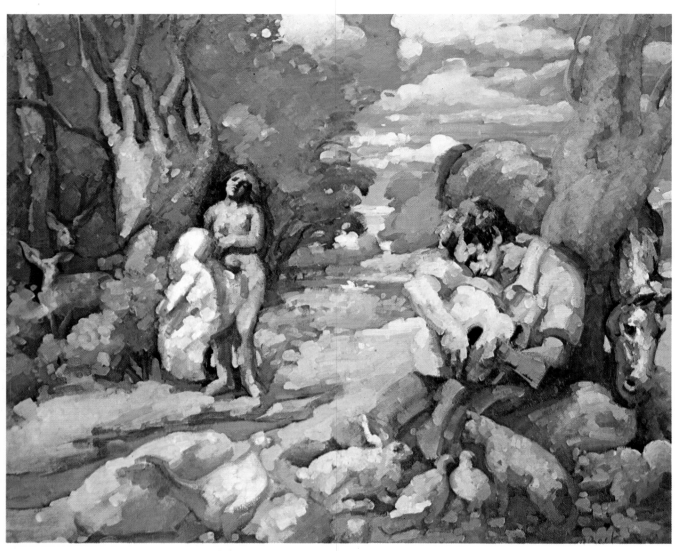

Orpheus Among the Beasts, 1972, oil, 42 x 50. Collection the artist.

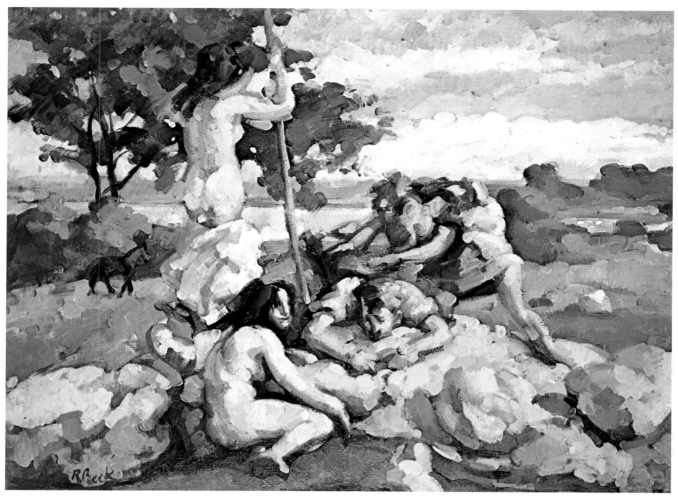

Orpheus and the Furies, 1973, oil, 30 x 40. Courtesy Genesis Galleries, Ltd.

the needs of a specific painting. There are occasions when she enjoys limiting her palette to certain colors, and she frequently sets up limitations and problems within her work.

Reflecting on some of her past work, Beck muses: "I was often interested in beautiful formal arrangements—gratuitous activity—complicating the canvas with objects and colors. Now it would be impossible for me to paint this way. My needs and interests have changed."

Beck's primary concern is "carving out pictorial space." Light is a major part of this: "When I'm painting, I'm thinking in terms of form and light, not a face or a lion's head. In an early painting from the 1950s, I took lights and the intervals between them and made my face. In more recent work Beck also uses light to illustrate the passage of time. She does many of her paintings indoors, in her studio, but occasionally goes outdoors to paint. Her point of view—and therefore technique—depends on locale. The studio pieces, a blending of actual objects, invented or actual studies or poses, have a sense of constancy. The fluorescent light will glow even if the morning is gloomy. The freedom of painting indoors is the play of calculations available to the artist. When Beck invents an arrangement, she chooses one source of light to create highlights and shadows.

Painting outdoors leaves Beck with different sensations: "Landscapes are harder to describe—the daylight in the country invades you. Outdoors I am confronted with the discipline of time. Outdoors I've only 20 minutes to capture the light; you get that image, and that is enough; time is important, and the tempo of your activity is changed." In many instances the landscapes are rendered with a freer brushstroke, and the necessity of time makes her use the paint more heavily.

In many of the studio pieces Beck's stroke is repetitious and tight. The strokes are small lozenges of color, fragments of light that Beck uses to build up the composition. The small strokes of color seem to vibrate against each other, and it is apparent that it is not how she mixes colors that counts but rather their conjunction to each other. The vibrations that result from the placement of color are not a question of value relations or rhythm but tension of edges: "I want to create a kind of vibration. It is this positive ache for some principle of structure. Everything for me becomes an edge. It's my obsession. The tension created by two shapes in two directions as they approach each other." Her intention is not to make us tense; she would like to make the painting "still, yet float; a balance, not a flux."

These lozenges of color vary in feeling from paint-

Self-Portrait, 1974–75, oil, 60 x 50. Collection the artist.

ing to painting. They may start out as tight in one painting with a gradual loosening up as the paintings are sequentially examined.

Beck concedes that she seems to go through cycles in terms of her brushstrokes, from a compact one to a more expansive one. Beck takes pleasure in quoting a line by Picasso: "You know, we need one tool to do one thing, and we should limit ourselves to that one tool. In that way the hand trains itself. It becomes supple and skillful, and that single tool brings with it a sense of measure that is reflected harmoniously in everything we do."

The landscapes that are rendered so rapidly have a deceptive feeling to them; is it their feeling of spontaneity? She nods at the paintings surrounding her: "A painting is conscious and inspired in the same breath; luck is rarely involved. If you chase spontaneity, it dies. The moment you can be spontaneous is when you've been working for days and are too tired to think of anything."

Spontaneity is sometimes mistaken for a false freshness, a gesture without connection. Beck is not concerned with a "one-shot" image. Some paintings are worked on steadily for months, others are abandoned and resumed until she's satisfied. "Too many painters stop too soon," she comments, "before they arrive at the place where it hurts, where it hurts to give up something fresh and spontaneous or beautiful. Hence, at best, their work looks open and uninhibited and may have, in fact, the unwitting aspect of first statements, but rarely does it convince us of its cause. In the imagination it remains thin. The point at which the picture stops is one of the elements—maybe the most important—which determines an artist's style."

Beck's style, her interpretation of form, is a blending of her technical views, her brushstroke, and, to some degree, her background in literature and art history. Not only is her connection with the first generation of the New York school enough historical baggage to carry around in her past, but lessons from the past centuries seem to creep into her work. Beck is very conscious of the works of Piero della Francesca, Cézanne, Braque, Picasso—"classical painters," as she calls them. A trip to Belgium whetted her appetite for Rubens, and she maintains enthusiasm for Rembrandt.

Occasionally, events are portrayed serially within a work. There are poses reminiscent of 15th-century Flemish painters, allusions to the Three Graces, and other mythological and astrological personages appear throughout many of her paintings. She refers to her own paintings and studies in overall compositions much as Matisse did in various works: One draws not only from the past but from the wealth within oneself.

Her interest in literature has enabled her to go from her general subject of lovers to more specific characters. But she considers the possibility of moving away from literary themes for a while. She sighs, "I have chosen an art that does not please. I don't think I've come to something lovable in my art. There may be more respect and empathy for human creatures."

MARCOS BLAHOVE

BY LOIS MILLER

UNAFRAID TO REVEAL what he calls his "poetic soul," portraitist Marcos Blahove looks as deeply into his subjects as he does into himself, discovering and assimilating his subjects as he gently encourages them to rediscover themselves.

People emerge from Blahove's canvas as they do from behind their roles. Each painting reflects artist and subject within a larger and even more elusive framework: the synthesis of the two. And the artist, primarily an oil painter, expresses the intensity of his experience through his technique: medium to heavy impasto; bold, spontaneous palette knife-work combined with a few delicately placed brushstrokes; and above all, warm, almost hot colors.

It is in this relatively recent use of vibrant color—Naples yellow, yellow ochre, cadmium orange, red, and scarlet—that Blahove feels he has made his first independent discovery as an artist.

"In my early work, my 'gray period,' I was primarily concerned with values. But when I began to experiment with color, I felt I had discovered a gold mine. I realized how much better color and color changes can be used to capture the effects of light, to express mood, and, in painting the human figure, to describe the personality of the subject. Now color concerns me most. Drawing is mechanical, brushwork is important but arbitrary, and values alone express little feeling."

Blahove first began to play with color and light when he painted *Girl Reading* in 1964, and he continued to experiment and expand his use of color until, in 1971, he completed his first predominantly red painting: *Mrs. Peter Hearst and Her Children.*

The artist's style and choice of subject matter have also undergone dramatic changes since he first studied art at the Circulo de Bellas Artes and the Academia Vicente Puig in Buenos Aires between 1949 and 1956. (Born in the Ukraine, Blahove moved to Argentina with his parents, both musicians, as a young boy.) In what he now refers to as an action natural to youth, he then rejected the strictly representational approach of the academies. His own work in his student days was of an abstract nature, influenced more by Antonio Mancini and Mariano Fortuny than by their 19th-century French contemporaries.

"I was also greatly excited by the daring experiments of the American Abstract Expressionists, the men who defied God to recreate nature. They were opening the door to an entirely new range of expression. I decided to go to New York City and study with Hans Hofmann and his followers."

However, during the ten-year period in which he formulated plans to move to New York and obtained an emigration visa, Blahove reconsidered his affinity for the Abstract Expressionists, and a gradual reversal of his attitude toward them brought about a major change in his style.

"I decided that the Abstract Expressionists preached too much. Although they had started something beautiful, they hadn't gone far enough. They freed the artist to express his emotions on canvas, but their abstract principles deprived their paintings of an even fuller range of expression. I think the subject has as much to contribute as the artist, and the interaction of the two offers the greatest potential for the expression of each. And as far as the viewer is concerned, I think the Abstract Expressionists took art away from the general public. Art, real art, should be universal—something every sensitive human being can enjoy."

So, like Mancini, Blahove began to develop his own expressive approach to representational painting, in which he tried to synthesize a realistic image of the subject with his own feelings about what he saw. When he arrived in New York City in 1960, he enrolled at the National Academy of Design to study with Ivan Olinsky, whose conservatively figurative works attracted him with their poetic colors and feelings. At this time Blahove turned his attention to painting the human figure, finding it offered him unlimited potential for expression.

"Most of what had been done so far in portraiture and in painting the human figure was depressing. It belonged to the 'brown school of painting.' Faces stared out blankly from canvases, looking stiff and standardized. The paintings failed to capture the

Pensive Girl, 1971, oil, 30 x 24. This painting displays Blahove's fully developed use of warm color as well as the characteristic softening of detail and his concern with effects of light.

On the Beach—Westhampton, 1971, oil, 10 x 12. High values, heavy impasto, and sketchy suggestions of background figures create the shimmering effects of sun on sand and water.

whole interior life in people that, to me, is nature."

Since Blahove committed himself to painting the human figure, his subjects have ranged from composer Aaron Copland to the families vacationing in the Long Island resort town of Westhampton Beach where Blahove lives during the summer, and from Mr. and Mrs. Henry Ford to residents of the Greensboro, North Carolina, area, where he lives the rest of the year.

Although he has chosen oil paint as his medium and the human figure as his subject, Blahove makes little distinction between art, music, and literature as the vehicles that express the world of feeling. To him, the effects of light have a musical quality as they play upon his subject and the surrounding objects. There is poetry in human communications, and colors and color combinations are to painting what notes and chords are to musical composition: the vehicles by which the artist expresses what he sees and feels.

Sincerity is Blahove's only requirement of his subjects: "I don't want people to try to be something they're not with me. I look for the inner poetry reflected in their eyes. And I find that other artists, musicians, and writers are particularly sensitive to what I'm trying to do. They appreciate my sincerity and like the result because of it."

Children, too, offer him easy access to the true expressions that inspire his entire approach.

Blahove likes quiet, natural poses rather than action and prefers to paint his subjects in their own homes, reflected by their own furnishings. And because light is an important element in his work—second only to color—he poses his subjects near a window whenever possible.

The artist begins each oil painting as he did the portrait of Aaron Copland, by sketching the subject in several different poses, using Conté sanguine crayons and pencils on paper. As he sketches, he talks with the sitter or silently observes him in conversation with others in the room. And, of course, music provides the background, helps to establish the mood, for the sitting.

"As I sketched Copland, I could almost feel his music around him as the light played on his face and the objects in the room."

He usually completes the crayon sketches in one sitting, during which time he begins to form his impression of the sitter and to single out the most expressive pose and the colors that best convey the subject's mood and personality. His final study is often a full-color watercolor sketch done in his studio from what he considers the most appropriate drawing, in which he experiments with color and gesture before making his final decisions.

"I decided to paint Copland looking to the right because the light was coming from that direction. In the watercolor sketch, I played around with cool colors, but returned to my original intention to use warm rusts and golds. Copland's personal warmth influenced this decision."

By the time he is ready to begin work on canvas,

Blahove has visualized the finished painting, down to the smallest detail, in his mind. From his feeling for the subject and by narrowing down his choices of color and form through the series of sketches, he develops a clear mental image of his subject that waits only to be given tangible expression.

"My visualization of the painting is much like an engineer's drawing of a bridge, in which the placement of every beam and bolt is carefully planned before the actual construction begins. I plan almost every brushstroke beforehand. The clearer my image, the more smoothly the actual painting progresses."

At this point one might expect the artist to take up his brush and proceed with direct painting, making only a rough block-in. But Blahove prefers to spend time with each painting. Using charcoal, he first copies the rough outlines of the watercolor study onto a good quality, oil-primed canvas that he stretches himself. For small paintings he often primes Masonite panels with acrylic gesso.

After fixing the sketch with a charcoal spray, Blahove covers the entire canvas with a transparent wash, leaving the line drawing visible beneath it. This light, initial tone, usually yellow if the colors to follow are warm, or blue if subsequent colors will be cool, is used to soften the severe white of the canvas and to serve as the first unifying element. Blahove thins the one with a mixture of one part stand oil, one part damar varnish, and five parts turpentine—the only ingredients he uses for both thinning paint and glazing. When the tone is dry, he works from his image of the finished painting to block in the colors and suggest the values that precede the final painting and brushwork.

With the block-in completed, Blahove begins the final painting during a sitting with the subject, then returns to his studio where, for him, the real creative process begins: "Now the most interesting, the most exciting things happen. Alone in my studio, I remember the sitter. I absorb him, assimilate him, until I feel I've become one with him. Then I put what's inside on the canvas."

The brushwork and colors Blahove uses at the finishing stage reflect the intensity of that highly personal experience. He uses the palette knife almost exclusively to create medium to heavy impasto textures in the foreground, background, and on the figure, then applies finer brushstrokes where the delicacy of features requires them. He adds or omits detail according to the overall mood of the painting, but he changes very little of his knife and brushwork at this stage, feeling that the entire painting loses a degree of spontaneity with every change.

If he feels that cool colors best express the personality of the subject, he uses either vibrant contrasts or pensive mixtures of ultramarine, cobalt, and cerulean blue. However, as in the Copland portrait, his present work is dominated by reds, golds, yellows, and oranges—emotional colors that express the artist's own sense of freedom and his open reaction to life.

Mrs. Peter Hearst and Her Children, 1971, oil, 20 x 24. Collection Mr. and Mrs. Peter Hearst. Predominantly red in tone, this painting marks the culmination of Blahove's experimentation with light and warm color that began in 1964.

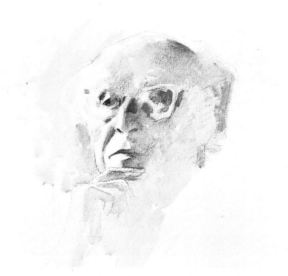

Blahove began the Copland portrait by sketching the subject in a variety of poses, using Conté and pencils.

In his final watercolor study, Blahove experimented with cool color and a different pose, but returned to his original idea.

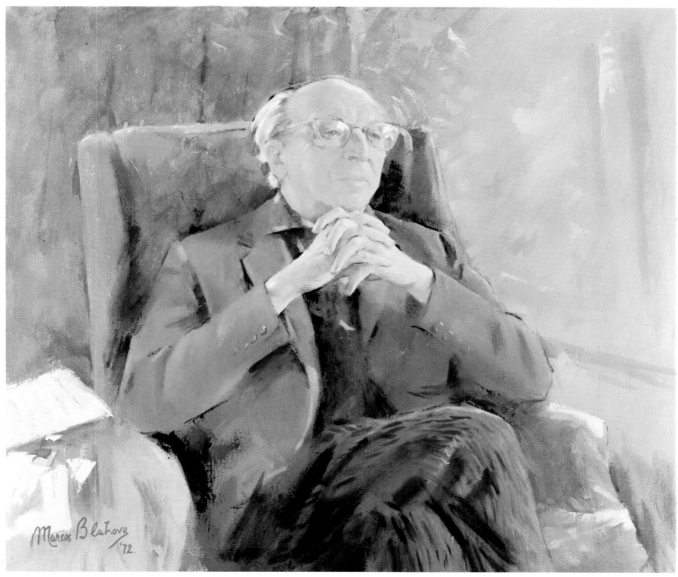

Aaron Copland, 1972, oil, 26 x 32. Collection Smithsonian Institution, National Collection of Fine Arts and Portrait Gallery. Blahove completed the portrait in the rusts and golds inspired by Copland's personal warmth.

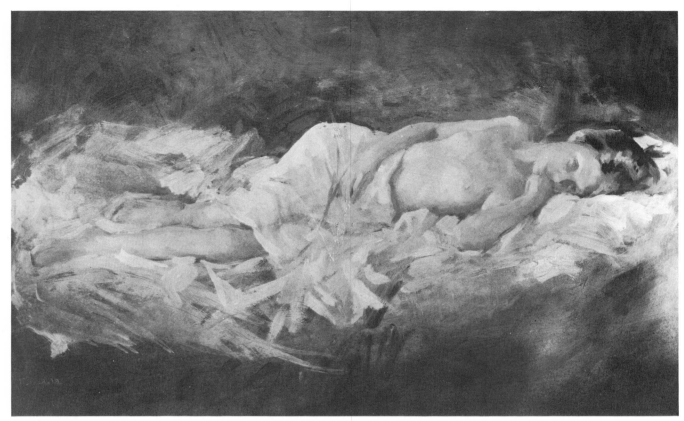

Reclining Nude, 1971, oil, 12 x 20. Light is a primary consideration for Blahove. Here warm light enveloping the figure completes the impression of dreamlike relaxation.

Pam, 1968, oil, 10 x 8. Although the pose appears passive, broad strokes and impasto suggest an underlying restlessness.

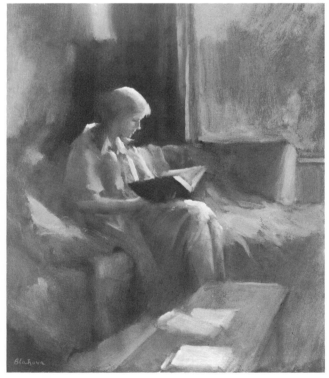

Girl Reading, 1964, oil, 14 x 11. This painting was the first in which Blahove began to experiment with color and light.

Blahove's works were first exhibited in America in a 1961 one-man show at the Fitzgerald Gallery in New York. Since 1965 his paintings have been exhibited annually, first at the Greensboro, North Carolina, Public Library, then at the Attic Art Gallery in that city, and simultaneously at the Westhampton Gallery in Westhampton Beach. He has been represented in group exhibitions at the American Artists Professional League, Allied Artists of America, Parrish Art Museum, Guild Hall of Easthampton, and Southampton College, and has won prizes at several of these shows. In 1972 his *Young Ballerina* won top prize, the Elliot Liskin Award, at the "Thumb Box Paintings" exhibition of the Salmagundi Club. And in 1973, it was announced that *Aaron Copland* would be on permanent exhibition at the Smithsonian Institution, National Collection of Fine Arts and Portrait Gallery, Washington, D.C. The artist also completed a book, *Painting Children in Oil*, published by Watson-Guptill Publications.

The artist conducts private painting classes, but spends most of his time experimenting and completing paintings in his studio. He rises just after dawn, to make full use of the daylight hours, and usually works twelve hours a day. He prefers individual commissions to one-man shows.

"I try to avoid the pressure of a one-man show. If I have to do ten paintings in one month, I usually want to destroy nine of them."

Since he began painting the human figure almost exclusively, Blahove has worked independently—partly from a desire to take the medium farther than has yet been done, and partly because he is primarily concerned with expressing his own ideas as an artist.

"Once he has studied basic techniques and observed the styles of the masters and of various schools, I think the artist should try to develop his own style by learning to express himself and use his medium independently. While I find the development of other artists interesting—and admire some of them greatly—I am more interested right now in developing my own approach."

HENRY CASSELLI

BY DOREEN MANGAN

HENRY CASSELLI is a man of contradictions. Although he is white, he paints blacks. His oil paintings have watercolor effects; his watercolors take on aspects of oil. Design is of major concern to him, yet he blithely throws the rules out the window. Furthermore, the two artists he claims most kinship with are also at opposite poles: Edgar Degas and Robert Motherwell.

These contradictions resolve themselves into superb paintings. Casselli's talent is undisputed. Yet he does incur criticism, much of which is directed toward his choice of subject matter: "Why do you paint blacks, Henry?" ask white people. "How can you see as a black man, Henry?" ask blacks.

The answers have nothing to do with regionalism or nostalgia; Casselli is not an anthropologist documenting the black experience; he is neither championing blacks nor patronizing them. They happen to be people he has a natural empathy with because he grew up among them. They were the people he lived next door to, the people he talked to as he walked down the street, the people whose lives he knew almost as well as his own. "That environment has been my experience, my association," he says. "I've soaked it in day after day, and it has to come out."

But the fact that he paints blacks is a secondary aspect of his subject matter, he insists: "The color of the skin is dark; the features are those of black people. But the paintings go deeper." Casselli's subject is all humanity. In fact, since the birth of his daughter, and since his wife Donna's renewed involvement with ballet, Casselli has been reaching beyond for subject matter, drawing from these intimate family associations. The subject is merely the vehicle for his statement that what might seem to be different worlds are really one.

A romantic notion, perhaps, but a glance at his paintings shows that this artist is no lofty idealist. His themes, indeed universal, are often dejection, misfortune, sordidness. His people's heads are bent, the shoulders are stooped, the faces wear troubled expressions. Even the titles of his work are from the language of dejection: *Almost Ain't Enough; Speak No; Mendicant Junkies; The Virgin Whore; A Troubled Man.*

But, the viewer might question, isn't happiness also common to humanity? Why does Casselli mostly portray the bleak side of things? This question may never be answered satisfactorily. The artist himself says he doesn't consciously try to paint what he paints: "It's something that happens innately."

But his background lends a clue. Granted he is not black. He has never been a junkie or a beggar. In spite of his relative youth, he paints with a maturity born of penetrating and sometimes grim experiences. Born to a family of humble circumstances, Casselli grew up in a poor neighborhood near the French quarter in New Orleans. Derelicts, prostitutes, and addicts peopled his youth, as well as just plain poor folk struggling to make a decent living. *Mendicant Junkies,* portraying the passivity and inertia of the drug-ridden, is an apt illustration of that environment.

Besides his environment, his early family life was sometimes troubled. And at the age of 20, he witnessed the death of friends alongside him at the battlefront in Vietnam.

Yet Casselli has not turned cynical. His paintings are not harsh; they do not accuse or reproach. With sensitivity and compassion he captures the dignity and strength of his subjects, although they are in the throes of misfortune. The question "Why?" reverberates throughout his work. "What happened? Why is this person in this situation?" Casselli wonders.

"There's more to see than what's on the surface. That's how I look at things." And that's how he hopes people will view his paintings. "*Follow not/your/ first instinct/nor/your second/but/search/through/ thought,*" he has written in a notebook full of gentle snatches of poetry.

The young contemporary blacks in search of their African heritage have captured his imagination. And he gives his design instincts free rein in portraying the movement. The hairdos styled after the Africans lend themselves beautifully to Casselli's Motherwellian bent; he delights in the big, chunky, awkward circles and ovals in that artist's work. "You can just reach out and grab them," he says. Notice, for example, the exaggerated bulk of the hairdo in *Afro Influence.* "It looks like a piece of sculpture."

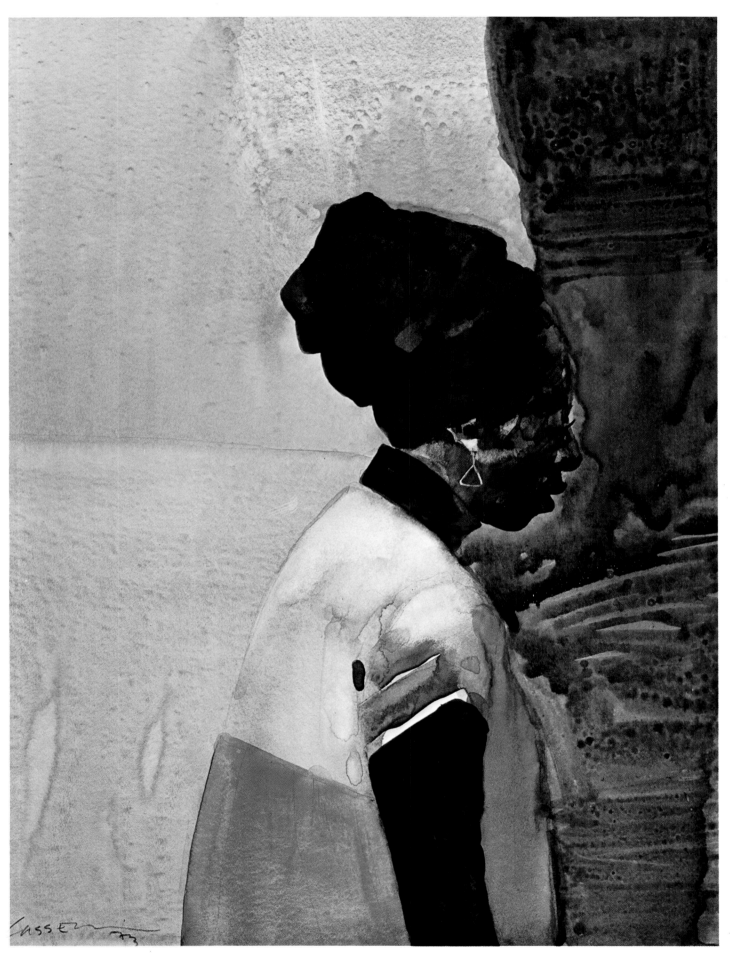

African Influence, 1973, watercolor, 11¾ x 9¼. Courtesy FAR Gallery. The artist uses a No. 12 round sable brush for his watercolors. Notice the lush use of pigment.

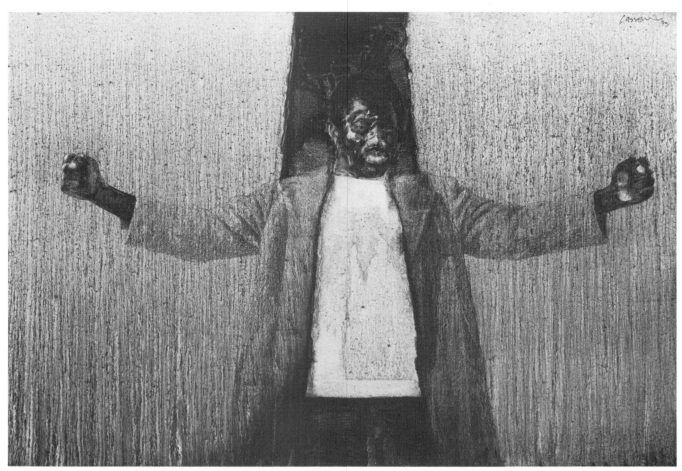

Crucifix, 1973, oil on paper, 19½ x 29¾. Courtesy FAR Gallery. Casselli creates a harmony of related shapes. For example, the light area of the shirt echoes the dark area behind the head.

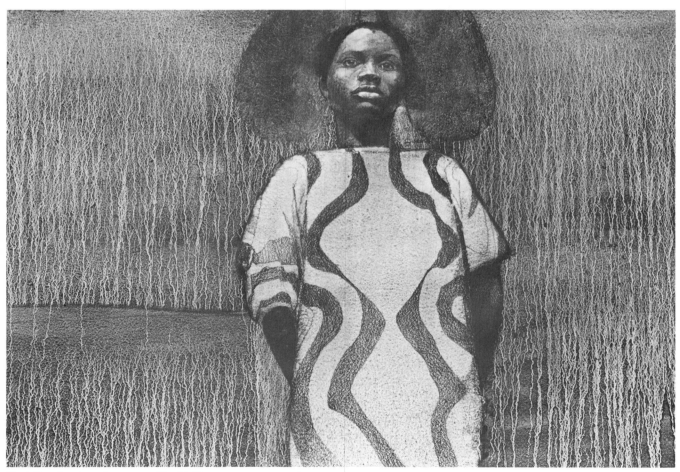

Black Renaissance, oil on paper, 26 x 34. Photo courtesy Mann Gallery, New Orleans. Casselli's mixed oil techniques permit him to develop a rich variation in texture.

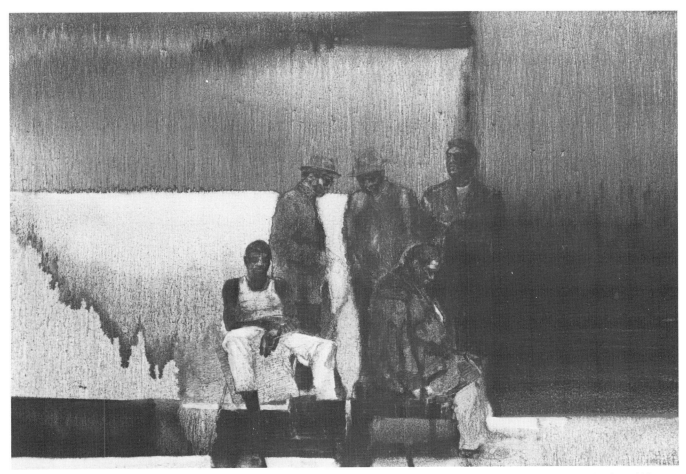

Mendicant Junkies, 1973, oil on paper, 19¾ x 29. Courtesy FAR Gallery. Set against an abstract backdrop, the painting captures the drug-ridden inertia of the junkie.

A strong Degas influence reveals itself in the drawing that shows through in parts of Casselli's paintings. "In a lot of Degas pastels you can see the charcoal drawing underneath," he explains. His adaptation of this technique is best illustrated in *Crucifix,* where the drawing of the coat filters through the paint—likewise in *Mendicant Junkies.* Here Casselli was more interested in retaining the abstract quality of the background, especially the area between the two standing figures on the left, than in painting the hand of the first of those figures. Other elements were also left exposed.

Afro-American is another design tour de force. "It's the successful blending of abstraction and realism," says the artist. The face, which is usually the focal point of a figure drawing, is down in the lower half of the bottom of the painting, taking up about one-thirtieth of the work. This asymmetrical design is reminiscent of Degas, Casselli explains, discussing the Impressionist's racehorses and nudes that were not totally included within the picture.

Afro-American is a prime example of Casselli's oil painting technique and bears witness to the subtle interplay between it and his watercolor technique. To him the principles of neither are sacrosanct. "There are absolutely no absolutes; no rules. People think oil should be thick and heavy in the light areas, but, 'Sez who?'" he grins mischievously. "In *Afro-American* some of the light areas of the face are where I actually took the paint off; it's like going back to the paper in a watercolor. The highlights of her glasses, her forehead, her upper lip were created by dipping a brush in medium [Casselli's medium is primarily turpentine], wiping it dry, and pulling off the paint. You might have to go into it a number of times. But oil remains workable for a long while."

The liberties Casselli takes with oils have caused a minor commotion: "I've had to put up with a barrage of comments like 'What are you doing?' 'Those paints look like watercolors,' 'Gee, that paint looks awfully drippy!'" But, unfazed by such criticism, he has gone on to create unique effects. For instance, in order to get the softness at the top of the Afro (in *Afro-American*), Casselli blotted the dark paint with paper towels. Then he applied medium freely with a brush, thus causing the light areas that run into the dark. "The broken paint gives an impressionistic effect," he says. "When the medium floats through the paint, it runs in little rivers and valleys."

Occasionally, the smallest touch of color is added to the medium-soaked brush. Casselli works the brush across the surface from left to right, generally moving from top to bottom. To make the medium or paint-plus-medium float, he tilts the painting in the direction he wants it to move. To stop the motion he lays it down flat. "In a sense this oil technique differs from watercolor because there's a certain amount of control. After working with this technique for a while I can tell what the paint is going to do." Indeed, the uniformity he achieved in the background of

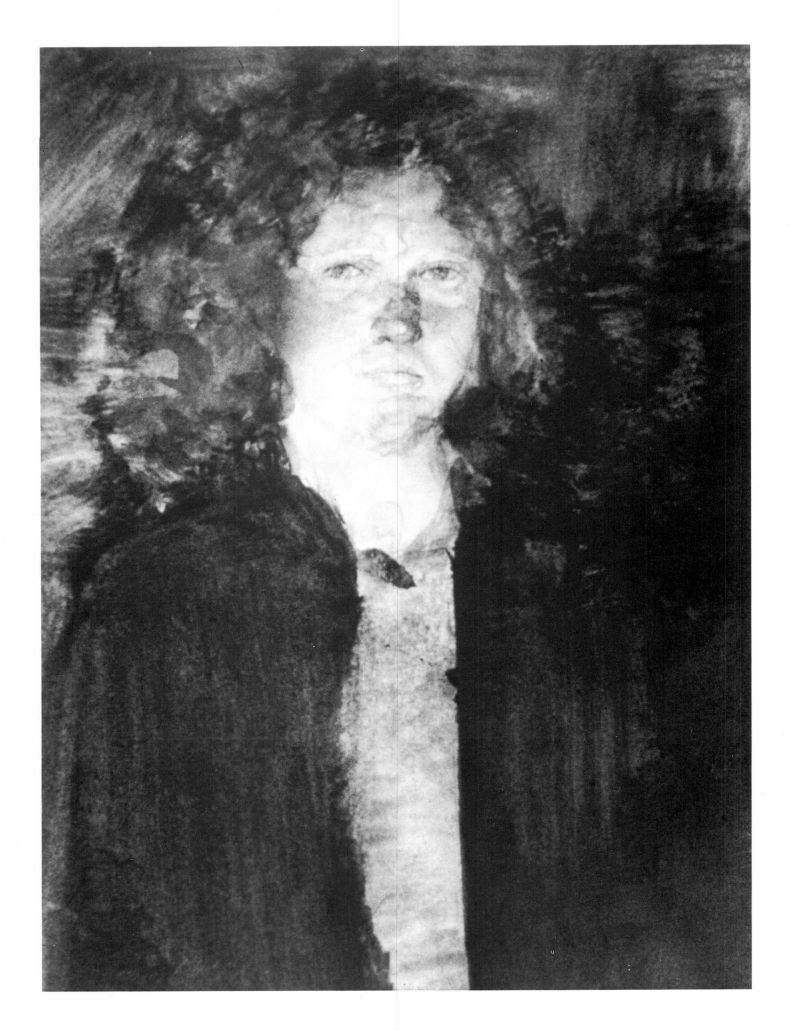

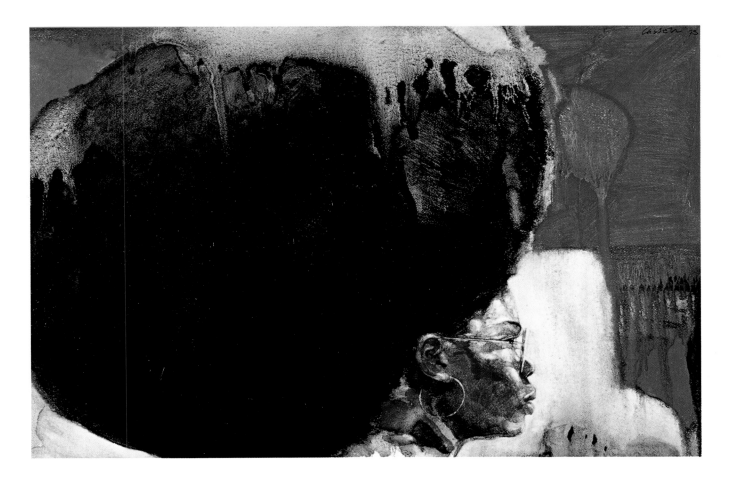

Left: *Red Head,* watercolor, 19 x 15. Private collection. In his more recent paintings, Casselli has been painting a variety of subjects around him.

Above: *Afro-American,* 1973, oil on paper, 19¾ x 29. Courtesy FAR Gallery. Red areas consist of oil used straight from the tube without benefit of medium, then spread out and scumbled with a bristle brush to give it transparency.

Right: *Speak No,* 1974, ebony pencil, 17 x 14. Photo courtesy Mann Gallery, New Orleans. The arms down in front of the body with fingertips facing each other, barely touching, form a motif that recurs in Casselli's works. He calls this a sort of "Why me?" or "Damn" expression.

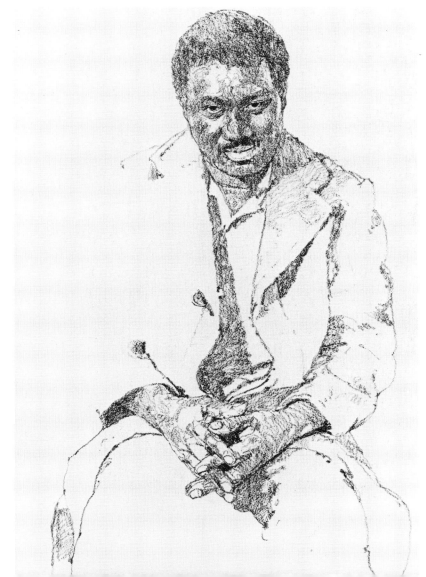

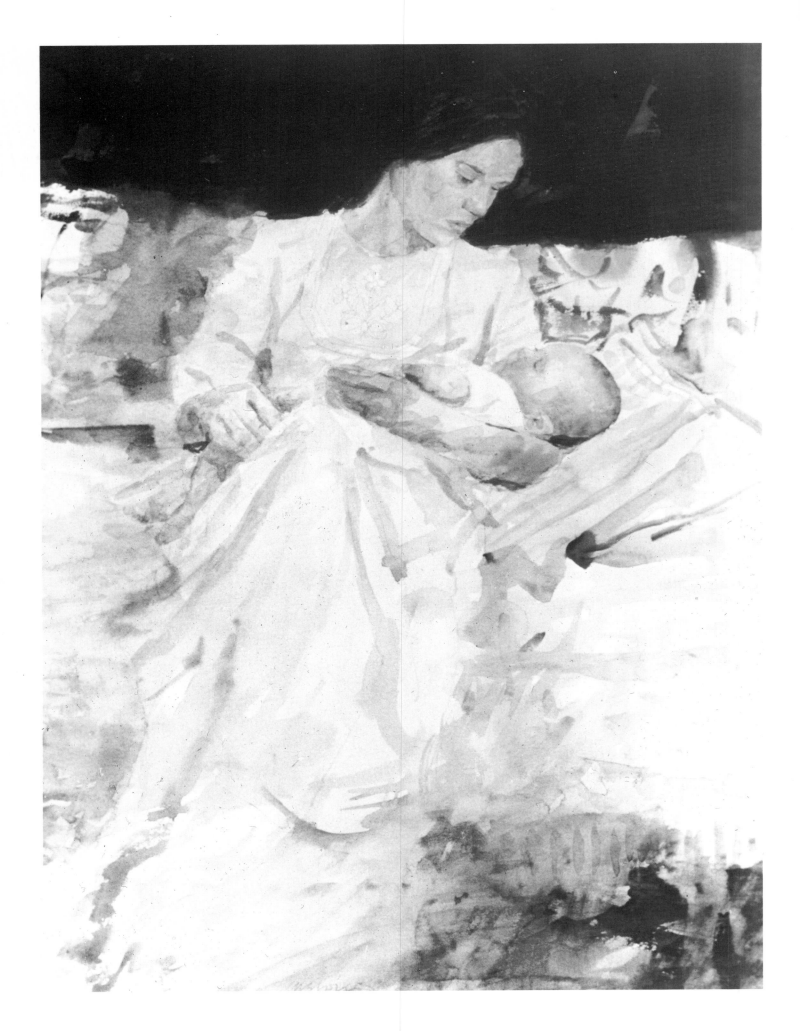

such paintings as *Crucifix* is a tribute to his technical expertise.

Casselli's preparations for an oil painting are simple. He stretches his paper (D'Arches 140 lb. cold-pressed watercolor paper) on a large drawing board of plywood or birchwood and secures it with staples. Casselli prefers this solid surface rather than the yielding ground of canvas, because his technique calls for a lot of "scrubbing off."

After stretching comes the drawing, which is done in pencil rather than oils. (In the interest of accuracy, he calls his oil paintings mixed-oils.) The drawing is sealed with a spray fixative so that the clear acrylic polymer medium, which goes on next, won't smear the lead. Casselli applies the acrylic medium to separate the oil paint from the paper and to prevent it from eventually blotting.

On occasion he paints on Masonite. Preparations for this involve sanding the surface, applying gesso with a roller, and sanding the surface again "until you get that sort of velvet but rough surface of watercolor paper."

Casselli's oil medium is almost exclusively turpentine, because he feels there's already enough oil and binder in the pigment itself to prevent the paint from flaking. Occasionally, he adds damar varnish to give the medium a little body (one part damar to ten parts turps).

In spite of flaunting tradition, Casselli is on the whole a purist when it comes to watercolor—he values its characteristics, clarity, transparency, and softness. Yet, as with oils, he is not bound by any of its rules: "Just as watercolor influences what I'm doing in oil, the oil in turn brings out what I'm doing in watercolor. For instance, I used to be hesitant about using a thick watercolor application in a dark area. But now I'll load up the brush real thick with watercolor and put it on." For example, see the blue in the turban in *African Influence*.

The artist feels the same freedom in pulling off paint in watercolor as he does in oil. To best accomplish this he sometimes paints on Strathmore hot-pressed paper mounted on 100 percent rag board. The slick, polished surface prevents the paint from being absorbed: "You can basically do some of the same things in watercolor on this paper that you can do with oils. If you wet it again you can pull the color off, which of course you can't do on absorbent watercolor paper."

Casselli's drawings, although often made as studies for paintings, are complete pieces in themselves. His favorite drawing tool is the Eberhard-Faber Ebony pencil: "I like to draw with something soft, because it's almost like drawing with a brush. The Ebony is, for me, softer than a 6B pencil." As for surface, Casselli prefers Strathmore drawing paper. "I don't enjoy drawing on a highly polished surface," he says. "It has to be exciting. Occasionally, I place the drawing paper over something I've been cutting mats on." The irregularities come through spontaneously (as in a stone relief rubbing), and he incorporates this random texture into his drawing.

Graphics is another area Casselli is developing, often translating a painting into a linocut. On the whole, however, Casselli, this man of many media, prefers to discuss his themes rather than his techniques. Yet his abilities and innovative qualities cannot be ignored. When one sees the finesse and workmanship of his output it is hard to realize that he is just getting started.

He first studied art in New Orleans at a small private art school to which he had a scholarship. His studies were continued under informal and certainly frightening circumstances on the battlefields of Vietnam. There he served as a Marine Corps combat artist. Since his discharge in 1970 and his first venture into fine arts, he has taken part in numerous exhibits and has won many awards.

Already Henry Casselli has explored much, and much remains. What his sensitivity, experiences, and talent will eventually evoke is something to look forward to.

Left: *First Born*, watercolor, 26 x 19. Collection Ronald Travisano. With the birth of his little girl, Casselli has been doing a greater number of paintings of those people in his most immediate surroundings.

PAUL COLLINS

BY MARILYN SCHAEFER

WHEN PORTRAIT ARTIST Paul Collins was traveling and painting in West Africa, his strangely pale eyes—described as "green" on his passport—aroused great curiosity. Among the groups that clustered around to watch him draw, some conjectured that his eyes might be part of the magic by which he created his mystifyingly real images. "Somebody asked me if I could see in the dark," Collins remembers.

The kind of realism that Paul Collins practices seems a little magical to most people everywhere. In Western art history, its spell is recorded as early as the 4th century B.C., when the legendary Greek painter Apelles is said to have painted horses so real that live horses neighed at them. And another painter, Zeuxis, made grapes so convincing that birds flew down to peck at them.

Realism of this degree is almost exclusively a tradition of Western Europe and its cultural antecedents and offshoots. Other cultures—African, Asian, Indian—seem never to have concerned themselves much with efforts to reproduce physical reality in this manner. The human figure, animals, trees, and plants have been considered by the vast majority of the world's artists as the raw material of their craft, to be designed, elaborated, *transformed* into art. As I talked with Paul Collins about his African portrait series, I felt a sense of exchange gone full circle in the idea of this black American carrying the realist tradition to that continent, which has been a major fountainhead of abstract art.

Within the Western tradition, the lure of perfect realism has always attracted a few artists even when the prevailing trend was quite different. There always has been a Zeuxis, a William Harnett, an Andrew Wyeth. And now, as a small countercurrent in the great stream of modern abstraction, there are the "Super Realists," or Photo Realists, in whose illusionistic paintings the old magic is again being felt.

The work of Paul Collins is related to, but distinct from, that of the Photo Realists. He shares their preoccupation with texture and the play of light, two crucial elements in the illusion we call realism. He also shares their dependence on highly developed skills and techniques. But while many of the Photo

Realists use picture projections and other mechanical and photographic devices, Collins relies only on the skill of his eyes, his hands, his mind.

But the really important difference between Collins's work and Photo Realist paintings is in the choice of imagery. Super Realists take their images from the hard, impersonal, and usually unappealing symbols of modern life: motorcycles, pick-up trucks, dimestore windows. When human beings do appear, they are gross, despicable, and pathetic.

The people Collins paints—and he paints people almost exclusively—radiate positive qualities: gravity, patience, shrewdness. It is a humanist's view of humanity, although Collins does not flatter or sentimentalize. It is this absence of cynicism, this unabashedly hopeful vision, that gives Collins's portraits a slightly unfashionable, even a naive quality, despite their technical skill.

Collins's humanistic vision derives in part from his political hopes and beliefs. Like many younger painters of our time, he talks about politics with the same intensity and sophistication that he brings to a discussion of art. This commitment to social and political issues is to some artists a source of distraction, confusion, and divided loyalties. Collins seems to have found a way to fuse art and politics with enviable ease.

He does it by letting his political interests guide him to the subject, but never letting politics influence his style. While many young black artists attempt to incorporate elements of African styles or symbols of the black movement into their work, Collins believes this is "a fad." He says, "Black artists need to relate to the human aspects of blackness rather than to the political aspects of blackness. Historically, art has always related to people." He is sure it always will.

Collins's desire to "relate to the human aspects of blackness" led him to his two-year sojourn in West Africa in 1969-1971. To finance this expensive venture he devised a plan that he recommends to other artists. He took his idea to several businessmen from his home town of Grand Rapids, Michigan, proposing that they finance the trip. In return he offered them 30 percent of all money from sales of the African work.

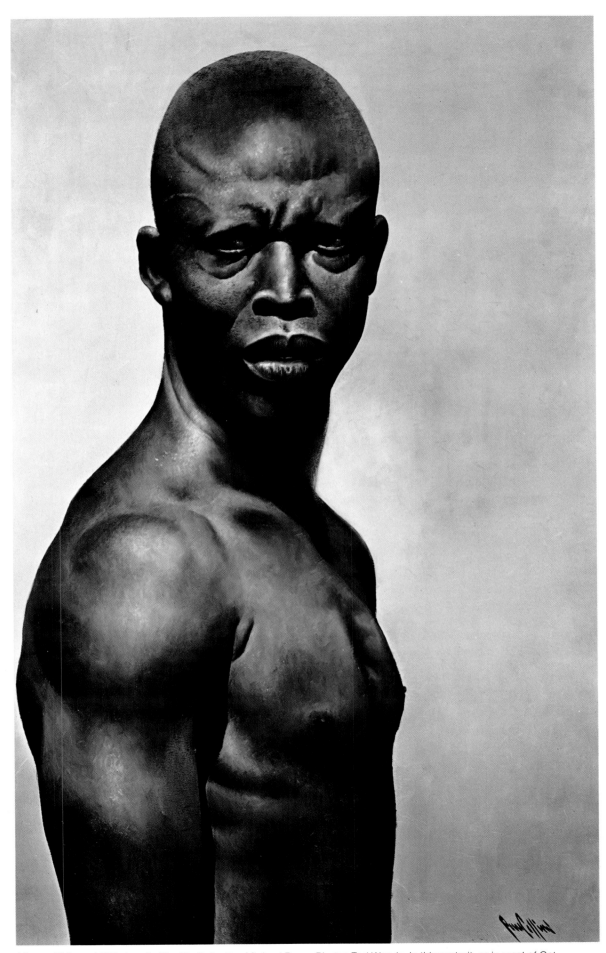

N'gore N'diaye, 1972, dry oil, 42 x 36. Collection Michael Berry. Photos Earl Woods. In this portrait, as in most of Collins's work, the final pose is put together by the artist from various sketches.

"It's worked out well both for them and for me," says Collins, who also feels that this method leaves him freer than he might be if he depended exclusively on gallery sales or commissioned portraits. He has since used the same method with a different group of backers to finance a two-year stint in South Dakota painting portraits of Sioux Indians.

Collins's time in West Africa was concentrated in Senegal with brief forays into Gambia, the tiny finger-shaped nation that pokes into the heart of Senegal along the banks of the Gambia River. During his two years there he produced about 35 paintings, mostly portraits. The series also includes a few still lifes. One painting shows vessels standing in the dust around a muddy water hole and several of the beautiful handmade boats used by Senegalese fishermen. One still life, of rusty links of chain imbedded in a wall, was painted on the island of Gorée, once a major point of embarkation for slaves being shipped to America.

However, portraits dominate the African series. Their subjects range from Senegal's President, Léoplod Sédar Senghor, to the fishermen, farmers, boatbuilders, marketwomen, children, beggars, and tribal warriors that constitute Senegal's highly varied population. Thirty of these paintings were published in Collin's book., *Black Portrait of an African Journey* (Eerdmans, 1971), which has a text by Tom Lee, a writer and student of African history who accompanied Collins on the trip.

The third member of the party in Africa was his teen-age son Michael, the eldest of Collins's four children. It was Michael's ability to cut through the shyness and suspicion of his contemporaries that made possible some of Collins's moving portraits of African children.

"Black Americans don't realize how western they are until they go to Africa," Collins says, shaking his head and remembering the strangeness of his first impressions. The official language of Senègal is French; the main dialect is Woloff; Islam is the national religion, and customs and dialects vary widely, depending on region and tribe. The climate is sharply divided into the *hivernage,* four months of almost continual rain, and the *saison séche,* eight months of no rain at all. Where you can go and what you will see when you get there are governed by these seasonal differences, which alternately turn roads and fields into muddy pools or dusty wastelands.

"But if you go into any culture prepared to assimilate," says Collins, "the problems are minimal." So, with not much more than a desire to see and share as

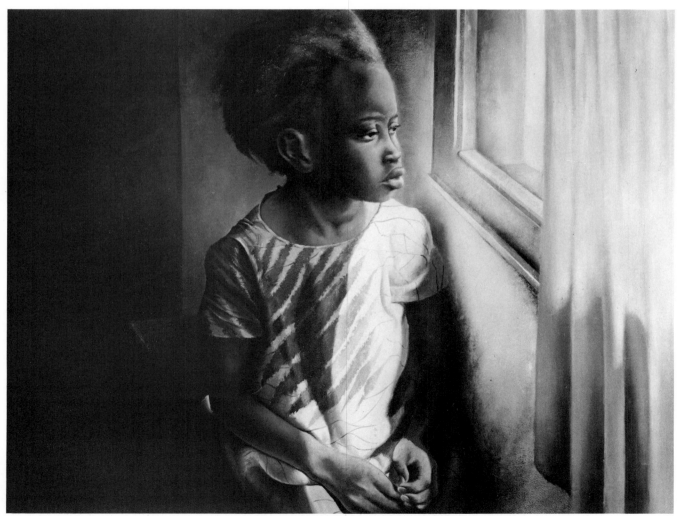

Ida, 1972, dry oil, 42 x 48. Collection Frederick G. H. Meijer. Light is a major element in many of the artist's paintings. Here it floods in from the window and suffuses, softening areas it reaches.

much local life as possible, Collins, Lee, and Michael set up headquarters in an apartment in Dakar, the capital city, and set out to explore first the city and then the surrounding country.

Mamsanou and *President Senghor* were among the very few of Collin's African portraits painted at formal, scheduled sittings. Ordinarily, Collins prefers not to have his subjects "pose" at all. His usual method is to work, from rapid sketches made on-the-spot as he observes his subject going about his or her daily business. From these sketches, and with the aid of a kind of visual "total recall," Collins then does the protrait in his studio. Some of his subjects never knew their portrait was painted.

Collins's approach may be unique for a portrait artist, but it was perfectly suited to the conditions and the goals of his African journey. Many of the portraits achieve the immediacy of candid photographs, and the whole series is distinguished by the absence of the frozen, self-conscious look that Collins sees as the bane of the art of portraiture.

The triumph of this method may be represented by Collins's portrait of a Bassari warrior who was sketched in just a couple of minutes when he suddenly appeared at the side of the road to watch the foreigners in their Land Rover depart from the remote country of his elusive tribe. In the final portrait, the light from above and behind the warrior illuminates his arrogant or indifferent gaze and glances off his spear and elaborate neck ornaments.

Naturally, Collins prefers a little more time than the Bassari warrior allowed him. Under ideal circumstances he likes to take about a week for each of the three stages of his method: studying the subject, sketching the subject, and painting the picture.

Some of the most striking portraits in the African collection are of people Collins got to know and was able to observe for some time before he painted them. His portrait of Senegal's champion wrestler N'gore N'diaye, for instance, came about because Collins, watching N'gore's workouts and matches, became fascinated by the man. They became friends. N'gore taught Collins karate in exchange for portraits of his children. They spent hours talking politics, and after an unfortunate fish dinner at Collins's place, N'gore taught him how to shop for fish.

From a handful of sketches made during wrestling matches and workouts, and from his familiarity with his friend's manner, face, and expressions, Collins did one of his strongest paintings (page 35). It is a half-length portrait of the wrestler scowling fiercely out of the canvas over his right shoulder. This must be how N'gore looks entering the ring. The close-shorn head, the furrowed brow, the gleaming skin, all add up to the impressive theatrical toughness that brings fans to their feet.

After the portrait was finished, Collins decided to add an arm bracelet: "Then I saw that was wrong, so I painted it out again. I have to get a finished painting out of my sight, or I keep fiddling with it."

As in many of Collins's portraits, N'gore's pose is

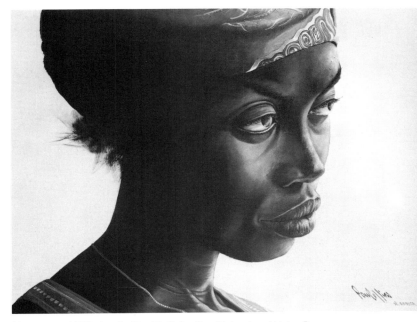

Mamsanou, 1972, dry oil, 42 x 48. Collection Richard and Helen De Vos. Here Collins captures the grace and beauty of his sitter in a pose that seems too natural to have been a studio portrait. But, unlike most of his portraits, it is.

the artist's invention, a composite made up from several sketches. The head, an almost frontal view, was combined with a body in profile from a different study. The final result is perfectly natural and convincing. Like all artists who love absolute realism, Collins knows that it has to be invented; nature is never perfectly true to itself.

Collins does not invent all the poses in his portraits, of course, Frequently, he uses a stance or position that he has seen the subject take habitually. This kind of pose has the double advantage of representing a familiar and characteristic position for the subject and of allowing the artist a decent amount of time to make sketches and studies. Two examples are the portraits of *Hawk* and of *Ida*. Both are in poses Collins chose from their own familiar repertory.

Hawk, fisherman and smuggler, sits with large black hands folded around crossed knees, his beak-like nose and shrewd eyes in profile. "I made the sketches while he was bargaining with coastal police—something he did a lot," Collins told me. This explanation made me laugh, because it shed a sudden light on the concentration and intensity in Hawk's pose and expression.

Hawk's story is one of the most interesting of those in Collins's *Black Portrait of an African Journey.* Like most Senegalese, Hawk lived a hand-to-mouth existence, "never owned shoes, never ate more than one meal a day, and never knew what it was to be free of the misery of poverty and disease." Then he discovered that a cargo of opium, hashish, or marijuana had a much greater value than a hold full of tuna. So he took his ancient diesel-powered boat south to Liberia and Sierra Leone for opium and north to Mauritania for hashish and marijuana. He hid the drugs in plastic pouches pushed into the gullets of the few fish

Right: Sketch for *Three Boys and a Boat,* pencil, 60 x 72. The artist's sketch captures the gesture and shadow pattern of his subject.

Below: *Three Boys and a Boat,* 1971, dry oil, 42 x 48. Collection Richard and Helen De Vos. ''Light has a way of animating a painting, making it come alive,'' says Collins.

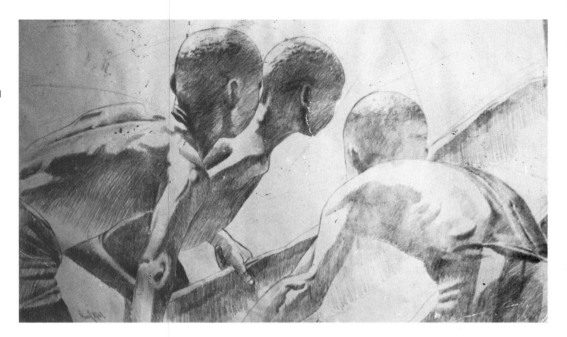

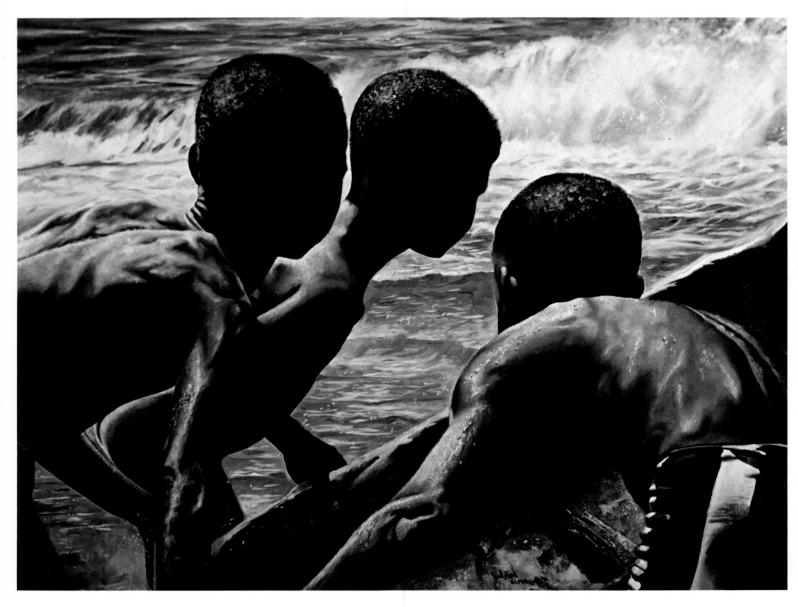

he caught to provide a respectable cover for his real trade. Having adapted to the harsh workings of the law of supply and demand, Hawk prospered. He has since retired in comfort to Paris.

"But won't Hawk get into trouble if his story is told?" I asked.

"No," Collins replied, "Hawk wanted his story told! He used to say there was some pleasure in doing it and some enjoyment in getting by with it, but the greatest pleasure was in being able to say you did it and got by with it."

"Light is the most important thing," says Collins. "It animates a picture; it can change everything." It is an important factor in all his work, but the way he uses it in his portraits of Hawk and of Ida show how much a realist can manipulate nature to his own purposes. The same hot African sun falls very differently on Hawk and on Ida, those two diametrically opposed characters. In the portrait of Hawk, strong light throws everything into clear, hard-edged relief. Tex-

tures of old wood, worn cotton, and bony hands are sharp and real. But in the portrait of Ida, Collins has let the light diffuse, almost dissolve the subject, as if she might fade into her own reverie. The light flooding in from the window softens every line and suggests the mystery of a small child's thoughts.

Although Collins's *method* of working was well suited to the "field trip" conditions of his African project, his *medium* sometimes gave him trouble. He likes the materials he knows and is not inclined toward experimentation, so he took all of his painting supplies with him from the United States. However, he found that oil paint dries much slower in the humid climate of Africa than it does in Michigan. And Masonite panels, which he uses almost exclusively, were cumbersome and expensive to ship. Luckily, the U.S. Information Service sponsored the traveling exhibition that brought the paintings back to the United States. The show opened in Dakar and went on to Lagos, Nigeria; Nairobi, Kenya; Paris; Lon-

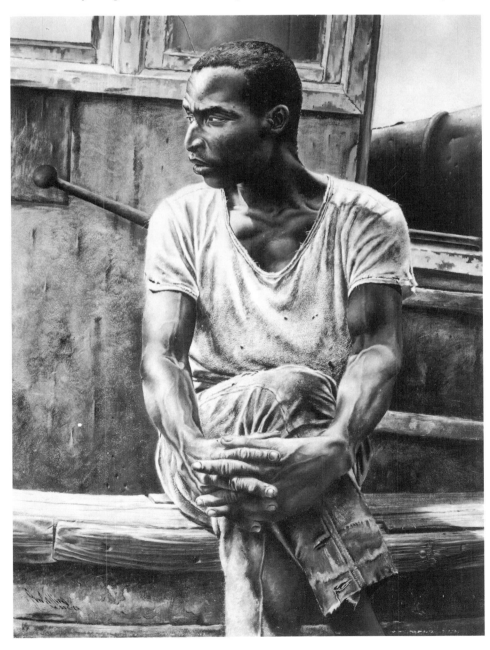

Hawk, 1973, dry oil, 54 x 48. Collection Richard and Helen De Vos. The pose is nonchalant yet intent. Collins captures his sitter's solitary strength and alertness, using the placement of highlights for pictorial focus.

39

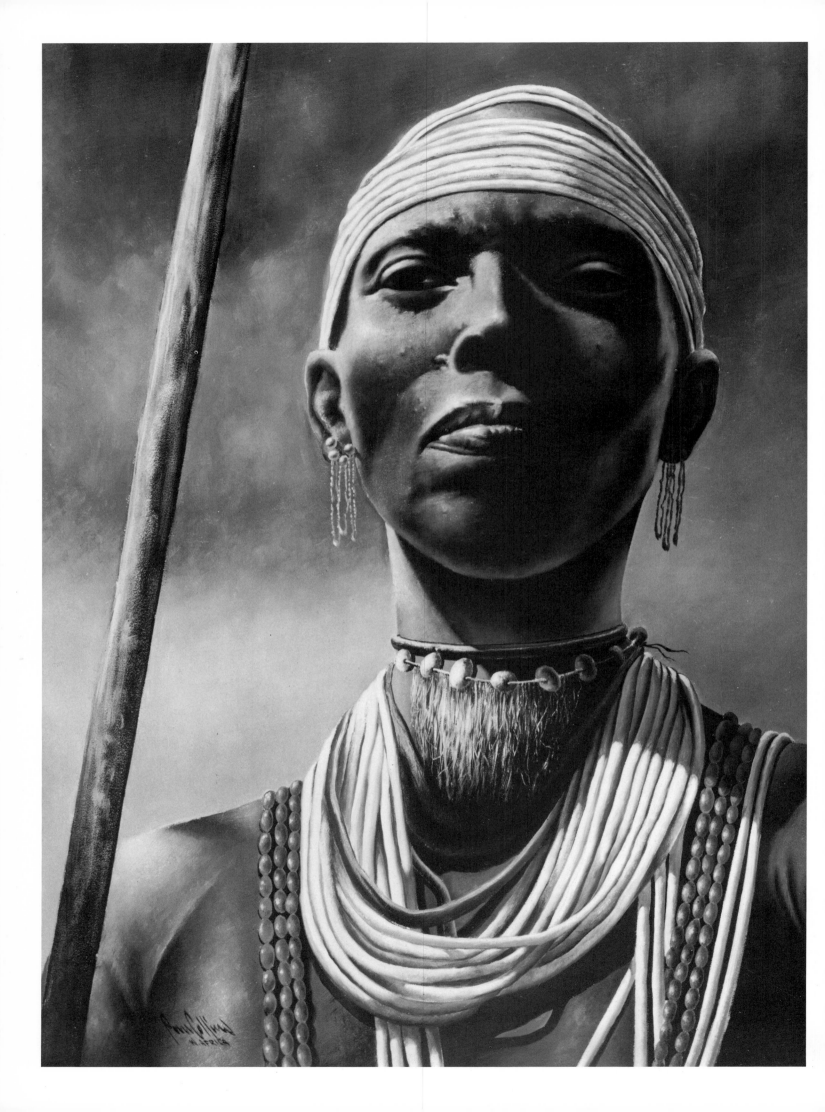

don; and Washington, D.C.

In returning to the subject of Collins's technique and medium—"dry oil" he calls them both—he said that he arrived at the technique very gradually over a period of about ten years. The medium has some of the flat brilliance of tempera and dries more quickly than the usual turpentine and linseed oil mixture used in oil painting. He said his medium is made of "resins and varnishes" and that he uses no turpentine. Pressed for a more specific formula, he became as vague and evasive as a Cordon Bleu chef asked to reveal the secret of his best sauce. The great strength of Collins's "dry oil" medium, whatever it is, is that it makes possible the variety of textural effects that his realism demands.

To get a surface as sensitive as his medium, Collins prepares his Masonite panels very carefully. They receive three or more coats of gesso painted in alternating horizontally and vertically stroked layers. A light sanding gives the final layer a soft eggshell-like finish that takes most kinds of brushwork well but is especially good for the drybrush techniques Collins likes to use. More recently, he has been using these gessoed panels for finished pencil drawings, and for these they also provide a sensitive surface.

Collins is primarily self-taught as an artist. Even his impressive store of technical knowledge has been wrested from books and long experimentation. He was born in Muskegon, Michigan, in 1936. His father died when he was three years old, and his mother moved to Grand Rapids, where Paul went to school and where he still lives when he is not traveling. He did well in school but was often discouraged from taking art too seriously. Some teachers urged him to go into something more serious, like medicine, or something less serious, like sports. In the tenth grade, as a kind of rebellion against a semester of crafts, he even flunked art.

The person who convinced Collins that he should take art seriously and that he could earn a living at it, too, was William Randolph Brown, an artist and graphic designer whose studio was near Collins's home. While Collins was still in school, he often visited Brown's studio. Brown urged him to try oil paint, the medium Collins has preferred ever since.

Under Brown's guidance, Collins dug into library books to study reproductions of Old Masters, concentrating on their composition and their light. He was also urged to get a good technical background, so he read all he could find about oils, varnishes, and the chemistry of paints. He had tried watercolors and tempera and experimented briefly with acrylics, but he always returned to oil paint.

After graduating from school, Collins went into business with Brown. Ran-Col Associates, their general design studio, gave Collins an opportunity to develop his talent for design, layout, and lettering. Large-scale super-graphics were a specialty of the studio. One of Collins's fondest memories from this period is of painting a gargantuan hamburger-with-everything for an outdoor advertisement. Though he s no longer a partner in the studio, Collins still does some free-lance design work: book and record covers and Black Movement posters. He also does portrait commissions.

But he prefers to do portraits in series. He completed, for example, a series of American Indian portraits, about 30 paintings. It seems somehow typical of him that Collins happened to be painting near Wounded Knee, South Dakota, in 1973 when the confrontation between Indians and government officials broke out. He ended up deeply involved in the negotiations between the two parties and wrote and illustrated an article about the experience for *Ebony* magazine. He grew to love the country, and with the help of Indian friends has built a small cabin on Reservation land, where he spends as much time as possible.

During the remainder of 1975, Collins was in Grand Rapids, working on a large mural tracing the life of Gerald Ford from boyhood to the Presidency. The mural, commissioned by a group of citizens of Grand Rapids, which is also Ford's hometown, was installed at the Kent County Airport early in 1976. The mural is painted on large Masonite panels and is 8 x 20 feet (2.4 x 6.1 m). "It's the hardest thing I've ever done," Collins says.

At the time Ford was president, Collins made sketches of him at Vail, Colorado, when Ford was there golfing. In keeping with his usual procedure, Collins worked out an arrangement under which he could sketch Ford as he went about his pleasures and duties. Collins was impressed by Ford's informality: "I think he and I were the only men at Vail who didn't have neckties." Collins had to be checked out for a security clearance before arrangements could be made to do sketches of the former president. Then he was given a direct line from his studio in Grand Rapids to Ford's then press secretary, Ron Nessen. By this means sketching sessions could be quickly arranged according to need and convenience.

After Collins's collection of Sioux Indian portraits was launched on its tour, and the Ford mural installed, Collins was ready to start a new series. At the time of this writing he was about to decide between two ideas, both of which interested him very much: an Israeli series or a series of portraits of American people at work. Paul Collins has a lot of energy and a lot of ambition; he will probably do both.

Left: *Bassari Country,* 1972, 54 x 48. Collection Richard and Helen De Vos. The Bassari Tribe is one of Senegal's smallest ethnic groups; Bassari Country is relatively inaccessible. In this work, painted from a quick sketch, Collins captures the imposing stature and aloofness of a Bassari warrior.

HARVEY DINNERSTEIN

BY HEATHER MEREDITH-OWENS

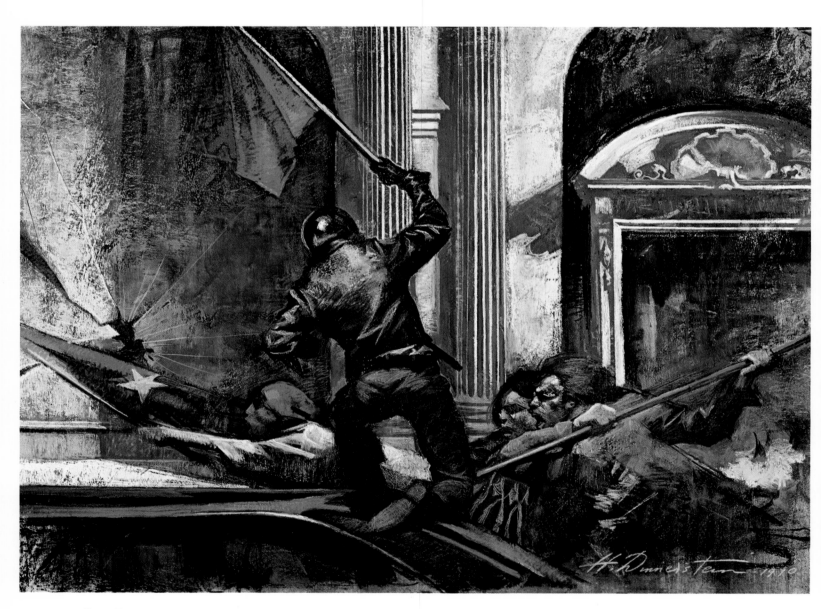

Above: *Terrorists,* 1970, pastel, 21¼ x 29¼. ''I viewed those street demonstrations as having the same sense of life force as a raging storm over a landscape.''

Right: *Blue Shades,* 1968, pastel, 17 x 16¼. Collection Mrs. John Buhrer. ''Certain technical information is useful, but I really feel that there are no secret mediums or formulas. The mystery of a work of art is more complex that that.''

Meredith-Owens: At what age did you decide to become a painter?

Dinnerstein: I drew precociously as a very young child. As far back as I can remember, I think I always wanted to be an artist. I grew up in a working class Jewish neighborhood in the Brownsville section of Brooklyn, and I can't remember any paintings or reproductions on the walls of our apartment. My parents had no sense of art or any conception of what it meant to be an artist. But they did have a great understanding of the things in life that really matter: They put human values ahead of monetary considerations. They encouraged me to continue my studies in a field that was totally alien to them and must have seemed, at that time, completely impractical. In retrospect, I realize that their support was quite remarkable and also that it meant a great deal to me.

Meredith-Owens: Where did you study art?

Dinnerstein: From 1942 to 1946 I went to the High School of Music and Art in New York City. When I was about 16 I began studying weekends in Moses Soyer's studio. It was the first artist's studio I had ever entered; I can still remember a mixture of sensations and feelings—the smell of oil and turpentine, the sense of anticipation and fear of the nude model, the feeling of serious dedication about the place.

After high school I won a scholarship to Carnegie Institute of Technology in Pittsburgh, which was then, like many colleges in this country, introducing design courses based on the Bauhaus system. In high school I had read with interest Gyorgy Kepes's *Language of Vision,* but the courses I encountered in Pittsburgh were dull and academic. Mostly, I missed the smells of the painter's studio, and, after a few

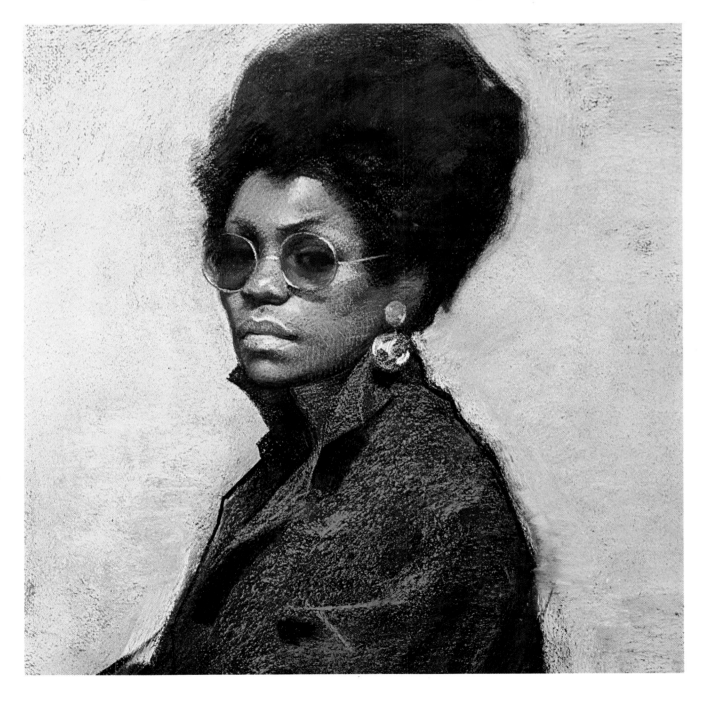

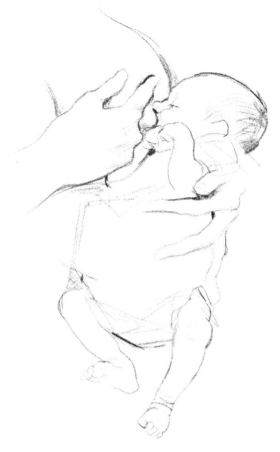

Newborn, 1960, pencil, 7½ x 5.

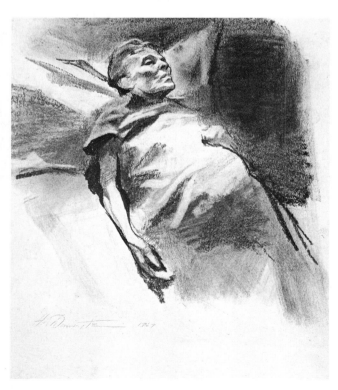

Sarah (The Artist's Mother on her Deathbed), 1967, charcoal, 13 x 12¾. "I'm interested in a great range of subjects: the explosion of light in a sunset, the birth of a child, the death of a loved one."

months, I left to attend the Tyler Art School in Philadelphia. There the curriculum provided for more painting. For a short time I also studied at the Art Students League with Kuniyoshi and with Julien Levi.

None of the schools I attended imparted a method or training that seemed meaningful to me. Perhaps the tradition had been lost several centuries ago when the workshop system disintegrated; that's a complicated subject. Anyway, I had to work out my own set of values, my own sense of tradition, both by studying paintings in museums and by working from life. I guess every generation of students does this to some extent. Probably the personal struggle and search and the absence of formulas results in some measure of vitality in an individual's work.

Throughout my school years I found that the other students were the most important part of my learning experience. A group of fellow students evolved over the years; some I had first met in high school and some at Tyler in Philadelphia. We had common interests and directions; we visited museums together, we discussed art and, together, we worked on similar painting problems. I think we learned more from each other and from studying great paintings than we ever did from any institution.

Meredith-Owens: Were you able to continue your career as an artist after you left school?

Dinnerstein: In 1950 I left Philadelphia and returned to New York City, where I shared a studio off Union Square with Burt Silverman. Then I had some difficult times: there were two years wasted in the army and, after I was discharged, a period in which I had to take odd jobs. Somehow I managed to get some drawing or painting done on a regular basis, whether I sketched in the barracks or drew on the subway going to and from work. I've always tried to maintain some continuity of work in spite of financial hang-ups, social obligations, or other distractions. I find it very difficult, almost painful, to get back to creative work once the rhythm is broken.

In the mid-1950s some of the young artists in the group I mentioned before started to exhibit at the Davis Galleries in New York. That gallery had a unique point of view: It was devoted to a kind of realist painting that depicted contemporary life. It was art inspired by realist painters of the past, with hardly a glance at anything painted after the 19th century. This was the heyday of Abstract Expressionism, and I think we all felt like non-persons in a totalitarian state. We were invisible to the offical "art world," but somehow we sustained each other through our mutual interests. I don't mean that there were no differences among the artists involved, but there was a comradery, a context in which to function that was very important to me.

As I look back on that period—which really wasn't so long ago—it's somewhat amusing and kind of frightening to see the incredibly rapid turnover of taste. Abstract Expressionism, then considered the quintessence of youth, energy, and the future, has

been supplanted by half a dozen other movements in quick succession. It almost seems inevitable in this faddist culture.

I exhibited at the Davis Galleries until 1964, when I started showing in Philadelphia at Kenmore Galleries. Harry Kulkowitz, the director of the gallery, helped me through some lean years: not simply with money to pay the rent, hire models, and buy materials, but also with the moral support so important to an artist's growth and development. He never made any demands upon the kind of painting I should do. It was this kind of patronage that enabled me to work and study in Rome. At present my work is exhibited at Kenmore Galleries in Philadelphia and FAR Gallery in New York City.

I might add, since you posed this question in terms of career, that I don't conceive of an artist as one who builds a career. That sounds too much like a "show-biz" hustle aiming at whatever one considers success—money, fame, and so on. I think being an artist is a way of life, a striving towards a certain kind of awareness of the world and yourself.

Meredith-Owens: You have done illustrations for magazines. What do you think is the difference between illustration and fine art?

Dinnerstein: That's a difficult question, especially as you present it. It suggests a hierarchy of values: low art and high art, illustration and fine art. But I don't think the distinction between the two is all that simple. Artists have often been concerned with storytelling in the past; they have illustrated everything from Ovid to the Bible. There is nothing in a commissioned work that automatically makes it inferior to a work conceived and initiated entirely by the artist. Unfortunately, the content of most contemporary illustration is very superficial, because the content of the assignment is often without substance. And there is always the element of compromise: after all, most magazines are in the entertainment business. But I think the relationship of artist to patrons who commissioned work in the past must have had its difficulties, too. Different times affect the nature of the relationship, but there have always been artists who maintained their sense of integrity and others who lost their nerve and "copped out." And there are many studio painters, working without patrons or commissions, who grind out meaningless drivel all the same.

I used to view anything labeled illustration as inferior in quality to "fine art," but I'm beginning to question all these artificial categories. If an artist communicates a personal vision that expresses some aspect of life in a visual image, then I have to consider it seriously as a work of art. What else is it?

Meredith-Owens: What subjects interest you, and why?

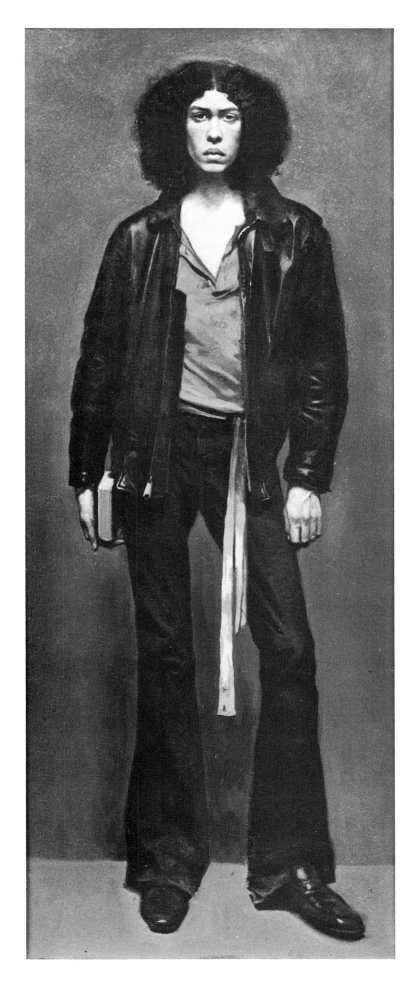

Michael S., 1970, oil, 28 x 12. Collection Mr. and Mrs. Fratkin. "But I must emphasize that the subject is not the content; it has to be something deeper, some personal insight."

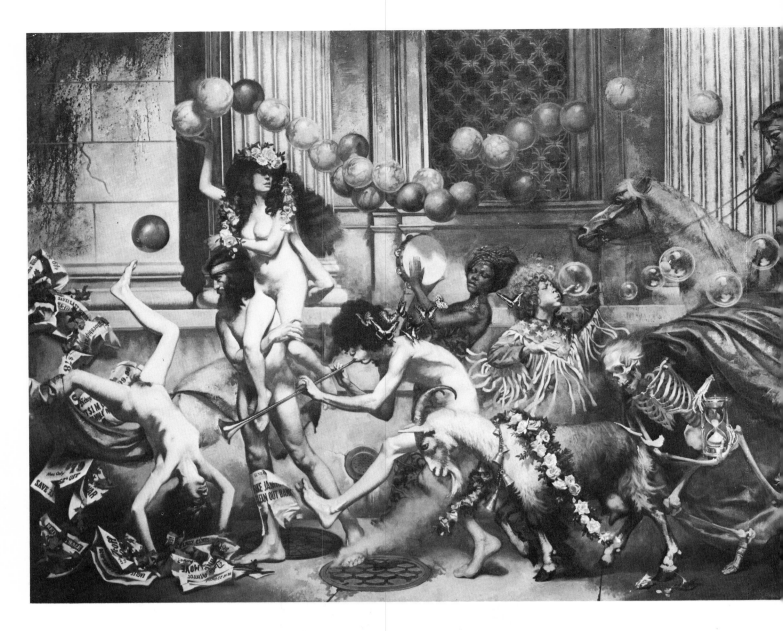

Above: *Parade,* 1970–1972, oil, 74 x 153.
"My subject in this painting is a parade; it
touches on certain contemporary events. I'm
simply describing the subject here, but I hope
the painting gets at something deeper. My
aim is to go beyond the transitory nature of
the moment."

Right: Detail from *Parade.*

Opposite page: Harvey Dinnerstein in his stu-
dio, working on *Parade.* "I found the greatest
difficulty was in maintaining a level of intensity
and energy over two years. The painting
seemed immense to me, especially at the be-
ginning when I confronted the blank canvas
that took up my entire studio."

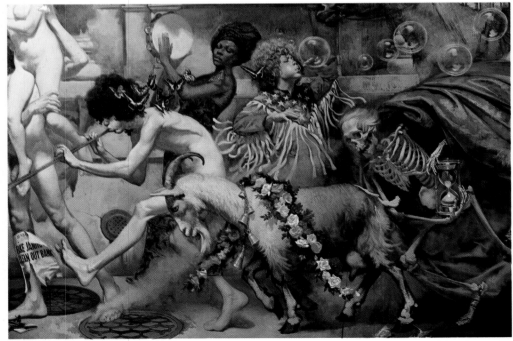

46

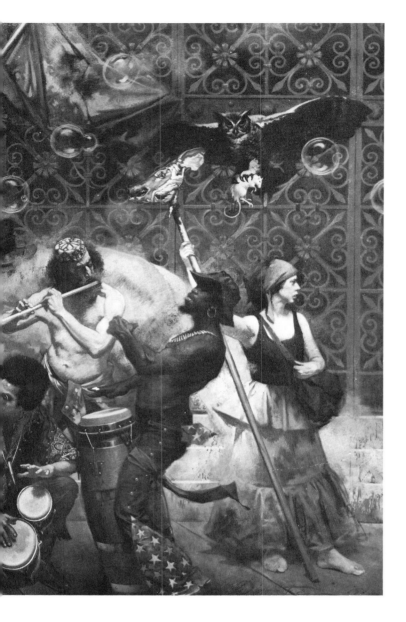

Dinnerstein: I'm interested in a great range of subjects: the explosion of light in a sunset, the birth of a child, the death of a loved one. I viewed those street demonstrations as having the same sense of life force as a raging storm over a landscape. But I must emphasize that the subject is not the content; the content has to be something deeper, some personal insight into the meaning of the subject.

Meredith-Owens: You have been working on one large painting for a long time. Why did you undertake this work?

Dinnerstein: I started working on studies for the painting in 1968 and started the canvas in 1970. I found the greatest difficulty in maintaining a level of intensity and energy over this length of time. The painting is 74 x 153 inches (1.9 x 4 m), which seemed immense to me, especially at the beginning when I confronted the blank canvas that took up my entire studio.

The question of scale is interesting. A monumental image can be achieved in a modest scale, as done by, say, Vermeer, Chardin, or Ryder. There is really nothing quite as boring as certain contemporary painters who present inflated images, or tedious rendering, on a scale that really contradicts the thin content of the painting. But I've always been intrigued with epic painting, the projection of a conceptual idea, which I think calls for a certain scale.

My subject in this painting is a parade; it touches on certain contemporary events. I'm simply describing the subject here, but I hope the painting gets at something deeper. My aim is to go beyond the transitory nature of the moment as, for example, Gericault's *Raft of the Medusa* or Picasso's *Guernica* reach toward symbol and myth, beyond the particular events they were concerned with. I don't want to

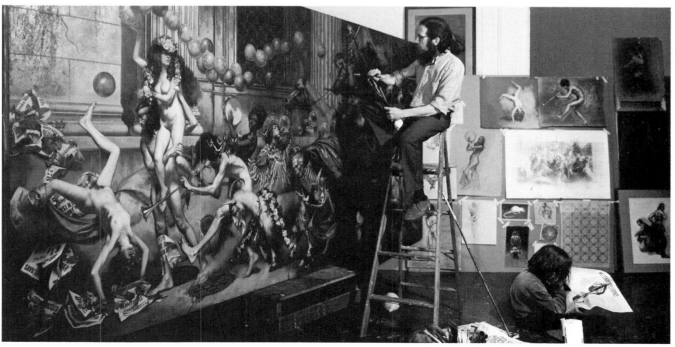

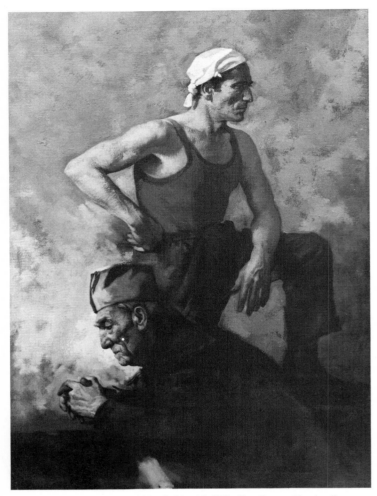

Roman Workers, 1965, oil, 50 x 40. "Whether I'm working in oil or pastel, my overriding concern is what I have to say, not the technical aspects of the medium."

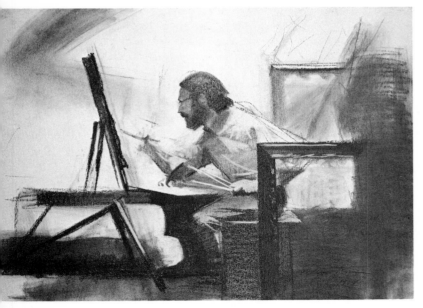

Self-Portrait, 1968, charcoal, 18¼ x 26¼. Collection Mr. and Mrs. Daniel Dietrich.

get involved in explaining the various symbols I have employed in this painting; that would be deadening. But I might indicate some ideas I have begun to think about. For a long time I felt that artists of the past (when society seemed more cohesive) had a rich tradition of myth—Christian, pagan, and so on—that offered a range of possibilities, a common language to communicate. I thought that these symbols had little meaning today. But one of the intriguing aspects of these street demonstrations, street theatre, or whatever you call it, is the use of masks, costumes, blood, etc., to express ideas that are explicit in their reference to contemporary issues, yet invoke mythic images of times past.

Sometimes, as the painting evolved, a gesture I had drawn from life developed other connotations that I was not altogether aware of. I remember one small example, in the midst of a wild confrontation between young people and the police several years ago, I saw a young man blowing soap bubbles. It seemed an absurd and humorous relief against the heavy action developing at the moment. When I painted it, I had great fun working on the rainbow reflected in the bubbles. The other day I came across an 18th-century allegorical engraving, with a symbolic figure of Time blowing bubbles over a papal tiara, royal crown, scholar's hat, and military order. The inscription, which is really superfluous, reads, "Naught under the sun is eternal . . ."

Meredith-Owens: Do you prefer working on-the-spot or in the studio?

Dinnerstein: I enjoy working from the model in the controlled light and comfortable environment of the studio. But there's more to life than that, and I often feel the need to get outside. I find working in the street, the market, or in a changing landscape very exciting in terms of a spontaneous response to life's infinite and unexpected possibilities. But I also find that I want to arrive finally at a statement that is more considered, more reflective than a flip capturing of the moment. I usually take my notes back to the studio and try to work out an image that hopefully retains some sense of that initial response to nature.

Meredith-Owens: How do you work on location, gathering notes for a painting?

Dinnerstein: When I work outside the studio I usually make small notes, to explore various possibilities, in the form of drawings, pastels, or small paint studies. I make many of these notes from different points of view, times of day and night, etc. What I look for is a visual idea. Sometimes this comes immediately; at other times I discard numerous notes and studies because they do not seem meaningful to me. In covering street activities involving masses of people and a great deal of movement, I often use a camera to capture a gesture or give some literal information about, for example, an architectural ornament or lettering on a sign.

However, I find it difficult to use the photograph

unless I also draw or paint directly from life. I usually end up having a model pose in the studio, perhaps in a gesture suggested by the photograph. I find I can work more succinctly and directly from life than from photographs. Maybe the pressure of working from a model that breathes, and moves occasionally, that has to leave after a few hours, forces the artist to make a commitment that is more immediate and direct. There is also a probity of form, air, and space that I find difficult to read in a photograph.

Meredith-Owens: What kind of drawing materials do you use?

Dinnerstein: Usually I draw with charcoal, because it offers the greatest range of possibilities, both tonal and linear, and because it can be erased easily. I use vine charcoal or a thin type of compressed charcoal and a charcoal pencil, or carbon pencil for a sharp point. I also use stumps and rags for blocking in large tonal areas. Sometimes I add black Conté crayon or pastel for accents of the darkest value.

Meredith-Owens: How do you start work on an oil painting?

Dinnerstein: I start working out an idea in small drawings or color notes, aiming at a broad concept of the painting. The color notes are usually in pastel, but occasionally I make small oil sketches. Often I have to make many studies before I get something that interests me. In setting up the canvas, I work on linen, which I prepare with glue size and prime with lead white. When the priming is dry, I tint the canvas with raw umber, raw sienna, or green earth. I begin by blocking in the forms tonally with raw umber, wiping out here and there with a rag, as you might use an eraser, back to the tint of the canvas. This is all done very quickly, the forms very broadly stated, and I proceed to work in color. If the painting is complex, I may have to do additional studies.

I try to plan the painting carefully; sometimes I even start with a grisaille underpainting. But I find that such a system of underpainting tends to lock me into a limited concept. I prefer to work more openly so that an element of spontaneity is always there, no matter how long I work on the painting. Although I paint fairly quickly, I usually spend a long time on a painting, working layer upon layer, trying to arrive at a resolution of form that is simple and probing at the same time.

Meredith-Owens: Do you use any paint medium?

Dinnerstein: Mostly I use stand oil, thinned by ½ with turpentine. For a thick, juicy gob of paint, I might use pure stand oil. Sometimes, when I start to lay in a large painting, I use a thinner medium: linseed oil, thinned by ½ with turpentine, and then on to the stand oil mixture. I try to use as little medium as possible.

Meredith-Owens: How do you go about working in pastel?

Dinnerstein: When working in pastel, I use all kinds of surfaces and many different papers, but I prefer working on a board I prepare myself. This is a heavy 100 percent rag board, primed with gesso that has pumice or marble dust dissolved in it. (It's best to tack the board to a stretcher to prevent buckling.) I brush the ground on the board and then I spread it out with a large spatula. (You can also prepare canvas this way.) I usually tint the surface of the board with a light watercolor wash and lay in the tonal values very broadly with charcoal. Then I proceed to work immediately in color.

As I work on the pastel, I employ fixative from time to time. This lowers the value of an area as a glaze does in oil painting. Fixing also permits further work to enliven the surface. On the completed work I do not use fixative. I've never found a fixative that doesn't destroy the freshness of the pastel color to some extent. Instead, I try to frame the pastel as soon as possible, protecting it with glass.

Meredith-Owens: Do you have a preference for any particular medium?

Dinnerstein: I like working in all media, and enjoy the unique qualities of diverse materials: the range and transparency of oil, the dry scumbling and immediacy of pastel, and the directness of a charcoal drawing. But my overriding concern is what I have to say, not the technical aspects of the materials.

I really feel that there are not secret mediums or formulas. The mystery of a work of art is more complex than that. Certain technical information is useful, but I think if the artist becomes obsessed with these concerns alone, he or she might just as well be an abstract painter and perhaps really is an abstract painter, though the painting seems to be concerned with subject and illusion.

EUGENE DOBOS

BY MARY CARROLL NELSON

EUGENE DOBO's satirical paintings are peopled with "players." A human parade crosses the shallow stages of his small oils. Each character postures and projects a message that Dobos hopes will be interpreted *As You Like It.*

"I'm concerned with human emotions, feelings, and aspirations expressed through symbolic types," says Dobos. "I don't explain, I suggest, and let the viewer bring his own interpretation from his own experience."

What Dobos suggests is the folly of being human. He observes as from a distance the foibles of those looked upon elsewhere as the leaders in society and gently mocks them in those situations where they are most at home: the cocktail party, the tennis court, the concert.

Dobos creates series of paintings, each one a sentence in a growing essay on a theme. He recognizes the similarity of satire to a literary form and says, "Satirists are more often writers than painters."

Punning and funning are Dobos's ways of getting at serious thoughts. "Funny?" Dobos asks, and answers himself, "Yes, but it is not a laughing matter." He makes his statements through his polished style of painting. The Dobos figure, whose arms, legs, and torso are stunted, has exaggeratedly large head, hands, and feet. Although the faces reflect Dobos's natural facility for portraiture, they have certain features in common. Their eyes are large and rounded, often with a Levantine cast. Their noses are prominently molded, sometimes slightly hooked, and beneath is a full, mobile mouth, suggesting pseudo-sophistication.

With absolute aplomb, Dobos controls the expressions of these faces. They are the focus of his attention, and his first effort in a new painting is to capture just the right set of the head, purse of the mouth, and lift of the eyebrow to mime his meaning.

Since 1963 Eugene Dobos has resided full time in Taos, New Mexico, where he has built an imposing two-story Southwestern home and attendant guest house, about four miles south of the village and a mile down a dirt road. It's relatively remote from traffic noise, but he speaks now of moving even far-

ther away from the humanity he views with affection—and avoids.

In his long, attractive, L-shaped living room one could easily miss the fact that this is also his studio. His simple equipment makes little disturbance in the spare, pleasant space. His easel is adjusted at an angle to the north window. He sits to paint, using a chest he carved himself to store materials. On top of the chest is a glass palette; a single Indian pot of immaculately clean, venerably seasoned brushes; a palette knife; a few tubes of oils; two plants; a covered jar of turpentine with a wire screen in it; and a couple of midget bottles of varnish. In the corner are a small selection of canvases, Masonite panels, one or two frames, and a half-completed painting. There is no odor of turpentine, due to the covering on his brush-cleaning jar. He doesn't use a medium to dilute his color. "I learned in art school that the more you tamper with pigment, the less brilliant the color," he explains.

In the sitting area at one end of this room is a coffee table decorated with a small, brazed-metal sculpture of a spirited angel similar to his painted ones. Eugene Dobos is the sculptor of this too.

Dobos does his sculpturing in a shop beside his home, the same shop where he can create a drapery rod or repair his Porsche. He creates his figures by bending, forming, brazing, and melting brass, copper, and other metals with his torch into single figures—as opposed to editions of bronzes.

The story of how this independent and competent artist arrived where he is includes pathos, tragedy, and violence, but he does not wish to linger on the details of it except to say that his parents were Russian-Polish refugees who landed in Hanover, Germany, in time to experience World War II under the Nazis. His mother is a fashion designer, and from her he believes he caught his interest in art at a young age. His parents divorced during his childhood, and he remained with his father.

Nearing the end of the war, as the Allies were pushing toward Hanover, the Nazis were fleeing; anarchy prevailed. During this unfortunate period, the young boy picked up what he thought was a dud grenade. It

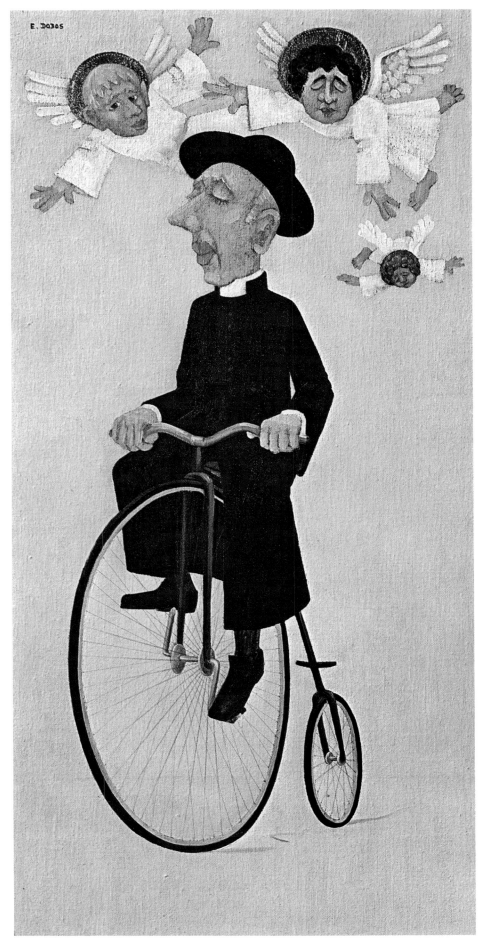

Velocipede, 1975, oil and gold leaf on canvas, 28 x 14. Courtesy Blair Gallery, Santa Fe.

Above: *Adam and Eve,* 1976, oil, 24 x 30. Courtesy Gallery A, Taos, New Mexico.

Right: *Me Last,* 1974, oil and gold leaf on canvas, 8 x 24. Courtesy Sandra Wilson Galleries, Denver.

52

went off. The many wounded were pouring into a hospital that was still functioning but without leadership. Through the efforts of his father and the dedication of a Russian woman surgeon, the child's life was saved despite his almost hopeless state. As a result of the accident, Dobos was left with only two digits on his right hand and a mechanical left hand.

When he was 17, Dobos and his father emigrated to the United States and eventually lived in Chicago. At the time of his arrival, Dobos, who spoke English fluently, had completed the *Volksschule* in Germany and had taken an industrial drafting course. The final project of the course was to produce a drawing of a carburetor. While the director praised Dobos's work, saying it was a fine drawing, he also pointed out it was not what the industrialists had in mind. So Dobos didn't try to get a job in drafting. Instead, he went to work for the Chicago Engravers Company, running errands. He taught himself and practiced painting at night. From 1951-1953, Dobos continued to work by day until he negotiated with the company to let him change to working in the art department on flexible hours at night.

From 1953-1957, Dobos spent eight hours a day at the American Academy of Art, where he studied under Bill Mosby and was a contemporary of the artist Richard Schmid, who became his good friend. School let out each day at 4:00, at which point Dobos walked across the Loop to the Chicago Engravers. At times, when there were rush jobs to complete in the art department at the company, Dobos might stay and work through for 16 hours straight. At other times he could complete a job in several hours.

Yearning to get away from the city in 1955, Dobos and three friends used his old Willys Lark to make a trip toward the Southwest. The car kept suffering electric failure upon reaching precisely 56 miles per hour. Driving slowly and burning so much oil that they finally wired a five-gallon drum where it could

steadily drain into the engine, the motley group arrived in Estes Park, Colorado. They meant to camp there but were put off by the ultra-cilivized facilities at the campsite and drove on at their slow pace through the night. The car's wiring frequently blacked out, waking the sleepers and frustrating whoever was driving, but eventually they reached Taos, New Mexico. Three of the group soon wanted to climb Lobo Peak, carrying their supplies by horseback so they could paint at the top. Dobos decided he'd rather paint on his own down below. As he drove across the bridge at Rio Hondo Canyon, the transmission on the Lark dropped into the river.

Dobos hiked into town, made permanent friends with Carlos Benavidez, who put him and his buddies up for ten days, and rebuilt his transmission from scrounged auto parts for the return trip to Chicago. On that brief, apparently hilarious trip, Dobos fell in love with Taos and returned each summer thereafter.

In 1957 Dobos received one of the mere seven scholarships offered by the Art Students League for a year of further study in New York. He had not yet developed his style at that time but had what he describes as a typically academic technique. Though he knew what his profession was to be, he had not decided on his specialty, only that the figure mattered most to him. He worked under a fine portrait artist who followed the tradition of William Merritt Chase and Sidney Dickinson. At first Dobos was interested in portraiture and painted a few portraits, including matching large ones of himself and his first wife, Lee, a sculptor he married in New York. He studied under George Grosz, but he doesn't believe he felt any influence from him; Grosz was then of advanced age and appeared only rarely in class.

Nonetheless, when he returned to Chicago, Dobos gradually put together his own style: the same satirical commentary he paints today. For a time he continued to work at the Engravers Company to support his wife and two children. Every three months he took his work to Frank J. Oehlschlaeger for appraisal. The dealer was polite but not interested until Dobos's style had matured. Then he not only accepted it, he began immediately to sell it. Dobos saw that the time to make his hoped-for move to Taos had come.

Wasn't he frightened at the risk of leaving a paying job to depend only on his painting for a living? His answer shows how differently Dobos views the word "risk" from the average American:

"There was no air raid, no bombing, no one arresting you, no papers to fill out. My life had been riddled with so many uncertainties, this was minor-league stuff. This was an exercise in freedom; if anyone is afraid to take a chance on it, he doesn't deserve it.

"In Taos there was a tremendous contrast to the cities where I'd lived all my life. This was the promised land, big sunshine and mountains, Indians in blankets. I felt I was born here—born anew.

"When living in Chicago I painted Taos landscapes, yet, when I came here, I switched completely to the figure, to humanity. Now that I'm here, the

E. DOBOS

Right: *To Our Health,* 1976, oil, 42 x 28. Collection Lars Laine Gallery, Palm Springs, California.

Below: *The Plants Are OK,* 1974, oil, 16 x 30. Courtesy Blair Galleries, Santa Fe.

Opposite page, top: *And All the King's Men,* 1974, oil and gold leaf on canvas, 20 x 30. Courtesy Blair Galleries, Santa Fe.

Opposite page, bottom: *I Am You and You Are Me and We Are All Together,* 1975, oil and gold leaf on canvas, 20 x 40. Courtesy Blair Galleries, Santa Fe.

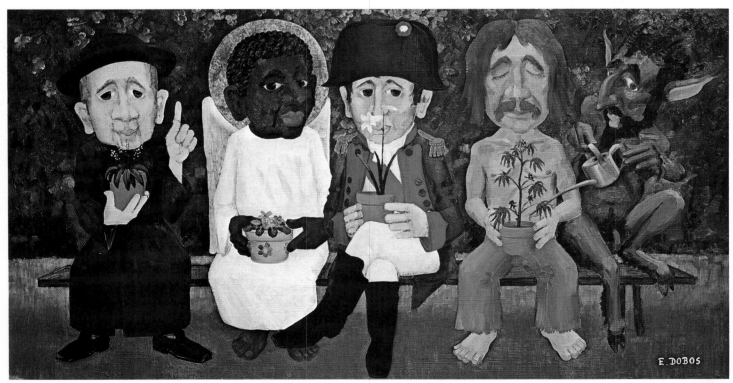

landscape is right out the window. I don't need to remind myself of it."

The style Dobos invented out of his own experience with life has been enduring because he has found it malleable enough to allow him room to change and grow as a person while still expressing himself in his own way.

Dobos says, "Nicolai Fechin (a Russian emigré artist whose influence in Taos is great) used to say, 'Don't paint an apple. Paint *the* apple.' But that doesn't work for me. I deal in types. Specific people will be dead tomorrow; types remain."

Though he prefers not to dwell on technical matters, it is obvious that Dobos has a finely honed approach to the art of painting. He doesn't express finicky choices for his grounds. He uses any canvas, including preprimed; if it's not impervious enough, he adds a layer of gesso. He covers his canvases completely with a thin wash of a neutral tone because he finds the white too startling. He paints on stock sizes and rarely needs a custom frame, but he plans to begin working on larger pieces soon; currently his largest canvases are about 36 x 60 inches (91.4 x 152.4 cm).

Dobos doesn't sketch. Therefore he spends considerable amounts of time contemplating a painting. Once he has it in his mind, he draws on the tinted canvas with pencil. "No beating around the bush," he says. "I go right to the point." He does the faces first. Usually his paint is fairly thin, since he believes a painting should be equally finished at any stage and therefore paints in all areas with a coat of color and brings them to the same level of completion. He doesn't build up thick layers of paint. After one layer of color has set, he may go over it carefully with a second layer. He uses a palette knife to drag on the second color in a rhythmic manner, making an unobtrusive texture that he invents specially for that area. Each part of the painting has an exactitude and simplicity that are more complicated than they at first appear. His forms are like cutouts with strongly drawn contours, yet there is a painterly, though tightly controlled, technique. Altogether, there is a rightness to his compositions, an apparent ease that disguises their sophistication.

Lest we mistake Dobos's humor for his sole message, however, in his lightly serious way, he says "I am involved in universal consciousness, in exploring my dreams." He is captivated by the writings of Carl Jung, William James, Ericson, and Freud. In conversation, which roams from one major discipline to another in an exploratory manner, Dobos reveals that he is a devoted reader of philosophers, from ancient to modern—a continuing student of life. He also has a vision of himself and the fact that he is even alive.

Several years ago, the Russian woman doctor who had saved him actually came all the way to Taos to see how he had developed. She seemed to view him as one of her star successes, and, after moving to the States, she went to great lengths to renew their friendship. Dobos, too, finds meaning in being alive to be an artist. His survival has taught him compassion and has given him high motivations.

He concludes with a thought that haunts every person, artist or not: "It is my wish to be immortal—through my art. One cannot set goals for this; only time will judge. It either happens or doesn't happen. My task is to live up to the best in me."

Reading the satirical message in his finely crafted paintings, one realizes its application to all of us—and we sense that beneath his irony Eugene Dobos wishes us all well.

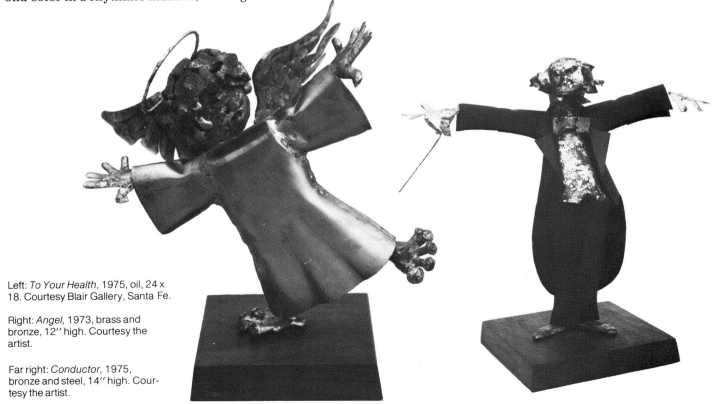

Left: *To Your Health,* 1975, oil, 24 x 18. Courtesy Blair Gallery, Santa Fe.

Right: *Angel,* 1973, brass and bronze, 12" high. Courtesy the artist.

Far right: *Conductor,* 1975, bronze and steel, 14" high. Courtesy the artist.

Photo Richard Carter

RUTH EGRI

BY CLINT COLLINS

"I HAVEN'T BEEN CONCERNED with making a reputation. If I wanted to make money, I wouldn't try to do it with art. My painting is an emotional outlet; without it, I'd probably wind up on a psychiatrist's couch."

When an artist makes a statement like that, there's a tendency to dismiss it as sour grapes or pretentiousness. But coming from Ruth Egri Holden, it rings true.

She has exhibited throughout the U.S.—in New York galleries, the Museum of Modern Art, the Corcoran, museums in New Mexico, in New Orleans, and other cities. The Delaware Art Museum owns her work, as do many private collectors, including Greta Garbo. Despite all this, she has never made a concerted effort to become a "name" in the art world.

To begin with, her location is not one calculated to gain fame. Ruth Egri (her professional name) works in Wilmington, Delaware, having moved there with her husband over 20 years ago. In that area, all painters labor under the looming popularity of Andrew Wyeth and the Brandywine River School of Art. Egri doesn't fit that mold.

Her studio is a model of pragmatism and modesty: It is an area in her basement so small that to see how her paintings look from a distance, she has to view them through a well-chipped reducing glass. Evidence that she has not been eager to sell comes from the stacks of paintings in her home, some dating back to the 1930s and done in the social comment style prevalent during the Depression.

"Just lately, I have become more interested in selling my paintings," she says, "because I worry about the problem my son Peter will have of what to do with them all when I'm gone!"

That sounds morbid, but Egri says it with a laugh and the same matter-of-factness that can be found in the dramatic, carefully organized space of her paintings. That organized space comes directly from an early experience in her education as an artist: "I had studied on a scholarship at the National Academy of Design in New York and at the Art Students League. In the summers I went to the Metropolitan Museum every day to draw from the casts and study the paintings, and those were wonderful days. But I felt I

wanted still more basic knowledge, and about that time I heard a lecture by Howard Giles on Dynamic Symmetry.

"I became intrigued by it. Most of my artist friends saw it as a sterile formula, especially in the 1940s when the freedom of Abstract Expressionism was emerging. But I felt I would study whatever there was to learn from it.

"Dynamic Symmetry is simply a design principle dealing with the orderly arrangement of unequal elements in a picture so that they have an almost mathematical relationship to each other. Howard Giles presented it primarily as a basic tool in organizing a given area. It has wide application whether it is used in realism or abstraction. Giles said, 'I'm just giving you the principles of design. What you do with them is up ot you.'

"I use it instinctively now, and go back to it if I am having trouble with a composition."

Egri's great concern with design in painting is balanced by a desire to make a statement. She says that she designs abstractly but considers herself a realist. Her subject matter comes from the everyday world: old cars abandoned and dismembered; restaurants with busy, complex patterns made by tables and chairs; cows shown as dynamic, angular forms; the cold blue desolation and loneliness of a men's ward in a hospital. But these subjects are subordinate to her favorite theme, which is women: women in groups, women laughing together, women on a bus, women in a revolving door, women under hair dryers, women in childbirth.

Some of these works—especially those showing women in the midst of childbirth—look as if they might have been done by a feminist. Egri explains the childbirth series: "The agony and ecstasy of birth is the most momentous experience in a woman's life. These paintings are based on what I saw many years ago while painting a mural in a hospital. I stored up the images of the women on the maternity wards in

Right: *Cafe,* oil, 48 x 28. Courtesy The Ware Gallery. "I start with complexity and simplify," says Egri, whose careful, almost mathematical structures and limited color create an almost surreal environment.

Entrances and Exits, collage and acrylic, 47 x 27. Courtesy The Ware Gallery. Egri juxtaposes the shapes of women with the geometric pattern of a revolving door to create graphic tension.

stages of childbirth, and these images and impressions eventually came to fruition in these works."

While Egri's work shows feminist overtones, the truth is that the theme of womanhood in her paintings involves something deeper than political involvement and the catch-phrases of pop psychology. Many of her early paintings are of women in urban settings, and the emphasis is on form and design. About 1950, however, her female figures start to become as much personae as design elements. Her first drawings and paintings of women laughing were done in strong reaction against the nonobjective works of the Abstract Expressionists.

Even so, her "message" is mostly implied. The figures are earthy, stolid women, often with featureless faces. The pain, loneliness, and strength of womanhood are there, and even the threatening aspects of feminine nature are hinted at. But it's not done with overt storytelling or sentimentality. The real drama comes from the imposing forms, from the dark areas played against each other for graphic tension, and from the curvilinear shapes contrasted with geometric patterns.

Egri is a native New Yorker. Her father, Lajos Egri, was a writer and editor for a Hungarian language newspaper. (He wrote *The Art of Dramatic Writing*, a standard work on creative writing.) Ruth Egri and her two brothers are all artists.

"From the time I was six, I was determined to be an artist. One evening I overheard my father tell a friend, 'Oh, you know how children are; she probably will change her mind. Maybe she'll go into dress designing or something.'

"Well, that made me so mad! Dress design, indeed! I made up my mind then that I was going to show him, and sometimes now I think that's the real reason I kept on working at art."

In fact, the parents encouraged their children. Their father would judge the children's drawings each night and reward them as he saw fit. The top prize was a nickel. When the landlord refused to have the Egri apartment repainted, each of the children was allowed to do a painting of his own choice on the living room walls. Ruth Egri did a nude.

A friend of the family was impressed by that painting and helped her enroll in the National Academy of Design, although, at the age of 15, she was technically too young to be admitted. The Art Students League and study of Dynamic Symmetry at the Roerich Museum came later.

In the 1930s she joined the WPA Art Project and painted a mural at Lincoln Hospital in the Bronx. She taught mural painting for one year at the Art Center in Spokane, Washington. Though her large forms and strong designs seem ideal for mural painting, she has done only one other mural. It was a donated work at the Delaware State Hospital near Wilmington. When she returned to New York, she worked for the Board of Education illustrating children's books.

Egri still has many of her oil paintings from the New York years, and having them on hand even-tually led her to switch from oils to acrylics.

With many layers of paint worked over layers still wet, Egri saw the early oils beginning to crack and decided to go to acrylics.

"Acrylics suit me better temperamentally. My ideas change while I'm painting. Nothing is rigidly planned, so the creative process goes on. With acrylics, I can work over a composition many times in a short period because they dry quickly."

Egri frequently paints completely over a finished work, redesigning it while retaining the original concept. Often she throws away finished paintings because they don't measure up to the conceptual image that prompted them.

Her ambition to explore all the subtleties of color and design suggested by a subject leads Egri to produce a series of paintings for each theme. "No sooner do I finish a painting than I see alternate aspects of the same subject, giving me a variation on the theme."

Egri says that, in another sense, each individual painting is itself a series—a series of destructions. "I start with complexity and simplify. I am most successful when I am not afraid to destroy. I will destroy certain parts of the picture that are good but don't work in with the rest of the composition. You can't save one little piece of a picture just because you like it."

She has hundreds of charcoal and pencil sketches, workmanlike records of people and places that show up in her painting. When she begins a painting, she puts these drawings aside and does not consult them again.

She starts with the compositional idea and lays in the main elements with a wash—or sometimes more definitely. Although she has told students never to begin on the white canvas, she often does it herself, because she knows she will more than likely be repainting the surface again and again.

These adjustments usually involve changing lines or contours to continue or echo directional thrusts. Shapes are played against each other for tension. Figures are "built in" to the background with repeated shapes, continued lines, and counterbalanced angles of thrust.

To analyze a painting, Egri will often use tracing paper to make a drawing of the outline of the major shapes. The simple outline enables her to see more readily the basic structure of the composition and how the parts are working in relation to each other. By just altering the lines in the tracing, she can quickly determine the effect of a new idea.

Egri uses a broad palette and is ready to experiment with many color combinations, ranging from subdued hues to pink and blue-green harmonies similar to some de Koonings. The color, however, always is used to serve the drama of the composition rather than to produce dazzling color effects.

Her technique with the acrylics enables her to achieve an appearance amazingly like that of oil. "You can't model the acrylics well for gradual shad-

Top left: *The Pawn Shop,* acrylic, 48 x 30. Courtesy The Ware Gallery. Egri uses color to serve the drama of her composition.

Top right: *Women Under the Dryer,* acrylic, 27½ x 20. Courtesy The Ware Gallery. This painting is one of a series prompted by Egri's observations during a rare visit to a beauty salon.

Left: *Discussion,* lacquer on wood panel, 18 x 40. Collection Ms. Janet Hickman. The figures of women become design elements, large forms played against each other and repeated with variations to create a strong, unified composition.

Above: *The Group,* pastel, 19¾ x 29½. Courtesy The Ware Gallery. Egri achieved the overall ghostlike effect, which unifies the figures and creates an air of mystery, by using a vacuum cleaner to pick up loose dust.

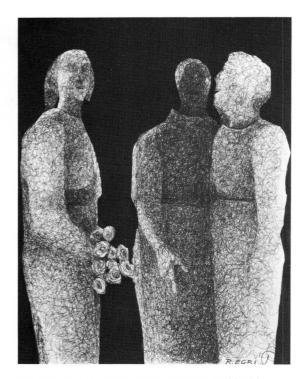

The Gathering, No. 2, pen and ink and acrylic, 20 x 16. Courtesy The Ware Gallery. Egri paints a black acrylic wash around this ballpoint drawing. The contrast draws attention to contours.

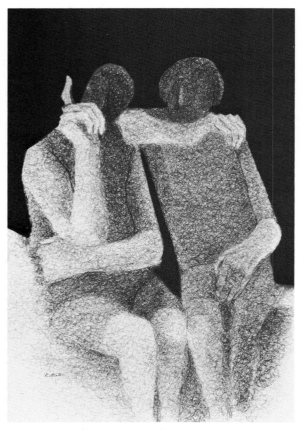

The Oracle, pen and ink and acrylic, 30 x 20. Courtesy The Ware Gallery. The stark quality of the background lends a shimmering quality to the figures.

ing," Egri explains, "so you give depth with color and tones."

Some areas are almost flat, with very slight color modulation within the area. She mostly avoids hard edges, using a dry brush to soften the edges of shadows or highlights, but she does not attempt to blend wet-into-wet. Nor does she use a gel or painting medium. A clue to her technique is her palette: The colors are laid out in thin puddles, not in mounds of pigment.

Some of the oil-like appearance comes from her use of white gesso instead of the white pigment from the tube, which she considers too opaque and gummy. The gesso is often laid in quite thinly with an expressive brushstroke, so the underpainting shows through.

At times she will mix gesso with a neutral color, wash it over flat shapes in a painting, then quickly wipe it off. The intensity of the area is toned down, an effect that also enhances the look of oil.

A frequent device in Egri's compositions is the imposition of the organic shapes of women against the geometric lines of a bus interior, a storefront, a revolving door. "I called the revolving door series 'Entrances and Exits,' " she says. "I had the idea one day while sitting in a restaurant. All the people constantly coming and going suggested to me the entrances and exists that are always going on in life."

Typically, she did several of these paintings, varying the shapes and using different color schemes. Only a few survived her critical eye. Egri believes she destroys more paintings than she keeps.

Other subjects have also come to her in mundane ways. Before an opening of a show of her paintings, she went—for the first time in years—to a beauty salon. She was struck by the humor and irony of the women under the mechanistic hair dryers, all hoping to become as beautiful as the photographs on the walls. The result was a series of satiric drawings and paintings called *Vanity, Vanity.*

Significantly, the "story" that prompted the paintings is not told in any obvious fashion. Rather, the abstract organization of space is the dominant concern. The women are arranged in awkward poses that give tension to the design and at the same time hint at the women's vulnerability. The women are dark figures connected to the menacing dryers, and the result is almost like condemned people in electric chairs. The colors are subdued, with movement imparted by the gesso applied thinly over color with broad, twisting strokes. Even the women's cigarettes are placed to reinforce the composition.

As usual, Egri did not use the sketches she made at the beauty salon when she began to paint.

"To paint from the sketch would be a total failure," she says. "You have to become the thing you are painting, and you can't do it if you are copying from a sketch."

The dark figures are another Egri touch: "I love my grays and blacks; I especially like the power of black."

She often uses black as background in the drawings she does with ball-point pen. They are done in a unique style—essentially a tangle of loops laid down as one continuous line. She tells how this technique came about: "One day the TV set was out of order. The screen was alive with shimmering, moving light. It was very much like snowflakes dancing in the wind. As I watched, forms emerged and dissipated again and again, each time becoming more distinct. It occurred to me that the best way to express that feeling of movement was with the circular strokes of the pen, interwoven threads of varied colors. I gradually build up the intensity of values where I need to create a feeling of vibration and materializing figures in space. Yet I am careful not to destroy the two-dimensional quality of the composition. As a rule, these pen-and-inks are not planned. I just let them happen."

The strength of these drawings is enhanced by the use of solid black or another color around the figures as background. These flat areas put into relief the figures that, from a distance, look pointillistic.

Another example of Egri's penchant for inventing techniques is the pastels, which she was concentrating on a few years ago. They show her insistence on careful design, but the figures have a multi-hued evanescence—almost as if they were done with an airbrush. And in a sense, they were. While working, Egri would pick up the loose dust by going over the drawing with a vacuum cleaner, using the soft brush attachment.

"I had never heard of anyone doing that," she says. "I just thought it might work. It blended the colors, thereby unifying them—like putting a watercolor under the faucet. I would go over the surface again with my pastels to pick out the accents where needed."

For all this experimenting, Egri's work remains an engrossing example of how the classic principles of composition can be used with power and elegance. It may yet bring her the public recognition she has not been anxious to seek. Meanwhile, she continues to work several hours a day in that basement studio she shares with some crickets, an oil burner, and a washer and dryer.

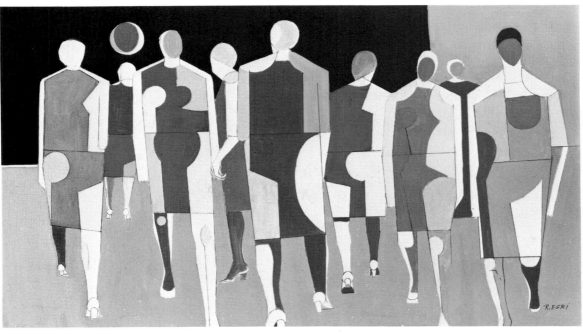

Lunar Magic, acrylic, 22 x 37. Courtesy The Ware Gallery. Egri creates the illusion of movement by the staccato bounce of flat patterned shapes.

SUE FERGUSON GUSSOW

BY DOREEN MANGAN

FIGURE PAINTINGS are rarely best-sellers on the art market. Buyers are more apt to purchase picturesque landscapes and serene still lifes to grace their surroundings or abstract and pop art to reflect their awareness of the latest trends, thus leaving figure painting out in the cold. "People don't want pictures of strangers in their homes unless they're buying your name," observes Sue Ferguson Gussow, who works almost exclusively with the figure in her oils, drawings, etchings, and woodcuts. For, despite the poor market prospects, she will not relinquish her fascination with the figure—an absorption that has endured since her student days and through her experiments with different media.

Gussow's figures are not archetypical. She avoids, for example, the classic studio nude, seeking instead the qualities that make each person unique. In this sense her paintings are portraits. She is what art historian Max L. Friedländer calls "a painter who makes portraits rather than a portraitist who makes use of the medium of painting."

Another aspect of Gussow's work is her belief that every painting is eventually a self-portrait; thus her works also reflect a search for self—as an artist and as a woman. For Gussow the artist this quest has difficulties whose roots are in the growing-up environment that she shared with so many women of her generation. Few of these women grew up expecting to pursue professional careers. "As a child and adolescent I was encouraged to be artistic, because that was an accomplishment," says Gussow. "But I wasn't encouraged to be a professional artist, and I didn't think of myself as being one. My attitude was 'Who, me?'"

In spite of self-doubts and disillusionment, though, she perseveres in her art. Gussow identifies strongly with independent, self-knowledgeable, professional women and shares their trials and anxieties. In her most recent figure drawings she attempts to unravel the tangled perceptions of contemporary women in terms of identity and sexuality.

Her subjects are sometimes nude or partially nude. Some poses border on the erotic. One drawing shows a bare-breasted woman wearing jeans that are open at the zipper. It is not clear whether she is dressing or undressing. "These are provocative drawings," the artist explains, "but there is something a little bit discouraged as well as provocative about these ladies. They're not certain of their sexuality." These are women of the 1970s, she goes on, caught in the confusion of shedding old perceptions: "They want to be daring but are afraid to let go." Thus she draws them as being unsure, lacking self-confidence, yet at the same time exuding a determination that is almost defiant. It is the conflict portrayed in these drawings that imparts dimension and makes them more than examples of outstanding craftsmanship.

If Gussow's drawings portray a concept of a whole generation of women, her oil paintings discover the individual. "A good portrait should have a sense of life, of a specific personality," says Gussow, "although it's not necessarily an exact likeness. Look at a portrait by Rembrandt or Goya; your instincts tell you this was a perfect portrait of this person. There's a sense of presence. You *know* this person lived and breathed."

The turmoil, and questioning, and the struggle evident in the figures of her drawings do not appear in the paintings. There is less emotion. The subjects look calm, quiet. "I paint them in repose," explains the artist, "so they look solemn, contemplative." One woman looks thoughtfully, almost quizzically, out at the world. Another lounges indolently, yet a little self-consciously, with hand on hip; another, with eyes downcast, is quietly absorbed in a book.

The theme throughout most of these portraits appears to be that of isolation, alienation, loneliness. This is, in fact, a theme that preoccupies the artist. "The most tragic thing about life is loneliness," she says. "There are no guarantees that you and your husband will stay together, that friendships will last. No one wants to be cut off from others." She concedes

Above, *Self-Portrait in Truck Window,* 1972, pencil on Basingwerk lithography paper, 19 x 14. Collection the artist.

Right: *May,* 1973, oil on canvas, 34 x 26. Collection the artist. Photo Curt Roseman. The strong geometric composition in this painting reinforces the strength the artist finds in her mother as a subject.

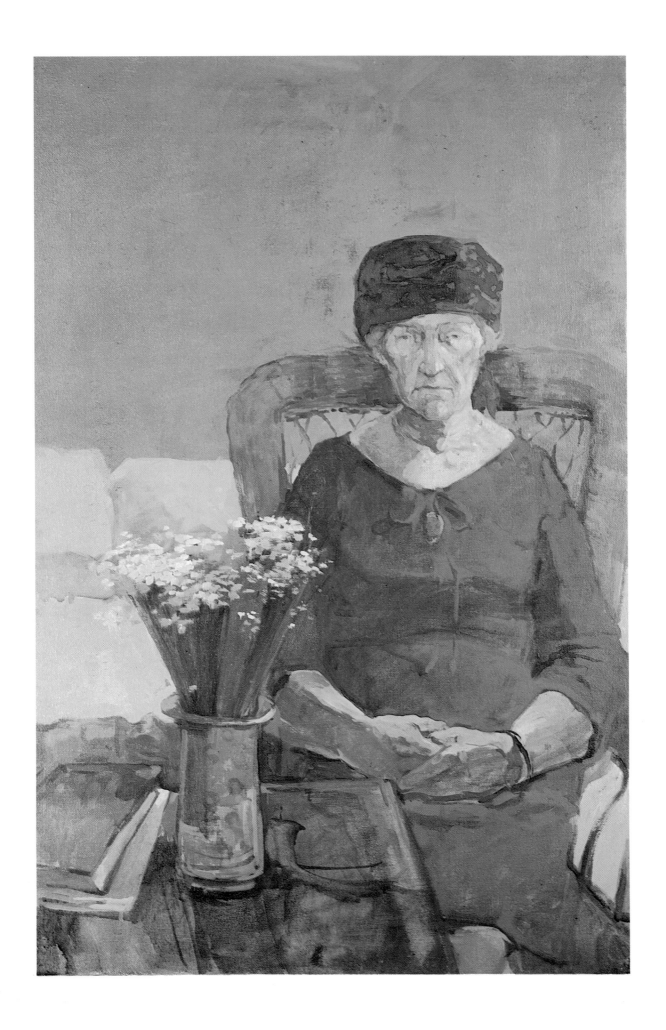

that her paintings of people may be a way of coming to terms with the loneliness that an artist, of necessity, must experience.

Intrigued by the mechanism of the psyche, Gussow compares the construction of a painting to the nebulous construction of a dream. "Dreams are art at its best," she says. "A painting must be invented in the way a dream is invented." The unconscious must be involved. Thus it often happens that months after a painting has been completed, Gussow will find meanings in its elements she hadn't realized before. Because of this phenomenon, she often refers to her paintings as conversations or dialogues with the past.

The objects in her paintings come to be there because they appeal to her in a way she can't define or because the shape or color seem right for her composition. "I frequently try many props before I decide on one," explains Gussow. "The moment does come when you know you have picked the right thing. The objects suddenly become very symbolic."

Gussow opposes a conscious effort on the part of the artist to invest meaning in a painting. If you self-consciously draw on the unconscious, it doesn't happen, she says, and you become imitative of others: "Each artist has to invent his or her own devices to trick the unconscious into coming out." As Max L. Friedländer points out, "Art is something other than imitation of nature. But to know of this difference and to think of it when working proves to be dangerous."

How does Gussow avoid this danger and yet create a validly inventive painting? Simply by concentrating on the mechanics: paying attention to the formal painterly considerations and considering the work as a structural entity. For example, what shapes fit together? Are the colors right? The shapes exact? She does not work by thinking and piecing an idea together. She goes about it spontaneously. And somehow the thin borderline between the what and the how of a painting disappears.

Facial details are not stressed in order to concentrate on the whole portrait. No one element is accentuated at the expense of the others. The figure is taken strongly into account and built into the composition. For instance, in *Vanessa and Paintings*, Gussow created a spatially effective composition around the woman's casual pose, with the plant in the left foreground lending support to the angle of her pose. The elements are well placed. The plant, for example, overlaps the wall, two paintings, the table, and the woman's arm; it unifies by subtly lending strength to the whole, but by no means dominating.

Color is also a tool of composition. In that same painting, for instance, the blue of the woman's pants

Christina in A Spanish Wrap, 1976, charcoal on German copperplate, 42 x 30. Gussow's line is decisive, and only a minimum of detail is needed to suggest the entire image.

The Green Gown, 1976, pastel, 42 x 30. Collection Dr. Malouf Abraham. Even within a simple framework, the artist gives great attention to a structured composition.

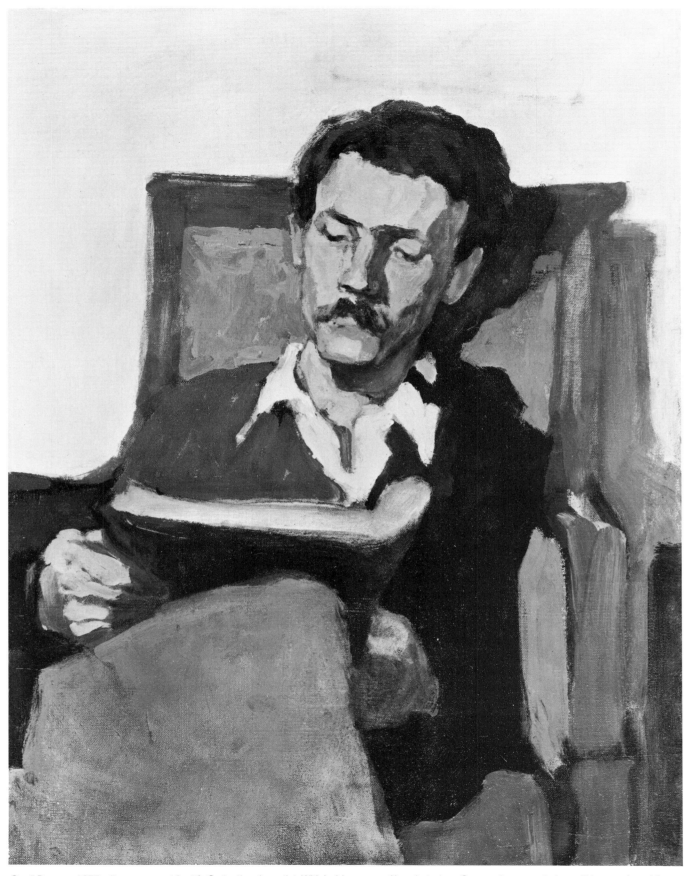

Cyrril Bonnes, 1977, oil on canvas, 16 x 12. Collection the artist. With bold sweeps of brushstrokes, Gussow has asserted a swift impression of the subject.

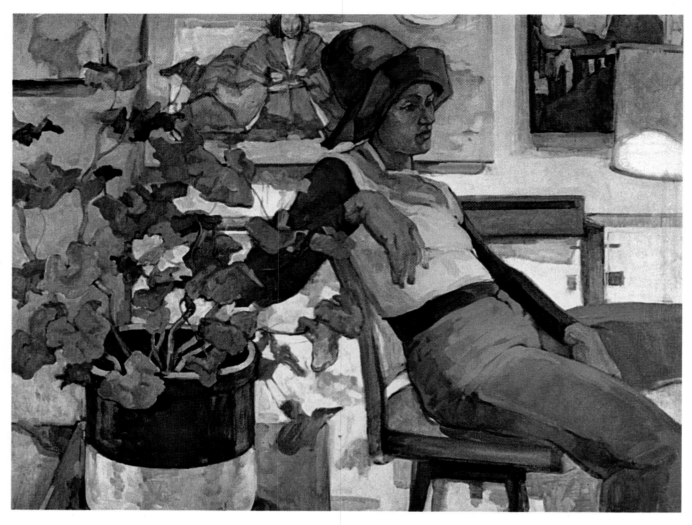

echoes the blue of the painting in the right-hand background. The dark shades of her belt and sleeves repeat themselves in the soil in the plant pot, and her shirt is a perfect foil for the large painting in the background.

Besides pose, color, and spatial arrangement, a wealth of textures and weights governs a Gussow composition. In *Chinese Character Puppet,* the juxtapositon of the satiny sheen of the doll's jacket with the texture of the wood the doll hangs from and the roughly sketched texture of the crocheted purse is a good example. And all these objects have a solid feel to them, in contrast to the print in the lower left of the painting, which curls delicately at one corner, with the merest hint of shadow evident.

Although she is now concentrating exclusively on painting and drawing, Gussow's career has been a process of investigation of various media and a movement from medium to medium. This has been an organic process rather than one based on conscious decisions, according to the artist: "When one has something to say, one finds the technique to say it, rather than the other way around."

Drawing was her first love. From there to printmaking was a natural progression. She calls this medium "the home for those who like to draw," but for Gussow there was another reason. She had always considered herself a painter. However, in her student days—in the mid-1950s—Abstract Expressionism was at its height, and Gussow, refusing to capitulate to a movement she had no feeling for, chose to devote her energies to printmaking, "where there is always room for figurative artists." Her involvement with printmaking is not, however, by default. Fascinated by the techniques, she devoted five absorbing years of her career to printmaking in all its aspects: woodcut, lino cut, lithography, intaglio. Of them all, the latter was her favorite. "It is the most painterly of all media," she says, "and the most flexible with its dots, lines, and grooves etched under the surface. It's a lot richer than litho and suits a painter's mind. It's amazing what you can do to a plate—incise, burnish, re-etch, soften—have all kinds of variations."

But gradually painting crept back into her life. "As much as the techniques of etching fascinated me," she says, "the medium itself became too time-consuming. There is too much mechanical work involved. It can take up to three months to complete a plate, but I can also spend these three months on a painting and see instant results as I work." Time, though, was not the only consideration. Gussow found in painting a more direct confrontation, an immediacy lacking in printmaking: "I wasn't even drawing as much as I liked." Thus, she returned to brushes and oils.

However, much as she enjoys drawing and is immersed in the techniques of printmaking, the execution of her oils reflects a more spontaneous approach. For one thing, she does no under-drawing and doesn't even do a preparatory sketch, which is surprising, considering her love of draftsmanship. If she

Above: *Chinese Character Puppet,* 1973, oil, 34 x 26. Collection the artist. This painting began with the puppet, which the artist saw hanging in a store window, posed as it is here. Subsequent props were chosen to lend an air of mystery as well as for their formal aspects.

Opposite page top: *Vanessa and Paintings,* 1973, oil, 26 x 34. Collection Dr. H. Babikian. Here the pose and suitable props were selected and arranged before Gussow began to paint. The she blocked in "shapes of colors," studiously avoiding any preliminary drawing.

Opposite page bottom: *Eakins' Baby,* 1977, pastel on German copperplate, 30 x 42. Collection the artist. The areas of transparent and opaque are juxtaposed to form an arresting composition.

Above: *Model, Doll, and Shopping Bags,* 1976, oil on canvas, 24 x 32. Collection the artist. The artist is intrigued by the still life shapes she finds in her studio and integrates them with her figure paintings.

Right: *Pink Nightgown,* 1976, oil on canvas, 17 x 19. Collection Louise O. Reiss. The casual clutter of items in and around the room harmonizes with the moment of private repose.

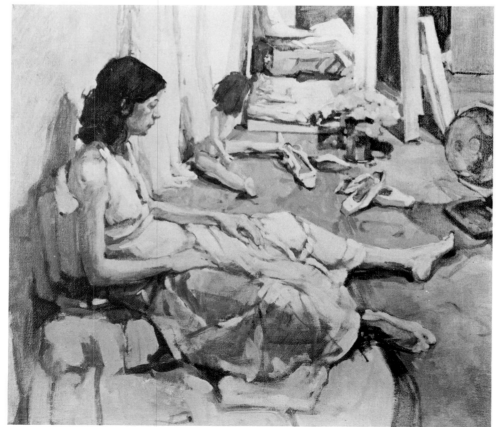

does a drawing, Gussow explains, she finishes it as such, she may develop an etching on the same theme, but not a painting. "It would be like painting a coloring book," she claims, "filling in the lines: I would lose a lot of freshness with that approach." Instead she prefers to let the painting build itself up: "It's not done methodically, but more by feel. I block in a painting with thin washes, then build it up more thickly and scumble or glaze in certain areas where I feel I need to." As she works, the figure and the space grow together. Her glazes, deftly placed, seem tissue-paper thin. (Notice the transparency of the shadow of the vase on the table top in *May.)*

Gussow's colors are cool, partially because of the northern light that floods her studio-loft in New York City's SoHo district and partially for a psychological reason—a certain restraint on the part of the artist: "There should be less of me and more of the sitter. I want a feeling of detachment—of leaving something not quite said." The cool, Dutch light of Vermeer intrigues her, she says, hence her recent fondness for cobalt blue.

Gussow finds certain shapes appeal to her for awhile and stretches a batch of canvases in those shapes, then likes others and does the same for the new shapes. The shapes are not too extreme, which Gussow believes becomes too tricky, but they vary enough to provoke excitement, and challenge her to explore new compositions. She primes her own canvases and leaves the natural tooth, rather than sanding it down.

Gussow uses what she terms a traditional medium: one-third each of linseed oil, damar varnish, and turpentine: "Sometimes the turps evaporates, and I don't even notice. When I start a painting I try to use as little medium as possible, keeping the lower layers thinned with turps so they won't take too long to dry. I build fat over lean, an important rule a lot of young painters seem to overlook, which accounts for some of the cracking of paintings you see in museums."

She employs a wide variety of hard bristle brushes and admits a fondness for "old, scrubby brushes" that, through much use, have ended up in shapes their manufacturers never intended them to have. Gussow's drawing tools are charcoal, india ink, and pencils—usually a No. 2 writing pencil: "It's not too hard or too soft."

As far as drawing technique goes, Gussow is mostly concerned with placement of shapes and tones. "I am very selective about where and how I use tone. I start a drawing with shapes and locations, not with descriptions."

The whole secret of drawing, Gussow claims, is learning to see. She learned this from Stefano Cusumano, who taught her when she was a student at Cooper Union. "He didn't teach any tricks of drawing—only how you look at form and discover it."

Besides studying at Cooper Union, Gussow has studied at Pratt Institute, Columbia University, and Tulane University. She has won a number of awards and prizes, and her paintings are in museums and private collections. Currently she is teaching, an avocation she highly enjoys, mainly because of the community she finds at school. "The students keep your mind 'shook up,' " she says. "If you stay in a studio all the time, you get too content with your own ideas."

In return for the artistic stimulation, Gussow tries to impart a little down-to-earth wisdom to her students. One of the most important things a young artist must learn, she feels, is to accept the routine that goes along with being an artist. In contrast to the expectations of many would-be young painters, the life of an artist is rarely a glamorous existence.

"A young painter should have marvelous dreams," she contends, "but there should come a point when you realize the everydayness of it and the hard work involved. You have to be your own greatest critic—even get disgusted or bored with your work. You must be able to give up what you do well and struggle with what you have to learn. In this way you get used to the rules of it, to the routine of being an artist."

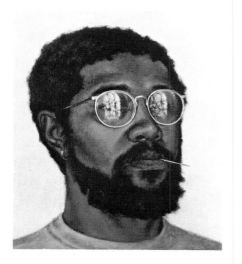

BARKLEY HENDRICKS

BY DOREEN MANGAN

A YOUNG MAN sits cross-legged on a bar stool, cigarette dangling from his fingers, and thoughtfully gazes at the visitor. A hip-looking young woman in shorts and T-shirt stands with her arms folded. Another woman in wire-rimmed glasses, hoop earrings, and a spectacular low-cut evening gown, poses in three different positions.

These are among the people who inhabit Barkley Hendricks's studio. They are his paintings—so life-size and lifelike that a friend of Hendricks commented, "No wonder you're not lonely here, with all these people around."

Hendricks's paintings are so immense (as large as 72 x 120 inches, 1.8 x 3.1 m) because, he says, "It's a Frankensteinian feeling of creating a being who can almost speak to me or step out of the canvas." But having a roomful of company is not the sole reason or, in fact, the actual reason Hendricks paints so large. He feels the life-size figures facilitate the confrontation between the viewer and the painting. "There's a saying in the black community: 'You put it out there and let others deal with it,' " he explains. He feels, when he completes a painting, that he has said what he wanted to say and the viewer can take it from there.

What goes on in these confrontations is difficult to describe. The viewer cannot help but be hit by the intensity, the immediacy, the drama of a Hendricks figure. The drama is sometimes quiet, sometimes exuberant. But there are certain dramatic elements common to all his paintings.

The most outstanding, perhaps, is Hendricks's style of painting. He portrays each person with great exactness and specificity—so much so that his brand of realism has been referred to by various critics as "straight-at-you" realism, New Realism, hyper-realism, cool realism. The latter seems most apt. It should be understood, however, that the phrase "Cool Realism" does not mean slick or superficial.

As a practitioner of "cool" realism, he is a true child of his environment, affected by television and photography—all the means of rendering an exact image that were not available to the pre-19th-century painters. Using the tight brushstrokes and shimmering lighting of the traditionalists, he produces faithful representations of smartly dressed young blacks who almost look like fashion plates.

The danger of such forthright portrayal is that of belaboring the obvious—of falling into the trap of simply illustrating the subject. But Hendricks does not fall.

What separates his figure painting from the illustrative genre—and heightens the dramatic quality—is the richness of expression, the evocative power his paintings transmute. He portrays contemporaries very much in charge of their own destinies, exuding self-confidence and self-knowledge. There is no hint of uncertainty or perplexity regarding identity. Through their poses and clothing they proclaim their style, their uniqueness. They are, as one critic put it, "familiar yet strangely unfamiliar." The viewer may be perplexed as to how to penetrate these sophisticated exteriors. Yet the viewer also knows, intuitively, that Hendricks's subjects not only look good, but they feel good.

Each individual's drama is played out in an unusual setting—in many cases a blank, flat background. One critic wondered whether these bleak settings were symbolic, showing the isolation of the individual and the strength of the individual in isolation. However, Hendricks's use of a stark background as a dramatic device is more apparent. He will, for instance, pose a black nude against a white background, a man wearing a light blue T-shirt against a dark blue background, a girl in a bright red sweater against dark red. This color counterpoint reveals Hendricks's subtle feeling for and use of color.

His use of these backgrounds has elicited favorable critical comment. But now, in a new phase of his ca-

Above: *Bedroom Eyes,* 1974, oil and acrylic, 10 x 10. Courtesy ACA Galleries. A self-portrait.

Right: *Yocks,* 1974, oil and acrylic, 72 x 48. Courtesy ACA Galleries. Using a photograph as source material, Hendricks captures the essential gesture of his subjects. "Yock" refers to both dress and behavior: "sharp" and "cool."

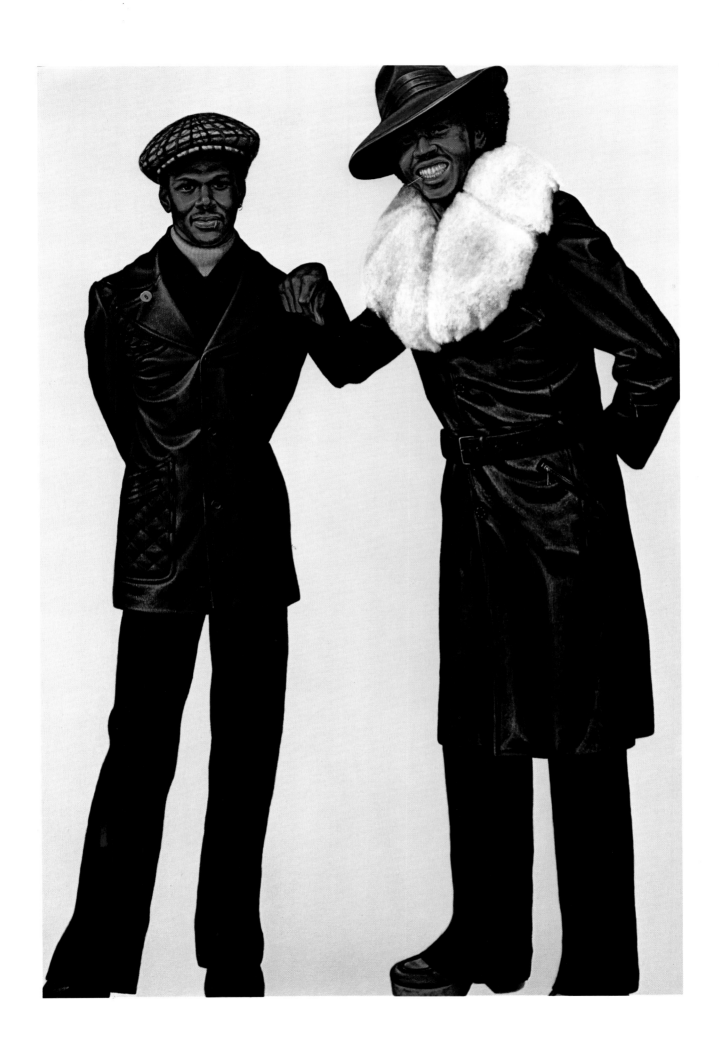

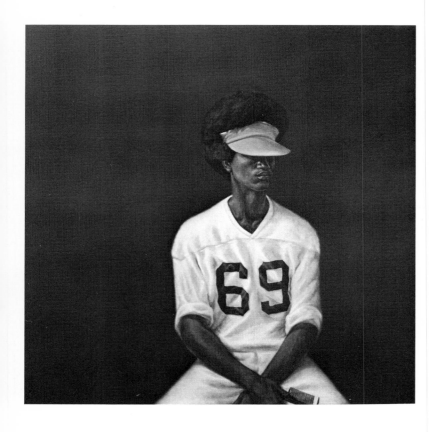

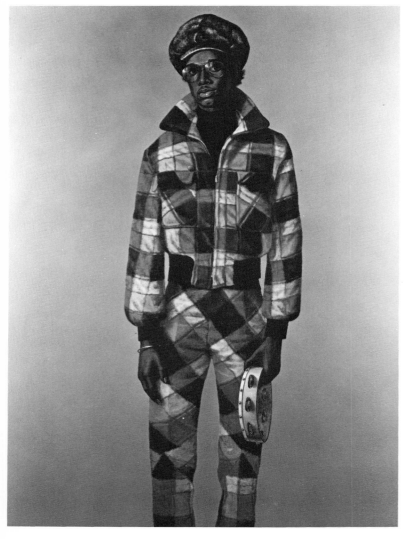

reer, the artist is coming back to using a representational setting. He cites *Arriving Soon* as the crossover point. It portrays a young woman sitting next to a Coca-Cola machine, brooding over some impenetrable mystery. Her shadow, an electric wire, electric wall outlets, and balloons indicate a background. "I am trying to integrate a little more of a still life situation into the background," the artist says. There is a patterned rug in one recent work, for example, and Moroccan tiles border the top of another. "This is an invitation to the viewer to go in a little."

But by far the most dramatic effects are seen in his superb use of white on white. *October's Gone: Goodnight* is a prime example. The young woman's evening dress is an icy white against a mellower white background. The only shading effects are seen in her face, arms, back, and the other parts of her body revealed by the dress. The dark of her leg, revealed by a slit in the dress, is a stark triangle against the white background, visually and compositionally striking.

These stunning white-on-white effects had their origins in an earlier phase of Hendricks's work: his basketball still lifes—an unlikely relationship, but valid. At a time when he was painting still lifes, Hendricks wanted to paint basketballs, which interested him more than apples, pears, vases, and so on. As he describes it, "Putting a basketball on a table with apples wasn't a satisfactory still life. I felt I had to put the basketball into an environment that I was comfortable with. So my studio became the basketball court, with myself as the referee." And, exploring an interest in geometrics, he painted basketballs floating in surrealistic arcs. Now Hendricks feels that in a white-on-white painting of a black person, the person's head floats much the same way his basketballs did. "These paintings are not radically different from the earlier ones," he says. "To me, flying is the ultimate freedom."

The artist achieves a white-on-white effect that really does feature different whites by a combination of oils and acrylics. The figures themselves are oils. The dress of the woman in *October's Gone: Goodnight* is an icy white: seven or eight coats of zinc white, the whitest of the three whites available to an oil painter. The flat area around the figure is acrylic paint, which he uses because of its rapid drying quality. Hendricks does not use acrylics for the whole painting, however, because "I really don't feel good modeling with acrylics. I don't like a painting to rush me. My recent style is thinner, juicier, more transparent, and I can't achieve this with acrylics." And he compares painting in oils to sitting in a sidewalk cafe: "You watch what's going on in a very relaxed way and don't get caught up in the rush."

Besides personality and scenery, costumes add to the dramatic flavor. Hendricks admires the flair and expression of his young black contemporaries and the way they wear their clothes. "There's a lot told in what one wears," he says. "Often the clothes have greater impact than the person." He points to a work in progress that features a six-foot-tall man in a long,

Opposite page, top: *Mr. Johnson (Sammy from Miami),* 1972, oil and acrylic, 60 x 60. Collection Dr. and Mrs. Michael McGrath.

Opposite page, bottom: *Blood,* 1975, oil and acrylic, 72 x 50. Courtesy ACA Galleries. Hendricks's limited palette, an extension of his "geometric" period, heightens the drama of his subject's confrontation with the viewer.

Above: *October's Gone: Goodnight,* 1974, oil and acrylic, 72 x 72. Collection Mr. and Mrs. Robert Russell. Three views; three Graces.

Right: *New Michael,* oil and acrylic, diameter 22''. Collection Mr. and Mrs. Aram Jerrenian. The second in a series of three portraits.

Below: *Napoleon,* 1972, oil and acrylic, diameter 60''. Collection Mr. and Mrs. Gerald Schefstack. Hendricks feels it's important for the artist to build a library of information inside the mind to draw on when needed. He became acutely aware of his own reservoir of information when the subject for this painting disappeared after one sitting.

graceful blue coat and wide-legged pants. "There's a continuity between the clothes and the person," he says. "In Paris I was fascinated by the West Africans wearing Pierre Cardin suits."

A Hendricks drama is further heightened by the presentation of more than one view of a model in the same painting, as in *October's Gone: Goodnight* for example, where we are presented with front, side, and back views of the subject. And a work in progress in his studio shows a young man in three different positions with different facial expressions: challenging, pensive, and the third looking away from the viewer, to cut off further communication perhaps. "With certain individuals, one view isn't enough," explains the artist. "I want to create a total painting rather than just a portrait."

But there is another reason for these multi-portrayals, or variations on a theme. While other artists cite Vermeer, Rembrandt, or a favorite teacher as an important influence on their work, Hendricks regards jazz music as his muse. He frequently paints to the syncopation of saxophonist Charles Parker, trumpeter Miles Davis, and pianist-composer Thelonius Monk, among others, and feels his style as an artist grows from the strength and flexibility of the jazz rhythm. He aspires to "paint as controlled and as compositionally tight as the Modern Jazz Quartet." He likes to quote jazz musician and composer Charlie Mingus, who said, "My music is as varied as my feelings are, or the world is, and one composition or one kind of composition expresses only part of the total world of my music. . . . Each composition builds from the previous one, and the succession of compositions creates the statement I'm trying to make at that moment. The greatness of jazz is that it is an art of the moment. It is so particularly through improvisations but also . . . through the successive relation of one composition to another." Substitute painting for music in the preceding quote and you will have 75 percent of Hendricks's philosophy, he says.

The artist's approach to his work is as straightforward as his subjects' presentation of themselves. He begins by building his own stretcher frames, which are collapsible so that his large paintings will fold in the center and fit into the back of his Volvo station wagon. The canvas is primed with four or five coats of Rhoplex, which is the binder for all acrylic paints. (Because he uses so much, Hendricks buys it in its industrial form in quantities of 50 or 55 gallons.) Then four or five layers of gesso go on top of that. And because he doesn't want to paint straight onto a white surface, he applies a thin wash of brown or red acrylic to give the painting "a nice undercolor that's lush and transparent."

He does not do a preparatory sketch for a painting. "Laboring over a sketch would kill the spontaneity for me," he says.

Next is his acrylic background, and when that's

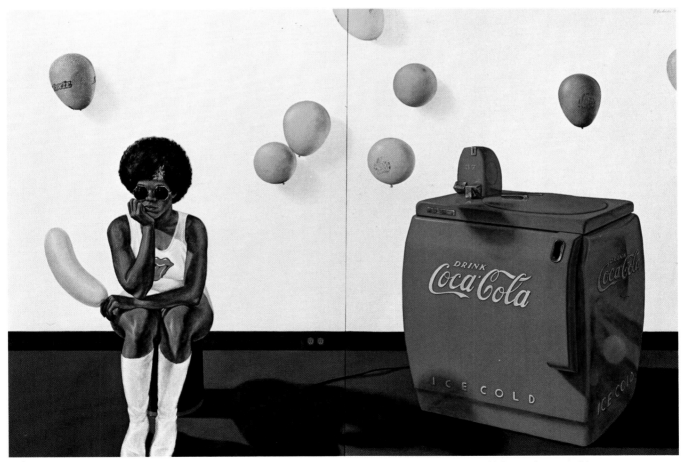

Arriving Soon, 1973, oil and acrylic, 72 x 104. Courtesy ACA Galleries. Inspired by the model's pose, Hendricks, on the spur of the moment, put two canvases together to get the right size and did a sketch.

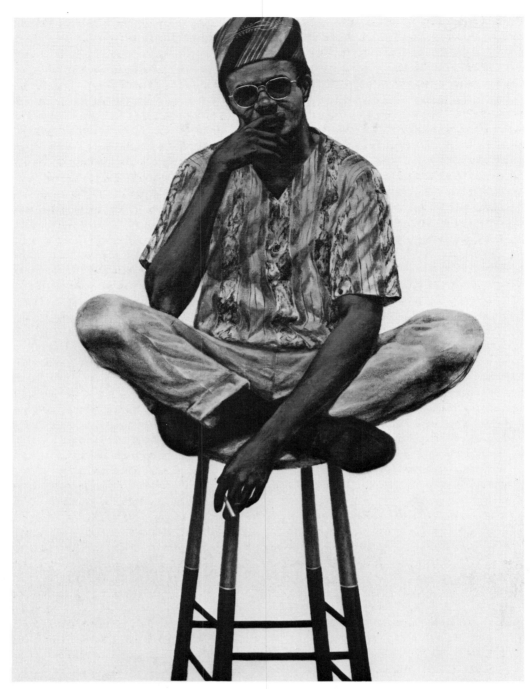

Brother John Keys, Over, 1971, oil and acrylic, 60 x 45. Collection of the Edwin A. Ulrich Museum of Art, Wichita State University. Photo Geoffrey Clements. Loose brushwork in the clothing provides a contrast to tightly rendered details and ''allows the painting to breathe.''

dry he begins to paint. Hendricks prefers to paint by natural light, but because his work is likely to be exhibited under a variety of lighting situations, he tries to cover all possibilities. So he often paints at night using incandescent bulbs, plus fluorescents to approximate daylight illumination.

Hendricks's interest in art stems from his childhood in Philadelphia: "I was always scribbling on the walls. You can go back to Philly and still see my graffiti." He studied at the Pennsylvania Academy of the Fine Arts from 1963 to 1967, preferring that to a liberal arts education with a major in art because of the constant exposure he would have to art. "And I enjoyed the professionalism of the Academy," he says. "I was like a sponge, learning whatever I could from everyone there."

The self-assurance he portrays in his subjects is clearly a reflection of the man himself—of his strength and confidence. Apparently he has always had a strong sense of self-awareness. (Hendricks gets irritated by questions like "Don't you paint white people?" He feels they suggest the old negative connotation of second-class citizenship. In other words, you're not fully painting people until you're painting white people.) When someone would criticize him in school, he relates, he would always argue back. At graduation one teacher told him, "You're a damn good painter, but an arrogant son of a bitch." Hendricks relates the incident with a smile. There is certainly not a trace of arrogance about him. One perceives only a strong sense of self. He is doing what many talented people have failed to do: couple his talent with the drive to achieve. And little by little he is making himself and his art known and appreciated. This is difficult for a black artist to do, he claims. "There are plenty of us around, but you'd never know it by the media coverage we get."

Yet this artist is overcoming that difficulty splendidly. His career resumé shows an impressive number of professional credits, beginning with a Masters in Fine Arts from Yale. The rest is a series of awards (including travel and study scholarships, such as the Rosenthal Award from the National Institute of Arts and Letters), group exhibits, one-man exhibits, and public and private collections where his work has been placed. In 1975 this meant inclusion in the Boston Jubilee Exhibition, three museum shows in South Carolina, and, in 1976, The Ulrich Museum in Wichita and ACA Galleries in New York.

He has already enjoyed remarkable success. Like many artists, he is subsidizing his work with a teaching career, as Assistant Professor of Art at Connecticut College. He regards teaching as the 20th-century patron of the arts. "Someone once said that it's the Medici of our times," he explains, "and I agree." Hendricks enjoys teaching, but he would prefer a more flexible schedule that would allow him to teach at his leisure.

What is in his future, Hendricks doesn't want to predict. But his capacity for exploring new directions never flags. He has expanded his drawing and photography as well as painting. "Each medium answered something in me. Photographs, for instance, capture a certain spontaneity. And each medium is unique. I can't draw my photographs or paint my drawings."

His drawings are unusual: collages done on graph paper with various objects lightly drawn in and items such as a *Time* magazine subscription blank pasted on. They are more designs than actual drawings. Hendricks uses the drawings as a vehicle for pulling together various unrelated elements to make a statement.

His black-and-white photographs seem more related to his paintings, not simply in terms of his subjects. He might, for instance, choose to *photograph* a group of smartly dressed young people; however, he usually paints-in a touch of color—a hot pink or a vivid green—such as in a woman's shoes or a car, to arrive at the statement he's after.

While he values the medium of photography as an art form, he resents its dependence on mechanics. Painting is, for him, more immediate: "I can push the paint around the way I like." It is for the same reason—distaste for mechanics—that he never ventured deeply into printmaking: "It is too much work of a mechanical nature." And he feels the same way about the darkroom work that is part of photography.

Hendricks is a realistic painter who enjoys dealing with human ideas: "concepts I can relate and gravitate to." He avoids what he calls "the stranglehold that Abstract Expressionism has on art. I like to go one step further. It's the human element that pulls me in."

And so he works on in his small New London studio, surrounded by life-size paintings in various stages of completion, on easels or hanging on the wall; his hundreds of record albums that spill out on his red painted floor; jars upon jars of brushes; tubes of paint; many drawings and photographs and memorabilia including, appropriately, a saxophone.

NED JACOB

BY MARY CARROLL NELSON

FORTIFIED BY THE EFFORT he has made to be an artist, Ned Jacob affirms that "This time in this country is the greatest period in history for a young person in art. There is a bold and enthusiastic market for almost anything with paint on it. Anyone who has ability, tries hard, and sticks with it will succeed in the art business."

Jacob knows all about trying hard. He has been a practicing artist since he was 18 years old.

Ned Jacob is a Western artist by choice. The West, for him, means all the people who live in it today or have lived in it in the past. His view of his subject is inclusive rather than exclusive. He finds Denver, his adopted town, a valid part of the West as well as a cosmopolitan city.

"I think that the artist is reflected perfectly in his work. The things that are important to him visually and spiritually are to be found there. My own interest in the American West, past and present, the celebrations of ethnic beauty, the uniqueness of the human subject, as well as my love of nature are the things that constitute the body of my work," he says.

There is a paradox, perhaps more than one, in this man and his work, for Jacob arrived at who he is and what he does after years spent roaming about, covering the entire country, hopping trains, thumbing rides, or going on foot. Moving this way brought him briefly in contact with all sorts of people. Though cautious, Jacob trusts his instincts and has been well-treated and often confided in. He feels that if you paint people you should enjoy them. "An important part of your role as an artist is to be comfortable with your subject matter," he says.

Tennessee born, Jacob was raised in New Jersey. His mother was a New Yorker and his father, a businessman, had emigrated from Germany. The museums and zoos of New York City were familiar to Jacob from childhood, for they were places his mother took him on frequent trips to the city.

At 18, Ned Jacob began his single-minded trek toward his goal of a full commitment to art. He refers to the "doting parental indulgence" of his boyhood interest in art as a "normal condition of life" and comments, "It is impossible to recall a time when the making of pictures was not as fundamental to my self-expression as the wagging of a dog's tail. The only apparent transition in my development was the realization that, in order to make art one's profession and to be self-sustaining in it, one must grapple with many of the harsh realities of life and must come to a workable marriage of the practical and the fanciful."

After frustratingly routine grade school art classes, he had the good fortune to have two good high school teachers, Margaret Johnson and Robert Gilbert. They took his work seriously and were the first of many knowledgeable and generous acquaintances who have guided his career. It was Gilbert who advised Jacob that he could become an artist without attending an art school, thus freeing him from many confining classrooms. Gilbert made art a little more human and accessible to Jacob.

Sometime in his childhood, Ned Jacob had seized upon the whole idea of "The West." His developing interest in American Indians had been fed by visits to the Museum of Natural History in Manhattan, and by the time he reached high school it was all consuming. After high school graduation, as he describes it, "I packed my cowboy suit and my paintbox and took off." Hitchhiking west, he soon found himself in Montana, near Glacier National Park, where he stayed four years.

To support himself he became a guide for the saddle horse concession in fall, spring, and summer. In winter he lived in a cabin on the Blackfoot Reservation. It provided only rude shelter. His lengthy stay, close to the Plains Indians, gave him a veritable expertise in their arts, crafts, and customs. Everything that he has developed in his career began in this period of his life, because it was then that he came to know the Indian as a person—as he really is. What he learned was sociological, subjective instead of objective. Friendship with the Blackfoot Indians has continued for Jacob and is renewed on his return trips to Montana.

It was in Montana that Jacob met Ace Powell, proprietor of an artist supply and artifacts shop and a Western artist. Again, he had met the right person. "What are you doing working for the Park if you

Belly Deep, © Ned Jacob 1973, oil, 24 x 35. Collection Dr. and Mrs. Robert Weakly. Jacob, who describes this painting as ''looking into the shadows,'' creates a rhythmic flow between the foreground grasses and figures.

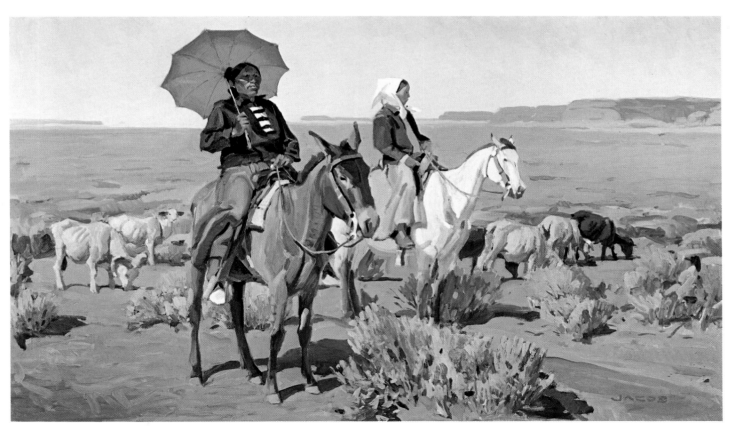

Red Parasol, © Ned Jacob 1972, oil on panel, 24 x 48. Collection Arrowhead Petroleum Corp. Contemporary Navajo women tending their property. Jacob captures the thin atmosphere and high-key quality of the sunlit plain.

Onde (Kiowa), © Ned Jacob 1973, charcoal and Conté, 22 x 12. Collection Mr. Kenneth Todar. This man is Onde. The otter cap is a badge of membership in the elite of the warrior class. Only men of wealth and valor were invited to join.

Chain Lighting Derner, © Ned Jacob 1973, charcoal, 21 x 16. Jacob captures the toughness of this veteran fighter.

Old Lady of Juchitan, © Ned Jacob 1974, charcoal, 22 x 16. A Zapotec matriarch whose proud heritage is courage and beauty.

want to paint?" Powell asked. "You can make a living at painting. I've been doing it for 30 years. You don't always eat good, but you can't starve in this country."

Ace Powell owned every issue of *American Artist,* back to its beginnings as *Art Instruction* magazine. Jacob spent the next snowbound winter reading them. He received support, lodging, and education from Ace Powell, and it became the beginning of Jacob's sustained practice in drawing. For the first time he could devote himself to the discipline of art; but, despite Powell's prediction, Jacob found he could indeed starve. He survived only because Ace Powell, the Indians, and local restaurants fed him. In his first year as a full-time artist he grossed $300. The second year his income rose to $500; the third year it was $750.

During his fourth year in Montana, Jacob read an article by Frank Waters on Nicolai Fechin, a famous early Taos artist best known for his portraits of the Southwestern Indians and Spanish people. Fechin's work and romantic lifestyle fired Jacob's imagination so much that he packed his things, including the Indian artifacts he had collected, and hitchhiked to Denver, then to Taos—where he saw the Pueblo Christmas celebration—and on to Santa Fe, Phoenix, Flagstaff, and back to Taos, his next home.

There he rented the old studio of Walter Ufer (another famous early Taos artist), which was formerly a penitent church. There was a large window in it and an electric light, though Jacob was so used to living without electricity that it took him six months to discover it. To have a studio of his own marked a major step in Jacob's life, an acknowledgment of his chosen career. Within the next five years, he occupied almost every good studio in Taos.

"The studio to me," says Jacob, "always was the most visible image of the professional artist. It gave me the feeling of legitimacy to rent Ufer's studio. Since then I've always rented a place that was physically a good studio: with space, light, and storage. Living comforts were the last thing I considered. I've always accommodated my living style to the studio itself. In Denver my first studio had no kitchen, so I ate all my meals out for three years." Jacob distinguishes between priorities this way: he chose living in the studio rather than having a studio where he lives. He stresses that the studio is a workshop and also calls it a "spiritual entity." It is a private place.

In Taos, Jacob again met the right person: Bettina Steinke. Steinke, well known for her portraits in charcoal, took an interest in his talent and shared her love of charcoal with him by giving him some fine quality paper and a few comments about charcoal tone. He went home to practice—for months before he achieved results he could call promising.

Jacob thought Steinke's drawings were beautiful. Typically, he set out to teach himself to achieve a high standard. And he did. Now he says, "I can be more expressive with a stick of charcoal than with any other medium." Jacob prefers the rich blacks of pressed charcoal. He uses rag paper for finished

work, toned charcoal papers by Strathmore, and a smooth rag bond for quick sketches. He does thousands of these sketches in a single year.

He says, "I don't think there's ever been a great artist who didn't consider drawing the foundation of the arts. The importance of drawing is underestimated today. Only after drawing obsessively for 15 years do I begin to realize how important it is—how profound is the need to draw not only competently but superbly. You have to draw with complete facility; not just cleverly, but accurately."

Drawing, he believes, is describing form, and the importance of it is its veracity, not the finish. The artist's eye sees deeper than the ordinary person's; drawing records what the artist's eye registers. During his poorer days, for practice, he drew every head and hand in one copy of a magazine. He did it on blank, huge newspaper rolls bought for only $1.50. Through drawing, he says, "You're ready for the unexpected: here it is, now it's gone. The practice serves you well. You can't develop this perception just painting from life. It is not how long you work at one drawing that counts." Sketching to achieve rapid accuracy is his aim.

Early in his career, Jacob focused on the human figure as his major subject. He is not a portraitist, but is a recorder of racial types. His paintings combine these studies with his other interests—diverse but related—one of which is Western history.

To prepare for his historical paintings, Jacob must find models. He might see the model first and arrange a suitable setting with authentic artifacts—costumes, weapons, musical instruments, headdresses, and footwear. If he does not own these things and cannot borrow them, he will make them. Over the years he has become as expert as an Indian artisan in creating Indian gear. For beadwork he calls on Indian craftswomen for help. Jacob might sketch a costume he wants, set about creating it, and then seek a model who fits the type he needs. He has no set pattern for arriving at a painting.

In a sense, many of Jacob's techniques are preparations for rugged field work. He pares down his materials and designs new equipment in order to become accustomed to the lightest-weight necessities for his art. He might deliberately set up a situation, both cramped and poorly lit, to see for himself if he can paint under adverse conditions. He travels and paints with an efficiency he develops beforehand. It is as if he were always in training for adventures ahead.

One of Jacob's self-restrictions is his palette. He achieves radiant color with Winsor & Newton's cadmium orange and cadmium yellow and Shiva's titanium white, in addition to any U.S.-manufactured ul-

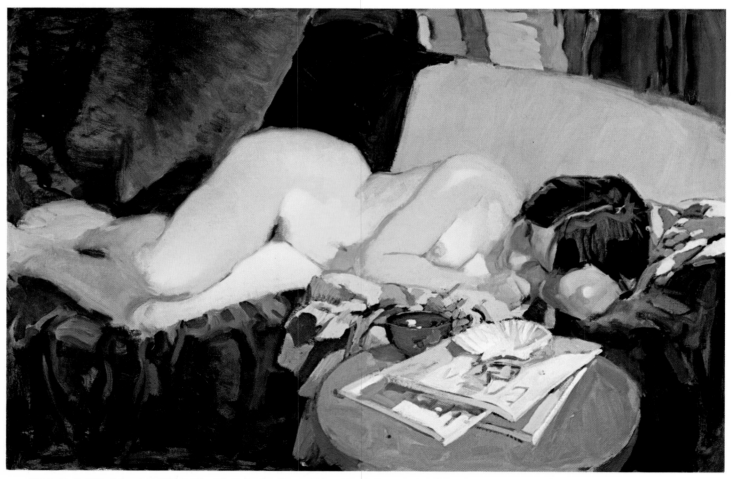

Paula, Nude, © Ned Jacob 1968, oil, 24 x 35. Collection Dr. and Mrs. John C. Lemon. Jacob begins with the flesh tones of his model and develops the rest of his palette from there. Here he began with ivory, painted color into the area around the model to complement the figure, and placed pure color areas lower right.

tramarine blue deep and alizarin crimson; he finds the latter two equally good regardless of which major brand. His severely limited palette forces Jacob to analyze color. He thinks in terms of true color, not in terms of pigment. An object is not brown, for instance, but might be yellow, red-orange, or green—or grayed yellow, or grayed orange. He grays his color with its complement, creating tertiary grays.

In the studio Jacob uses stretched linen canvas primed with white lead, or Masonite primed with Liquitex gesso. He begins a painting with a wash of pigment diluted with mineral spirits. As the large areas become resolved he paints more freely, applying the paint in the final stages straight from the tube. He paints more thickly on the Masonite panel than on canvas, restraining his use of impasto on canvas for the sake of longevity. Painting on a rigid surface, Jacob allows the bristles to sculpt the paint. On canvas, his strokes tend to smooth out somewhat for a different effect.

Jacob is methodical. He sets out his colors in this order, clockwise: white, crimson, orange, yellow, and blue. Outdoors and indoors he uses paper palettes for convenience. When the mixing area gets muddy, he cuts the center out, exposing a new mixing area but retaining his pigments along the outside edge. In the studio Jacob has two other palettes. He covers his taboret with a thick piece of milk glass to give him a sizable mixing area. He also has a gracefully cut, beautifully balanced, arm palette; this he finds useful for mixing close to his eye, since he can turn it to catch the light, or for mixing some distance away from the easel, which is important on larger works.

Jacob restricts his medium mixing, believing the less you mix pigment with the admixtures of oils, varnishes, and so on, the less chance it has of cracking. As a result, there is a freshness to his paintings, each color area seeming clean and unmurky.

Jacob paints during his travels whenever he is free of commitments. "More and more," he says, "I'm going out on location. I think of my painting as very compulsive. I'm interested in painting almost anything and travel to keep myself interested. In a month's time I'll paint a wide variety of subjects, from African game to a Taos landscape to nudes in the studio." When painting in the field, he uses small, primed, Masonite panels or rag illustration board sealed with white shellac, diluted four to one with alcohol. After a trip he pins up his latest crop of oil sketches along the wall of his studio. They are clear, colorful statements: some are already paintings; some are used to spark studio paintings.

Each major painting makes a new set of demands on Jacob. Although a small sketch may trigger an idea for a painting, Jacob estimates that 75 percent is imagination. It is a requirement for him that he arrive at each painting in an individual way, emotionally and intellectually. "I insist on the uniqueness of each painting," he says. Jacob works diligently on his major oils but is not abundantly prolific; he tries to prepare one large show per year.

Besides painting on location, Jacob takes 35mm slides. Back in his studio he has a screen, a comfortable chair, and his projector in readiness. There he studies the slides, looking for ideas; then he works up thumbnail sketches. These sketches, which are based on slides, are combined with selected sketches done on location. He pins them to an extra-large drawing board tilted nearly vertical. As ideas jell, he sketches varying compositions. Step by step, the painting grows. These compositions become his major works.

A rapidly executed painting has the freshness and vitality Jacob seeks. His brushwork has the direct looseness exhibited by Delacroix, particularly in his studies of lions and other oil sketches. Jacob believes there is a natural kinship among those who paint quickly; they use a brush shorthand that has a look of its own.

Thorough mastery of his craft has been Jacob's goal. He has never deviated from it. "I believe in professionalism in artists," he says. "This means, for me, doing the best job I can, using good materials, framing properly, putting my work in a gallery where it is hung with dignity, and maintaining consistent prices."

The first sign of success to Jacob was his ability to rent both a studio and an apartment. His studio is a model of professionalism. Located in downtown

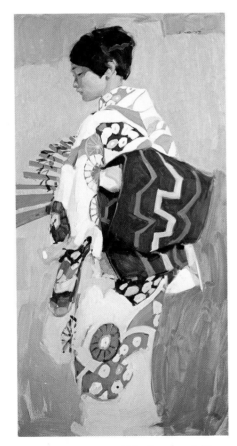

Sumiko, © Ned Jacob 1968, oil on panel, 48 x 24. Collection Mr. and Mrs. Jack Dunne. Isolated patterns and slightly flattened out forms suggest the overall richness of a Japanese print.

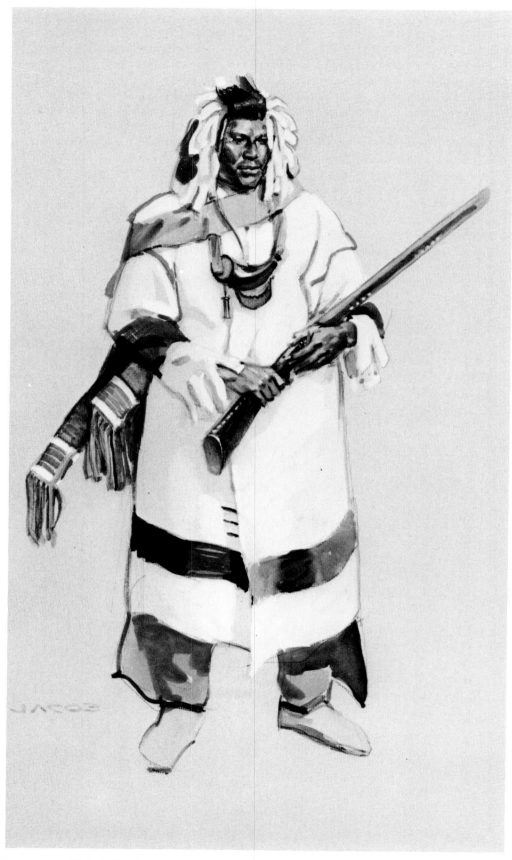

Crow Hunter—Winter, © Ned Jacob 1972, gouache, 24 x 14. Courtesy Sandra Wilson Fine Arts Galleries.
One of a series of historical costume studies. Each is a vignette painted on gray watercolor board.

Denver, it is the entire loft of an old carriage works, half a block deep and 30 feet (9.1 m) wide.

Since Jacob is left-handed, he turns his right shoulder to the window. From there he has a long view to his model stand. For backdrops he uses rolls of photographic background papers; he has rolls of many colors stacked in one corner. When in use, the roll is lowered from a rod placed high on the wall.

An antique lay figure, a full-sized mannequin of wood jointed even in the fingers, can replace the model. (At one point it wore Indian buckskins with beaded moccasins and served as a stand-in model for a seated Jicarilla Apache carrying a rifle.) Beyond the studio the space is divided into storage, workshop, and empty areas. The workshop is, like the rest of the studio, neatly organized. Jacob builds frames there when necessary. He used to do everything himself, including goldleafing, but now has trained a young man to work at his direction.

One of Jacob's methods is to acquire a frame prior to finishing a painting on a Masonite panel. He turns the frame backwards on the easel and mounts the work in progress into the reverse side of it with brads. The frame holds firmly in the easel, more firmly than the panel alone. When the picture is complete, he turns it around and mounts it permanently in the frame.

In judging an artist's work, it is sound to apply the same standards the artist sets for himself. An artist reveals his own standards in the choice of problems he is trying to solve. Ned Jacob attempts difficult problems and solves them with subtle mastery of composition, color, and draftsmanship. He practices a kind of derring-do with a hard-earned insouciance; for example, that old bugaboo, white on white, is one of his specialties. He might distinguish as many as five whites in a canvas with a crystal clarity. A certain fluent grace, a seeming rightness in his choices, makes Jacob's paintings readily available to enjoy. It is only on second glance that the artists's self-imposed restrictions are apparent and the intellectual standard he has set for himself is revealed. He has earned the right to look back and know he has merited his rewards, yet he is still stern in view of his art:

"I like for people to see what I intend them to see. I sign my painting, and I *mean* Ned Jacob saw this. It's my fault if I'm not making myself clear. I want my work to suggest reality.

"I want to continue growing. It's false security to win success."

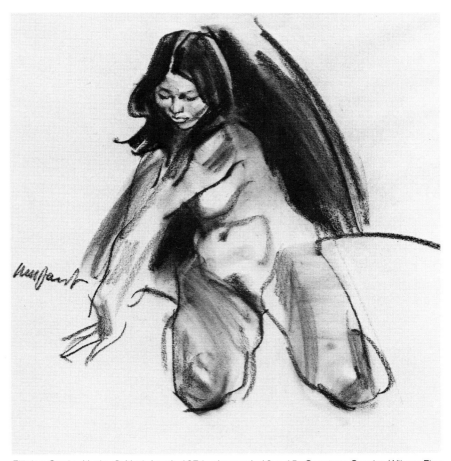

Filipina Study, Nude, © Ned Jacob 1974, charcoal, 18 x 15. Courtesy Sandra Wilson Fine Arts Galleries. One of Jacob's intents is to capture the ethnic characteristics of his models, including anatomic structure, gesture, facial features, complexion.

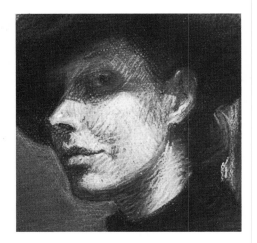

ANN LEGGETT

BY DOREEN MANGAN

A CONVERSATION with Ann Leggett is a stimulating experience. She is excited about her work and shows it. She talks with enthusiasm and irrepressible humor about pastel painting, Old Masters' oil techniques, an open-heart operation she witnessed and sketched, and the Zinacantan Indian community in Chiapas, Mexico, where she spent eight years before her recent move back to New York City.

While living among the Zinacantans, she learned to speak their language, Tzotzil (Tzō-tzeel), eat their food, wear traditional clothing, participate in their religious rituals. But probably the most fruitful aspect of her Mexican sojourn was her exploration of the pastel medium and development of her own pastel technique.

"Pastel brings out the beast in me," says Leggett,

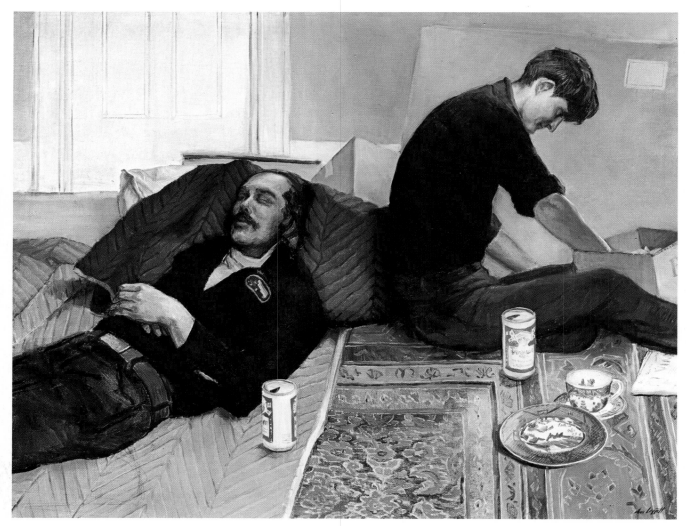

Active and Contemplative Moving Men, 1976, oil, 31½ x 39. Cooler in palette than most of her paintings, this was influenced by a show of 19th-century French paintings Leggett had seen just prior to this work.

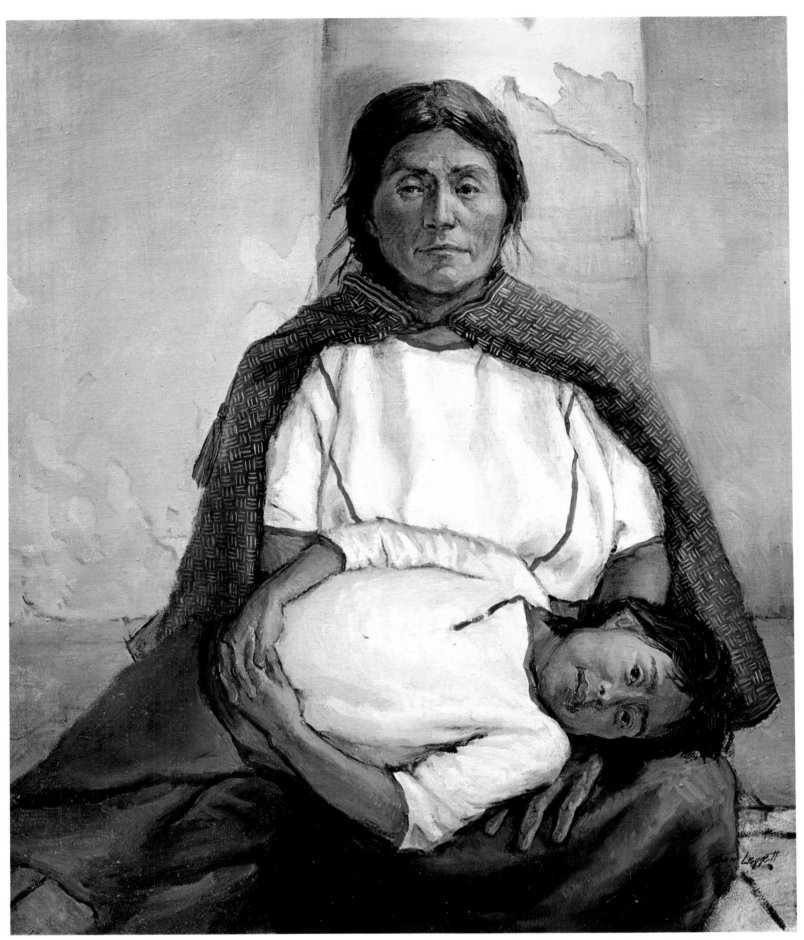

Mal and Manu, 1975, oil, 28 x 24. Collection Elizabeth Stephens Depperman. Manu, one of Leggett's godchildren, was also her favorite child model, partly because of her powers of concentration. Here she posed herself on the lap of her mother, a woman of courage and humor.

who, with her lively eyes and smiling face, seems anything but beast-like. "I love the gutsiness of the medium. Pastel has had bad press because of the weak pastels that have been produced. But potentially it is the least wishy-washy medium there is."

Leggett delights in the directness of pastel: the fact that there is nothing intervening between pigment and paper; no chemicals, no water, no plastic. And she is enthusiastic about the color range available to the pastellist. "You can really go wild shopping for pastels," she says. "There's everything from black to white. There are very strong colors, earth colors and some wonderful 'ugly,' dirty pastel colors. I love to put the bright ones with the 'yucky' ones. And sometimes I feel, 'Gee, I must work that one in somewhere!'"

Color was not one of her strong points, the artist explains, before she began using pastels: "I've learned a lot about color simply because they were there. I have literally hundreds of pastel colors."

Leggett's pastel paintings look like oil paintings, an effect she wants and arrives at by using the softest pastels available. Sometimes she softens them further by steaming them. This wasn't necessary in Chiapas because of the humidity, especially in the rainy season. But in more northern climates she softens her pastels by holding them over a humidifier.

The painterly look of Leggett's pastels is further heightened by her method of application: She builds up layer upon layer. The danger of such application, Leggett points out, is that the top layers get muddy because they pick up what's underneath. She avoids this by spraying on fixative between layers: "Some people don't use pastels at all, because they feel Degas invented the only fixative worth using, and his recipe is lost. But I find that any old fixative in a spray can is good for this purpose," she explains.

She also admits cheerfully to the sin of pollution: "I'm definitely going to ruin the ozone layer by using the spray can, especially when I'm working way down in the darks." She has tried using a mouth-blower but finds that it makes blots in the painting

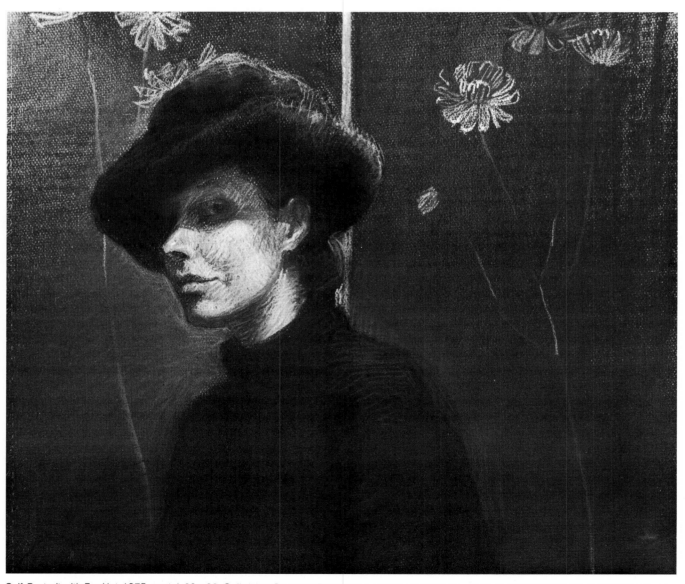

Self-Portrait with Fur Hat, 1975, pastel, 20 x 26. Collection Clarence Barnes III. Leggett contrasts the relatively smooth background with the rough texture of the paper and the horizontal lines from the corrugated cardboard on which she draws, made visible with the heavy build-up in the face.

and also doesn't have the force of an aerosol can.

Leggett also finds fixative invaluable in reducing contrast between a light and dark shade without muddying it: "Just give it a lot of spray. You'll find that the more spray you give it, the more you reduce the contrast. If you don't want to reduce the contrast all over the area the spray is hitting, just fashion a piece of paper to cover up what you don't want to spray."

Some artists object to pastel painting because of the messiness involved. But Leggett revels in it: "I am extremely sloppy and have no inhibitions about smearing the pastels with everything from my fingertips or arms to my shirt. I have what I call my 'paint-hand, smear-hand' technique. I lean the painting against something steady and apply the pastel with one hand and smear with the other, simultaneously. Sometimes I apply it all squished together, sometimes not, depending on whether I want what is underneath to show through or not."

A unique feature of Leggett's pastels is her heavy use of dark colors: "I don't think anyone has tried very much to take a light colored piece of paper and work for blacks."

Leggett uses traditional pastels rather than the fairly new oil pastels, which she feels negate the purpose of the medium. She uses pastel paper made by the French firm of Canson and Montgolfier, which she says is "not too out of sight in price." Her favorite shades of paper are a brownish-gray and a tint that resembles hot chocolate. Ochre, yellow, and gray shades are also among her preferences.

Leggett's "drawing board" is a piece of corrugated paper board onto which she tapes her pastel paper. She uses this for two reasons: It is very light and can be easily moved around. "I like to turn my work upside down and check for mistakes in value, design, or composition. I also hold it right-side-up in front of a mirror to check for errors." The corrugated paper board has "a weird, springy surface" that appeals to her. She claims she would never use anything else for pastels.

Leggett prepares to do a pastel by just looking at the paper for a while. Then, usually with a piece of pastel that is only a little darker than the paper, she sketches in all the elements of the painting. "You should get the drawing correct at this point," she advises. "Eyes and elbows should be in their proper places, and so on."

The next step is to think more about the painting and to smear a dark brown or black where the shadows are. This is a very thin application. "Then," she says, "I think about it some more. I spend about ten minutes thinking for every minute I spend painting."

After that she might put a thin smear of the same shadow color all over; then an average light tone; then a halftone. "The nice thing about pastel," says the artist, "is that it lends itself to trying out. You can keep trying out as long as you keep it thin."

She applies her highlights and darks at the end. "It's easier to add than substract," she explains.

"Don't pile on you lightest lights and your darkest darks right away. Work in both directions and work up to them. Keep the painting going all over at the same time. What you're doing in the lower left corner may affect what you do in the upper right."

As far as corrections go, Leggett has a unique "make your goofs early" philosophy. "Try to time your mistakes early, before you have heaps and heaps of pastel on your paper," she advises. "If you goof in the early stages, take the corner of your sweatshirt or T-shirt and wipe. Drawing goofs should be committed early. Shading mistakes are easy to correct in the later stages. And color is fun to correct. Sometimes you might even have a happy accident and discover something wonderful you might not have discovered if you hadn't made the mistake." If your goof is a drastic one, she concludes, start all over again.

Skilled as she is in pastel, Ann Leggett is also an accomplished oil painter, and her commissioned portraits are executed in this medium. Like her teacher Frank Mason, she is a devotee of the Maroger medium. Under Mason's tutelage, Legget learned to make her own paints, after the methods of the Old Masters.

Because both these undertakings are potentially hazardous, Leggett hesitates to describe them in detail. Amateurs should not try them unless supervised by someone who knows the processes. But the artists who master them will be rewarded for their efforts, Leggett feels, especially when mixing their own paints. "You save money, and you grind your paints to your own preference. I think, for instance, that there's too much oil in ready-made oil paint. I like to use it pretty stiff, and I can always add a little more oil if it's needed. It's not necessary to grind fresh every day," she explains. "If you set aside one day you can grind half a year's supply."

Sometimes, before beginning an oil painting, Leggett does a small pastel study. "It helps me work out a number of things," she says. "Pastels are sometimes a jump ahead of the oil, especially in terms of color. I work out a lot of color ideas with the pastel. What I'm doing with colors in pastel is really ahead of what I'm doing in oil, because I get lazy with oil. For example, I'll just use pressure on the brush to change the value when I could be throwing in more color."

Leggett describes her oil painting method essentially as one of problem solving: "When I'm working, I'm not thinking consciously about what I'm doing; I'm just solving problems as I go along." This is a way of working that each artist grows into as he or she becomes more experienced, Leggett feels. The neophyte painter does a lot of saying to himself or herself, "What am I doing?" But gradually the artist becomes almost "computer-like," according to Leggett, putting together bits of acquired data to solve a particular problem.

To provide a firm foundation for this process, Leggett feels the artist should have a solid training in the basics of art, especially drawing. She's delighted that

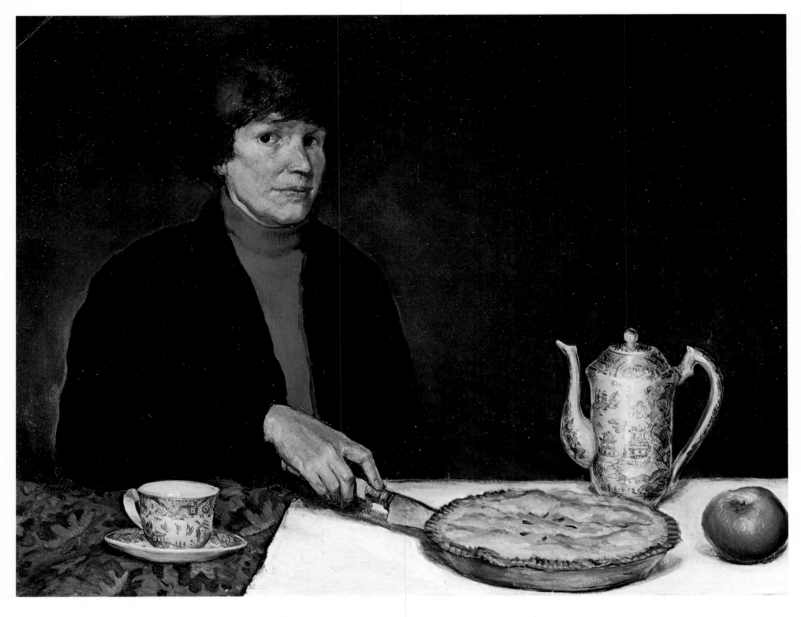

Above:*Apple Pie and Mother,* 1975, oil, 24 x 34. Collection Barbara Vaughan Leggett. Leggett purposely placed her mother in a setting surrounded by objects which, by virtue of placement, size, and detail, become as important as the figure.

Right: *Son of Fiesta in Tenejapa,* oil, 1968, 31½ x 31½. Private collection. Leggett tells a humorous story about the creation of this painting. She talked about an earlier painting, *Fiesta in Tenejapa,* so often that one day two friends, who were tired of hearing about something they had never seen, invited her over for dinner and then, presenting her with canvas and paints, told her she couldn't leave until she had painted them a copy of the much-touted painting. Leggett agreed and worked all night, finishing the painting from memory by morning. As she finished and stepped back for a final look, the inspiration came for a smaller painting on the same subject: *The Son of . . .* reproduced here.

drawing seems to be coming back into fashion. "Drawing is very much a rational and intellectual discipline," she says. "There's a time to sit down and make a very conscious study of it. It's no coincidence, I think, that many great draftsmen, such as Michelangelo, have been architects. In dealing with the body you are dealing with structure, complicated by the fact that the body doesn't stand still. You have to consider weight, stresses, where does this muscle go, what does it do, what's its relation to the rest of the body." Leggett herself has been drawing since she was about three years old. "It's something you study all your life." One of her favorite drawing exercises is sketching football games from television. "I really don't understand football very well. But what I like about the televised games is the instant replays. You have all those people piling up and flying through the air. Like a Baroque painting. Crazy things happen!"

Many of Leggett's sketches are done with Conté crayon on tinted paper. And to train herself for doing etchings, she has been drawing with pen and ink. "It's a real challenge," she says. "If you get too dark, you've had it! It trains you in planning ahead."

Leggett's love of drawing and sketching helps her prepare for her oil paintings. In fact, if you happen to be acquainted with her, your face may appear in one of her paintings as a villain, a saint, or even Venus. "It's dangerous to be a friend of mine," she says with a broad smile, "because I collect faces. I go around sketching people. If I see a really good face on the subway, I'll draw it. And when I'm making up a painting, I frequently use the features of acquaintances, relatives, myself, even total strangers."

Faces are the focal point of most of Leggett's paint-

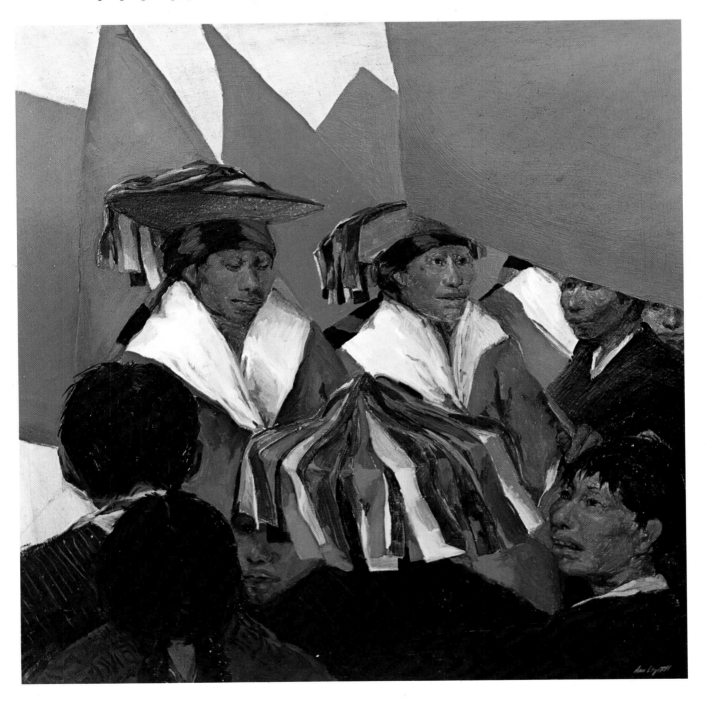

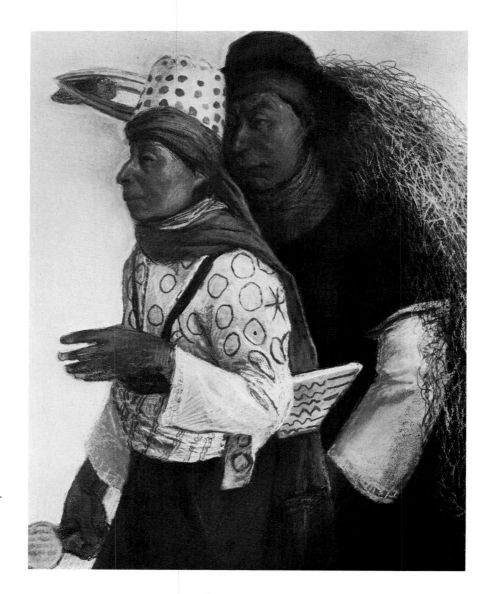

Kúkúlchon and H'tsonte, 1973, pastel, 26 x 20. Collection the artist. Translation: Plumed Serpent and Wearer of Spanish Moss. Leggett creates a psychological portrait through the placement of the two figures who are linked ceremonially by making H'tsonte larger, crowding and hovering over Kúkúlchon.

Moving the Mattress, 1975, pastel, 20 x 26. Collection the artist. Fascinated by the way the mattress flopped over the moving men, Leggett creates a portrait of two workers and the rhythm of their work.

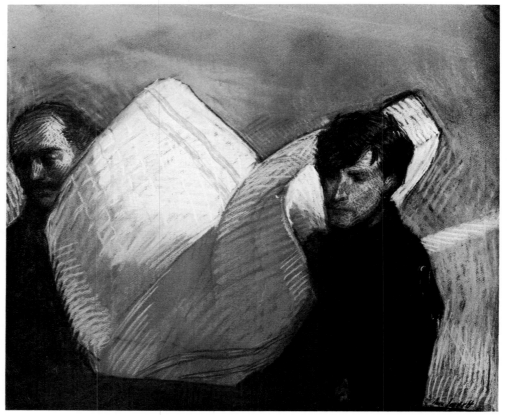

ings, so her "collector's instinct" is understandable. And she has been blessed with what she calls a "head camera" or photographic memory, which allows her at will to sift, sort, and select appropriate eyes, nose, mouth, and other features to suit the painting of the moment.

But many of her paintings are actual portraits. Her stay in Mexico afforded her a number of interesting and willing models because of the friendly relationship she established with the Zinacantans. She admired the people for their light-brown, delicate, almost Oriental features. "They are very poised," she says, "somewhat reserved; and a little raunchy, but in the context of poise and elegance." The Zinacantans, for their part, found the "gringo" artist in their midst to be rather interesting and funny. "But they think I'm too big," says Leggett, who measures 5 feet 8 inches (1.7m). "To them, I was a giantess!"

In spite of physical and cultural differences, Leggett made her niche in the community and even entered a ritual kinship with one family, whose daughter became her goddaughter. In this capacity the artist was frequently called on by her "family" to help out at religious ceremonies: "I made tortillas, ran errands, and brought home certain women who got too drunk, which does happen at ritual occasions." But probably what endeared her most to the Indians was her mastery of their language, Tzotzil: "I realized I had to learn it if I was going to be able to communicate with these people, most of whom do not speak Spanish." It was difficult to learn, but she could eventually "make little puns in Tzotzil, play the little conversational games, and behave with a reasonably suave manner in polite society." All these efforts paid dividends in the form of outstanding paintings, some of which feature religious officials in ceremonial costumes. In *Kúkúlchon,* the official is wearing a bird suit. In *H'tsonte,'* the man is wearing a wig of Spanish moss, also ceremonial attire.

Leggett also executes portraits on commission. "This sort of work is really my bread and butter," she says. But she sees no real distinction between it and her other painting. She approaches a commissioned work as she would any subject, with a great deal of speculation about the person. "I often try to think of a story featuring the person, to clarify what I want to do with the portrait. I think of what kind of series his life would form. I try to think of the person as an individual: What does he do for a living? What does he think about life? Is he conservative? Liberal? Does he like cats? I try to think of anything that might give me an angle on him."

Another way of getting an angle on a subject is to draw a caricature from memory. "I do this after my first meeting with a client," she explains. "The idea is to find out what physical details I remember about him. Does he have eyes that pop out? Do his ears stick out? Does he waggle his eyebrows?"

Unlike some portraitists who feel they must make an effort to flatter their clients by ignoring or skimming over unattractive features, Leggett has no compunctions about painting it as she sees it. In fact, she claims to be partial to "interesting" noses. How does she cope with a client's objections to her "paintbrush verité?" "Every portrait painter should be a good talker," she grins. "If you and your client are at odds—he thinks something is a little wrong with the mouth, and you like the mouth the way it is—you can frequently talk him into agreeing with you. And the nose? 'Why, that's the most distinguished nose I've ever seen!'" Leggett goes on, with tongue-in-cheek humor. "Convince the client that he doesn't want just a pretty picture, but one of character and distinction." And she gleefully relates John Singer Sargent's retort to a client who complained that there was something wrong with the mouth in her portrait. Said Sargent, "Well, perhaps, Madam, we ought to leave it out altogether."

Ann Leggett was born in New York. After high school she attended Sarah Lawrence College until she was what she terms "semi-kicked out." She then entered the Art Students League, where she served an apprenticeship with Frank Mason: "I got the kind of wonderful training people used to get in the old days and don't get too much of now. Frank is an excellent teacher. He gave us a thorough grounding in the basics." Her apprenticeship duties included everything from grinding pigment to modeling, and priming canvases "by the millions."

On a trip to Mexico in 1967, Leggett became so fascinated by the Zinacantan culture that she decided to stay. For the next eight years, except for infrequent visits back to New York, she lived in Chiapas and painted every aspect of the Indian life and religious rituals. In 1975 she decided to return to New York to pursue another phase of her career. Within a short while she acquired a loft near Gramercy Park in Manhattan, sold a number of paintings, won awards, has had several shows, and has been accepted by the Edward Merin Gallery in New York. These factors, combined with her enthusiasm and eagerness to explore new subject matter, indicate a fruitful career for this young artist.

ALICE NEEL

BY DIANE COCHRANE

PICTURE A PALE WOMAN in her 70s with white hair and sad, all-knowing eyes. She lives in a cavernous apartment on Manhattan's upper West Side and paints in a nearly barren livingroom that has needed plastering and painting for untold years. Although suffering from a lingering flu, she works almost without stop on a large portrait. Despite the enormous effort she is expending, however, the subject won't buy the painting when it's finished; her subjects almost never do. Instead, she will add it to the already vast collection kept on her "shelves of the past."

A depressing picture, isn't it? And who wants to be depressed these days? Okay, let's try another thumbnail sketch.

Imagine a woman who, like Miss Jean Brodie, is in the prime of her life. Only this woman, I suspect, has always been in her prime, both as a young woman and now, even though her hair has faded and extra pounds blur her Liv Ullman-type beauty. This woman is renowned as the most powerfully original portraitist of her time. Her paintings hang in well-known museums; she receives honorary degrees from colleges; she paints the rich and famous who are attracted by her high intelligence, endless delight in her own work, and heartbreaking laugh.

Now, bring these two images together, as if you were focusing a camera, and who do you have? Alice Neel. Neel has been painting portraits for over 40 years—portraits executed not for the benefit of the subject, but as an expression of a high art form. For when a viewer is exposed to the gestures and facial nuances of a Neel portrait, he or she experiences a shock of recognition, a confrontation with universal truths that must underlie all art.

Many of her sitters have been the poor and unhappy of the world: ghetto children; deranged seamen near breakdown; tired salesmen, such as a weary Fuller Brush man who came to her door and eventually found himself sitting in front of her easel, where he had fallen asleep. All have known or will know defeat; their portraits tell us so.

But if Neel portrays the martyrs of the world, she also paints the livers, the swingers. Andy Warhol bared the scars from his battle of the sexes for a painting, while two notorious transvestites decked themselves out in their Saturday night best to pose. And she doesn't neglect the rich (Stewart Mott, whose father was board chairman of General Motors), the talented (composer Virgil Thompson), the genius (Linus Pauling). Even children are subjected to her scrutiny. In the painting of James Farmer's children, the older girl projects a cool poise that may help her face the uncertain world of black and white, while the younger sister looks as if she might escape the burden of her people with her sassiness. On second glance, however, the twist of the mouth and the wise, staring eyes seem to say that she already knows all about the cruelties of man.

There is practically nobody, or at least no type of person, Neel hasn't painted, from Depression poets and artists to the inheritors of our brave new world of the 1960s and 1970s: black revolutionaries, drug addicts, liberated women. Her "shelves of the past" have been kept up-to-date and house a microcosm of creatures who populate the eastern megalopolis.

Why then do these paintings continue to collect dust on her shelves, rather than star in private collections? Certainly not because of a lack of critical acclaim. Says art critic Hubert Crehan, "She is the most original portrait painter I know: sophisticated in craft, passionate in expression, and wizardly in wresting potent psychological insights from her subjects."

And therein lies the rub: those psychological insights. How they can offend—or at least not attract, except in a peculiarly painful way, like a wound that is sore, but is one's own. One man, for example, a noted figure in the art world, spends hours in front of his portrait at Neel's gallery, studying it intently, but never offers to buy it.

Not that there is anything offensive about her paintings. It's simply that she manages to express what the world has done to its citizens and how they have compromised and made their deals with it in or-

Right: *Timothy Collins,* 1972, oil, 62 x 40. Courtesy Timothy Collins Neel posed the subject in this bold, rigid plastic, geometric chair to reinforce the idea of strength.

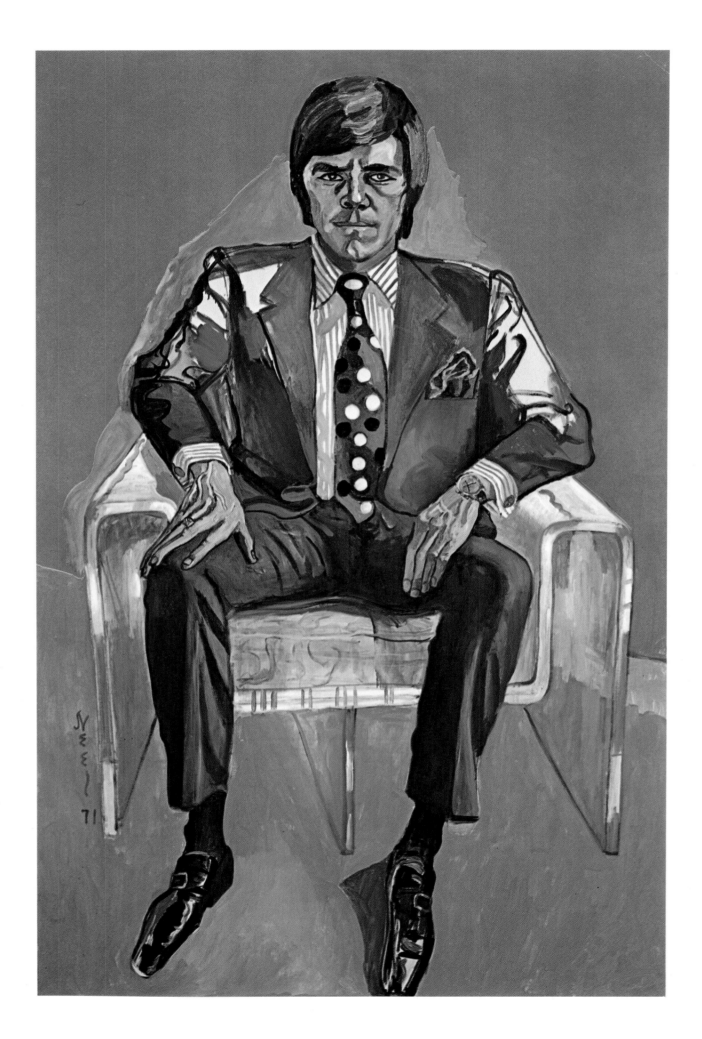

Diane Cochrane, 1973, oil, 43 x 30. Courtesy Diane Cochrane. Author Cochrane's pose permitted her to watch the painting in progress. Neel left the jacket partially unpainted to allow her initial drawing to show through.

Walter Gutman, 1965, oil, 60 x 40. The simple off-white background and almost abstract body accentuate the detailed painting of the head.

der to survive. Her work demonstrates the victory of mind over matter, with matter, or flesh, paying the price.

And what a price. If she paints a rich man who has clawed his·way to the top, a fierce destructive quality finds its way into his portrait because, as Neel says, "You don't get rich that way without your face reflecting the destructive process." So just as she records a sitter's varicose veins or hirsuteness, she also evokes his mental warts and tics. The soul is fused to the body in a way that hasn't been seen for a long time.

And indeed Neel is a throwback. Modern art for the past 40 years has concerned itself with the tensions of man's mind, but only in an abstract way. Neel seeks to describe the fears, pressures, harassments that plague mankind as they affect the human figure. Tension shows up on her canvases in rigid backs and talon-like fingers; anxiety in twisted lips and tight, furrowed brows.

Neel seems to draw her inspiration from two sources. First, she is heir to Northern European expressionistic painting. This tradition saw man beset by the horrors of civilization. But Neel chooses not to look through the glass quite so darkly. She tempers these truths with their positive counterparts to portray people compassionately and more accurately.

More important to her development as a painter of men's minds, or their souls, is her sensitivity to them. Neel came of age during what she calls the "psychological era." Freud and his followers in psychoanalytic thinking were reaching their zenith in popularity. Many intellectuals were impressed by their discoveries, and so was Neel. Although she never considered entering the profession itself, she wanted to use psychological techniques to portray the human condition. And apparently they have worked. Not long ago, after showing slides of her paintings at the National Academy of Sciences in Washington, she received many calls from psychiatrists, congratulating her on her psychological insights.

Pinpointing psychological truths is important to Neel, but no more so than the esthetics of a painting. She loves to draw and usually draws and paints at the same time. "But not everybody thinks I can draw," Neel confides mischievously. "Hilton Kramer (art critic for *The New York Times*) says I can't, that I just throw off my immediate reactions to a subject." But others, including many of the country's most prestigious critics, artists, and teachers consider her not only the finest draftsman, but also the best figure painter around.

Neel earns such accolades by employing a number of seemingly crude devices. She models by breaking up form into what looks like simplistic blocks of bold color. Yet few, if any, artists today can duplicate the results. She outlines her figures in strong blues or black in an almost childlike manner. But these outlines grab the attention of the viewer and rivet it to what's inside. She is a master at defining hands. With the fewest possible strokes she captures not only the

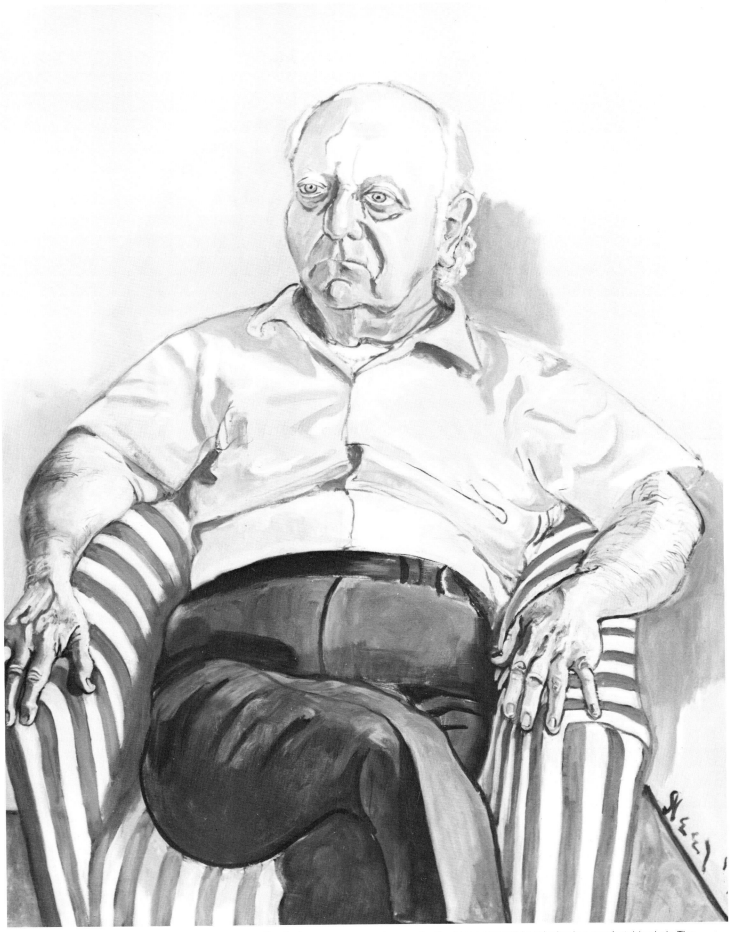

Virgil Thompson, 1971, oil, 48 x 37. Neel, impressed by the famous composer's unpretentiousness, posed him relaxing in a comfortable chair. The painting is mainly light pinks and grays.

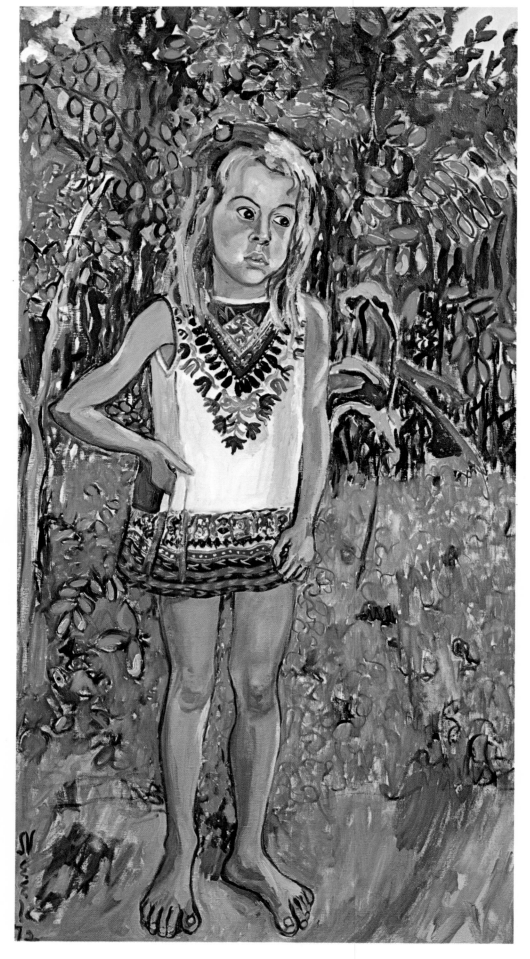

Olivia, 1972, oil, 54 x 28. ''Children are hard to paint, because they are generally too restless to sit for long.'' Here Neel catches her granddaughter amidst an overgrowth of lawn and shrubbery.

veins and joints of a hand but also the tensions of the entire body. She sometimes leaves areas of canvas—the background, perhaps, or an arm—untouched. To the untrained eye it looks as if she hasn't finished the painting. On the contrary, she has the intelligence and discipline to stop when she has caught the quintessence of the subject, knowing that any further refinement will conceal the essential man as effectively as the mask he wears in public.

Still, there is something to critic Kramer's statement about Neel's immediate reactions. Once she gets excited about a painting, she works quickly and with great passion. This spontaneous approach accounts for the intensity, the aliveness of the final painting that viewers frequently comment on, even though the figures may be rather distorted.

Her usual procedure goes like this: She spends about a half-hour talking to her subjects, getting to know how they feel. ("My chair is almost like a psychiatrist's couch.") As she listens she dissects their personalities with scalpel-like precision. And because direct contact is necessary for her to get at the core of a subject, she doesn't like to work from photographs, although she has on occasion. *Time* magazine, for example, asked her to do a cover portrait of Kate Millet, but she refused to pose. So a photograph substituted for the real Ms. Millet.

Nor does she work from memory unless she paints within twelve hours of observation. That doesn't mean that remembrance of things past plays no part in her paintings. Neel once met Walter Gutman, for instance, coming out of a gallery carrying a hat that looked as if he had slept in it. Two years later, when he finally posed for her, she asked him to bring the same hat and assume the same stance that she remembered from that meeting. Such concrete preconceptions are fairly rare, however.

Once on canvas, Neel doesn't try to be very literal. The legs of a young man she painted struck her as resembling zucchini squash; she painted them that way. Another woman was given a very long chin. Yet when Neel saw her sometime later she realized she had made a mistake; the woman's chin was really much shorter than she had painted it. The distortion, however, was valid, she felt, because when the woman talked, that's the impression she gave.

Neel begins a painting with any feature that interests her the most. "I might start with a mouth and work from there." And she asks her subjects to pose until she feels she has caught the essence of them—which means the essence of the entire figure, not just the face. When one sitter told her, for instance, that he would leave her his sweater to work from because she wouldn't need him for the body, she objected: "I need all of you."

The choice of colors and the determination of composition stem from her perception of the subject. To illustrate this point she uses the painting of Timothy Collins as an example. Collins is a brash, young Wall Street operator from the West. Some people may consider him a slick wheeler-dealer, but Neel sees him another way. "He looks like a warrior to me; he has a hero's face and reminds me of Verrocchio's equestrian statue near Venice. So when I started to paint him, I wanted to emphasize his strength. To do this, I used a very large canvas and posed him in a chair that reinforced the idea of strength. At first he sat in a homey old armchair of mine, but I realized that a hard, plastic chair suited him much better. The colors were picked to highlight two almost contradictory characteristics of his. The vivid orange background accentuates his dynamic quality, while the gray around his head represents the seriousness and sensitivity he also possesses."

Over the years Neel has become bolder in her use of color and in the dimensions of her paintings. At one time she stretched all of her own canvases; now they are too big for her to do so. And as she enlarged the scope of her work, the placement of the figures surrounded by wide open spaces has become more and more important to the esthetic development of her painting. In fact, positioning a figure in space is one of the most pleasurable aspects of painting for her, since, like all good painters, she is interested in the abstract quality of her designs. "If, for example, you were to turn the painting of my granddaughter Olivia upside down, you would be much more aware of the abstract composition of it."

Neel's family—her two sons, their wives and children—are among her favorite subjects. In particular, Nancy, Neel's daughter-in-law, and Olivia, Nancy's daughter, appear in many paintings, allowing the painter to indulge in one of her favorite themes: mother and child. Today this theme is under heavy attack from feminist artists as a stereotype image of women's art. Neel, also an ardent feminist, disagrees; she feels motherhood is part of the feminine experience, and a valid one to paint. So she continues to pose mothers with children—typical of her rebellious unwillingness to conform to the going philosophy.

This rebelliousness has been the hallmark of her career. Early in life, Neel decided to "paint a human comedy, such as Balzac had done in literature. In the 1930s I painted the 'Beat' of those days: Joe Gould, Sam Putnam, Kenneth Fearing, etc. I painted the neurotic, the mad, and the miserable. Also I painted the others, including some 'squares.' Like Chichikov (in Gogol's *Dead Souls*), I am a collector of souls." But while she was painting her magnificently realistic portraits, all the world was celebrating abstract art. Her art was not only unsellable to the trendsetters of the art audience, but inconceivable to them as well.

And yet, she wasn't completely unknown. As far back as the WPA, Neel was recognized by her peers. Joseph Solman, writing in *The New Deal Art Projects: An Anthology of Memoirs* (Edited by Francis V. O'Connor, Smithsonian Institution Press, Washington, D.C., 1972), describes her work at that time as "curiously original." But not until the early 1960s did she exhibit with any regularity, and as late as 1968 Solman could still say of her: "She is a loner, un-

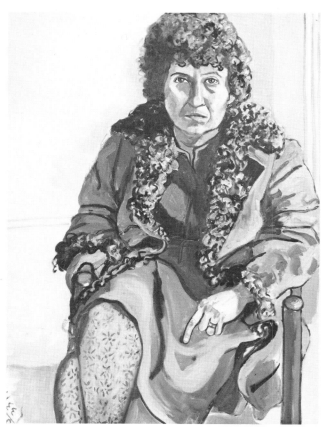

Dorothy Pearlstein, oil, 40 x 30. Neel enjoys developing details. Here the hair, fur, and stockings are set off by a simple background.

Joker's Friend, 1968, ink on watercolor paper, 30 x 22. Neel's drawing is broken into bold, uncomplicated shapes.

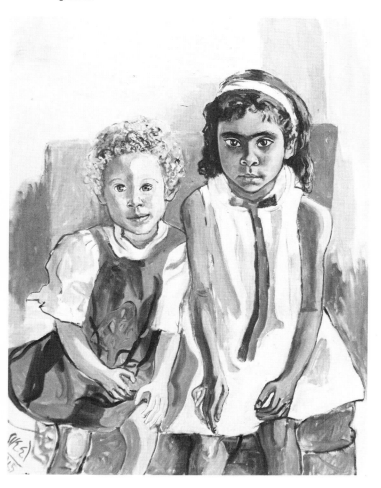

Above: *Mother and Child,* 1967, oil, 42 x 34. A favorite Neel theme. Here is the artist's granddaughter Olivia at three months. Note the anxiety in her mother's eyes; this is her first child.

Left: *James Farmer's Children,* 1965, oil, 35 x 28. Courtesy Mr. and Mrs. James Farmer. By subtle gesture and facial nuances the artist captures the distinct personality of each child.

classifiable, and therefore receives no popular publicity, such as some fourth-rate followers of the hard-edge school obtain."

Such freedom, of course, doesn't come cheap. She has done without many things, and lived, for instance, in an inexpensive apartment in Spanish Harlem (a neighborhood she enjoyed immensely) for many years until she moved to another unfashionable address. But the price for going against the tide has in no way diminished either her or her painting.

Now she's "making it" at last. The Whitney Museum of American Art and the Museum of Modern Art are just two of the many museums who own her work. (The Whitney held a one-woman show for her in 1974.) Among the awards she has recently won are the Childe Hassam Award, the National Endowment Award, the Benjamin Altman Award, the American Academy of Arts and Letters Award, and a degree as Honorary Doctor of Fine Arts at Moore College. And many prestigious groups throughout the country ask her to speak and serve on juries.

Alice Neel *is* in the prime of her life. She has captured the respect of an audience who once couldn't see farther than the latest drip, spatter, or Campbell's soup can; she's providing an exciting model for young women artists; and she's more productive than ever. But the first image of her I described is true too, only its depressing aspects were illusionary. For, as Alice Neel says, "Painting in a room by yourself can be the most exciting adventure you can have."

PHILIP PEARLSTEIN

BY JILL SUSSER

AMONG THE AVANT-GARDE, things change quickly. Long regarded as the territory of the old line artists, "realism" has been discovered by a number of well-known painters who have seceded from highly publicized movements like Action Painting, Abstract Expressionism, and Hard-Edge Abstraction. These artists are attempting to find a new and fresh way to observe and interpret what the eye sees. In spite of the fact that these artists are totally independent of one another in attitude and style, critics have named the group New Realists because of certain common features: an urge to look at nature with a cool-headed objectivity, recording (in sharply focused realism) what is seen with a clarity and intensity that avoids "impressing" the viewer with virtuoso brushwork or technical tricks, thus allowing the subject to speak for itself.

The most outstanding, influential, and controversial figure considered to be part of this group is Philip Pearlstein, who has received worldwide recognition for his mastery of the figure. Pearlstein has defied the standards set by Abstract Expressionism, the dominant avant-garde art movement of the 1950s, which dictates that one must express "self" in a work of art through the manipulation of line and color. The function of a work of such art was to express feelings. Until the early 1960s, Pearlstein was considered an Abstract Expressionist: His drawings of landscapes and Roman ruins were transferred to the canvas, then abstracted with harsh colors and violent brushstrokes.

In 1962 Pearlstein became dissatisfied with the limitations of Abstract Expressionism; he rejected the idea that the artist must use his work as a vehicle for venting emotion. Instead, he attempted the opposite: to remove "self" from the process of painting altogether and to concentrate on technical problems. In doing so, he reintroduced realism to the public eye in an entirely new form.

Pearlstein paints the figure exactly as he sees it. That the figure is human does not influence the manner with which he conceives it on the canvas. To Pearlstein, the figure is simply a complex still life object, a fact of nature that presents itself in a variety of ways. Pearlstein selected the figure because it presented infinite possibilities of spatial and mass complications. He cares neither about ennobling nor degrading the figure. That the model appears bored and glum in his painting is evidence of his disinterest in making human beings appealing subjects. As Pearlstein says, "Of course they look bored; they would rather be doing something else."

The models are often depicted with shoulders slumped over, stomach protruding, one leg clumsily positioned in front of the other. He explains, "This is the way the figure moves in reality. The body is not always beautiful or even attractive, so I paint it that way."

In taking such a literal approach to art, Pearlstein shocked the art world and challenged the value systems of his time. He became the subject of much controversy and attack. While some critics hailed him as the best of America's realists, others dismissed him as an anachronism, accusing him of using academic subject matter. He was labeled as a heretic, a reactionary painter using the nude in a sacrilegious manner. He was considered radical by others, critics who felt his work was too blatant, too shocking.

More than a decade has passed since Pearlstein first presented his nude still-life paintings, and in that time he has achieved world-wide recognition, becoming one of the most influential and widely imitated painters today.

Just why Pearlstein changed his painting from an uncontrolled emotional thrust of energy to a totally disciplined, pragmatic approach is a difficult question to answer. Pearlstein feels that there is really no single force in his life that caused this change of direction. He has often said, "Realism is not something I chose, but something I found myself in." Pearlstein sees his development as a painter as a product of natural maturation, a product of intellectual growth.

In trying to recall some of the most meaningful experiences contributing to his growth, Pearlstein mentioned his role as a teacher, which he feels has helped him clarify his thinking. Writing about art also functions to provide him with a more clearly defined rationale for painting.

As he examined his thoughts about art, Pearlstein

Two Seated Nudes with Yellow and Blue Drapes, 1970, oil, 72 x 60. Photo Eric Pollitzer. Courtesy Allan Frumkin Gallery. All details receive equal attention: joints, fingernails, facial features, drapery, and patterns of light and shadow.

Two Seated Models, 1968, oil, 60 x 48. Courtesy Allan Frumkin Gallery. Pearlstein is not governed by traditional rules of composition, although the figures are crowded to one side, the artist has left space at the right side of the canvas.

Two Female Models Sitting on Blue Homespun Quilt Coverlet, 1971, oil, 48 x 60. Collection Dr. and Mrs. Jerome Smith. Courtesy Allan Frumkin Gallery. The artist paints the model in the mood as he finds it: if the model is bored, she is depicted that way.

Female Model in Red Robe on Wrought Iron Bench, 1972, oil, 60 x 72. Courtesy Allan Frumkin Gallery. Refusing to succumb to the limitations of the picture format, Pearlstein crops the figure in whatever way he chooses.

discovered that Abstract Expressionism seemed contrived to him. According to this view, all Abstract Expressionists were expressing the same kind of anguish, the same kind of emotion. Pearlstein now calls Abstract Expressionism "a repertoire of marks and drips." He found his realistic drawings more interesting than his painting; he preferred the precision, control, and individuality evident in his drawings.

Pearlstein feels that he had gone about as far as he could with Abstract Expressionism, and he tired of trying to create something definite with elements which could not be controlled. From these frustrations he concluded that it would be more satisfying to work with those elements which could be controlled, focusing on problems of technique. "Maybe I changed because of belligerence," he chuckled. "It's always more fun to go against the stream."

He joined a group of artists who hired a model weekly to work directly from life. Before that, Pearlstein has based all his paintings on realistic drawings of rocks in Maine and Roman ruins in Italy, which he then abstracted on canvas. When he first started to work from the model, Pearlstein conceived his paintings the same way he had his rocks and ruins. This new work from the model "was like learning to write with my left hand." His work transformed from an expressionistic technique to a realistic one as he learned to "see" in a totally new way.

Pearlstein begins his paintings with a huge sketch, an exploratory drawing done in paint with loosely filled-in color areas. The model falls into a new pose as he works, and Pearlstein changes the drawing. Once the final pose is determined, he marks the floor and drapery with tape so that the model can return to the same position after rest breaks.

Pearlstein develops a sketchy but complete painting during the first few sessions, filling the entire surface of the canvas. To determine accurate sizes of areas and colors he depends on visual relationships. For example, he holds up his brush before his eye to see the proportion of the size of an area to the size of the brush and then determines the size of another area by holding up the brush and measuring it against the first one. Color is determined by a similar process of comparing degrees of darkness and lightness, intensity and dullness. He says by doing this comparison carefully, he achieves a semblance of nature.

After the entire composition is blocked in, Pearlstein goes over individual parts, building up volume and details. As he studies a particular area of the model for long periods of time, he eventually finds that this area fills his entire vision, his whole consciousness—an intense, almost hypnotic process. This is the most time-consuming stage of his work. "It's like Zen," he says. "You become the form."

Pearlstein then unifies the painting, going over the entire canvas about three times. Each painting takes about 12 to 15 three-hour sessions with the model. No portions of the composition, not even the details on a rug, are attempted without the model present, as

Pearlstein feels the play of light and shadow change with the slightest variation in the setup.

Pearlstein likes to use disposable paper palettes because he can keep the surface clean easily, and he uses lots of paper towels to smooth out colors and remove excess paint from the canvas. He paints with hard bristle brushes, but admits that he uses his fingers "maybe almost a third as much." To clean his brushes he uses a special brush cleaning solvent rather than turpentine because he feels that it does a better job. Also, "Soap and water ruins brushes," he says. "It takes the life out of them."

For a paint vehicle, Pearlstein mixes one-quarter damar varnish, one-quarter linseed oil, and one-half turpentine. This mixture holds up well as a painting medium, so he does not experiment with other, more complex ones.

Skin tones in Pearlstein's work are obtained primarily with earth colors; he uses Naples yellow, raw umber, raw sienna, Mars yellow, Mars black, titanium and zinc white, cadmium red light, and cadmium red deep. "The other colors that I use on my palette are determined by the environment—the colored draperies, and so forth."

Pearlstein has made some definite stylistic choices that remain constant throughout his work. For example, by setting himself as close as four or five feet from the model, he heightens his perceptual awareness and focuses more sharply on details. Foreshortening is more exaggerated, and there are dramatic distortions created by the distance between forms, which explains why Pearlstein is often called a spatial illusionist. When the hand of the model is closer to Pearlstein than any other part of the body, and is therefore larger than the face, for example, Pearlstein paints it exactly that way. As an illusionist, he re-creates proportions as he sees them, regardless of the resultant effect.

Pearlstein has also chosen to paint the model nearly twice life-size. He is not interested in any shock value created by the large format, despite that some viewers interpret that the artist intended to elicit a certain startled reaction. Rather, Pearlstein seeks to record all details, a totally scrutinizing presentation of the figure as it really looks. In order to allow himself the space to accomplish this, he prefers a larger working surface. Each detail is given equal importance; the head is as important as a small scar. Details are enhanced visually by artificial lighting: three severe electric lamps hang from the ceiling just above the area where the model poses. Pearlstein prevents all other light from interfering with his setup; windows in the studio are boarded up so that conditions remain constant with every pose. Additional volume results from the light and shadow cast by these strong light sources, and every area of the figure demands equal attention. Unlike artists who use a single focal point in their painting, emphasizing one area and softening another, Pearlstein presents the viewer with an overwhelming amount of information to take in at a first glance.

Two Female Models on Apache Rug, 1971, oil, 60 x 72. Photo Eric Pollitzer. Courtesy Allan Frumkin Gallery. By painting very close to his models, the artist obtains exaggerated effects of foreshortening.

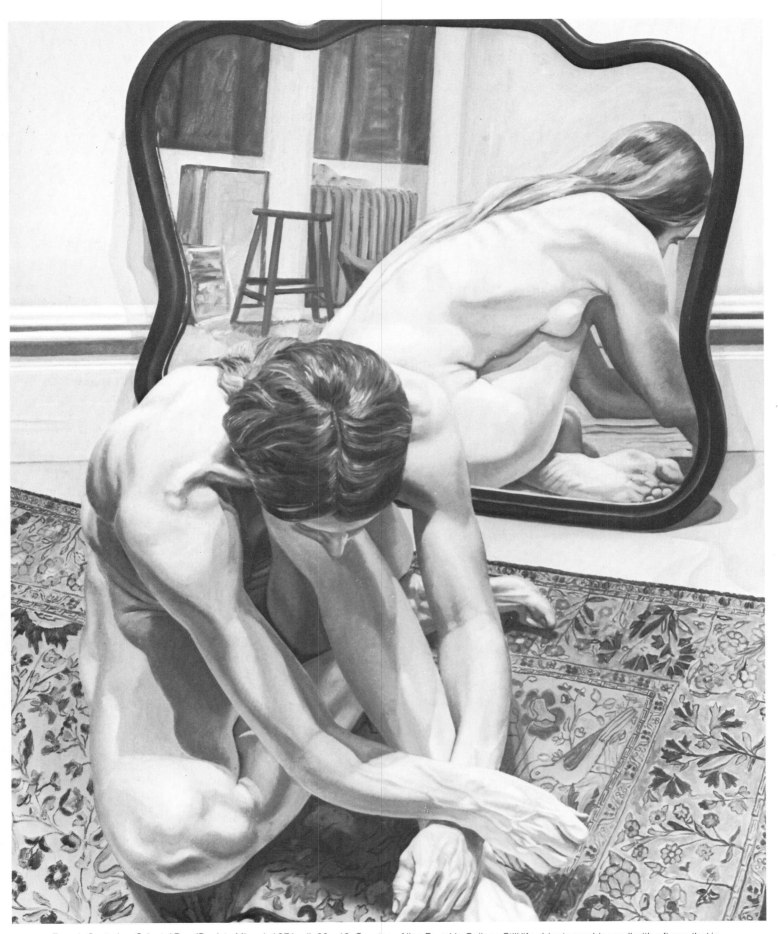

Female Seated on Oriental Rug (Back to Mirror), 1971, oil, 60 x 48. Courtesy Allan Frumkin Gallery. Still life objects combine well with a figure that is depicted very much as an object of still life itself.

Pearlstein's sense of composition is also innovative. He occasionally poses his models so that one almost masks the other. They may stand vertically within an almost square canvas, leaving a great deal of space on one side of the painting. Pearlstein explains that his choice of pose frequently results from noticing the way the model has casually placed himself or herself between poses. He refuses to succumb to the demands imposed by the subject or by the picture format. Further evidence of this fact is the seemingly indiscriminate cropping of the figure's limbs. As can be seen from the paintings reproduced here, it is not unusual for his paintings to depict a figure with an arm and the head cut by the edge of the canvas.

These elements of Pearlstein's painting are best understood if they are examined in terms of his rationale for painting. That all details are equal in importance is justified by his basic premise that his paintings are not about human values, but about visual ones. That the model is sometimes shown with parts of the body blocked by another model or cut off by the extremity of the canvas is additional proof that Pearlstein uses the figure as he would use a bowl of apples or a pot of flowers: The figure is simply a still life object.

Contrary to the impression one might have of a painter who has ruled out "self" as an element in his work, Pearlstein is warm, down-to-earth, intense. When he paints, he has a look of one who truly loves what he is doing. He is a believer in self; he feels that one's individuality inevitably comes through in the creative act. But, in spite of this, he feels that an artist will create better paintings if he explores technical aspects of the painting that he can control, instead of those elements that are intangible.

Pearlstein's works have been reviewed in almost every major publication, and his paintings have been reproduced in several national magazines. He has had numerous one-man shows at The Allan Frumkin Gallery in New York City and has been exhibited at the Whitney Museum of American Art, the Georgia Museum of Art (which held a major retrospective of his work), The Vassar College Art Gallery, Tanager Gallery, Wichita Art Museum in Kansas, the Thelen Gallery in Cologne, Germany, and in West Berlin.

Success, for Pearlstein, is not new. It began at an early age. When he was in high school, Pearlstein won a national art competition sponsored by *Scholastic* magazine, an award granted by the noted American painter Reginald Marsh, who acted as juror for the competition. This award resulted in two full-color reproductions in *Life*.

Born and raised in Pittsburgh, Pearlstein studied there at Carnegie Institute of Technology, then moved to New York to attend the Institute of Fine Arts at New York University, where he received his master's degree in 1955. At night Pearlstein went to school, and during the day he worked as a commercial artist. During this period he began to achieve recognition for his paintings. He appeared regularly in group shows and had his first one-man show in 1955. This period also marked the beginning of the publication of a series of articles written by Pearlstein on his theories about art.

In 1958 Pearlstein was awarded a Fulbright grant to study in Italy and a grant from the National Endowment on the Arts Fund, and in the early 1970s he was honored with a Guggenheim fellowship.

CORNELIS RUHTENBERG

BY DIANE COCHRANE

IN 12TH-CENTURY CHINA, during the golden age of the Sung dynasty, painters celebrated nature in their landscapes. Guided by the principles of Zen Buddhism, they diminished man to a separate but equal status with all other living things in the universe.

In 20th-century Iowa, which has neither known a golden age nor produced a uniform style, a Latvian-born painter named Cornelis Ruhtenberg paints mostly people. Her spiritual heritage is German Expressionism, with its emphasis on humanity and spirituality.

Line was all important to the Chinese artists. With economy and accuracy of brush strokes, they evoked a mood by interweaving the rhythms of graceful curves and forceful angles.

Rhythm transfigures Ruhtenberg's paintings too, but her compositions are structured by tonal values. Masses of pale tones are juxtaposed with dramatic dark shapes to orchestrate a mysterious tonal music.

What's the connection, then, between this American and the Orientals? What do they have in common? Ruhtenberg would be the first to agree that, on the surface, there is no more similarity between her work and that of the Chinese than there is between a Mahler symphony and a Bach fugue. On another level, however, the intent behind the paintings is the same. Pointing to a delicate Chinese painting on her wall, she says she would like to duplicate the landscapist's ability to express the quintessense of a subject in such a seemingly simple way that it is difficult to see how it was done.

Ruhtenberg's desire is an accomplished fact. While the Chinese delighted in distilling the rhythms and meaning of nature from their intimate knowledge and realistic observation of the landscape, Ruhtenberg does the same sort of thing with figures. No effort is made to copy or duplicate a person's features; instead, she concentrates on discovering what Betty Chamberlain described in a review of Ruhtenberg's work as the "oriental essence" of a subject. So she studies and draws the same people over and over again until she "knows" them.

"Knowing a subject" does not depend on the articulation of psychological insights. Indeed, Ruhten-berg rejects the analytical in favor of the intuitive in order to arrive at a simple but definitive statement of people as they are: an old man dignified yet stunned by sickness; a man recaning a chair caught up in the threads of his work; a trio of musicians so intent on their performance, they are transformed into a paradigm of musical forms. (Ruhtenberg is repeatedly drawn to the last theme, for it combines her own love of music—she is an accomplished flutist—with painting.) In all cases a mood or feeling is evoked that the viewer can readily identify because Ruhtenberg has caught the essence of the scene.

Once in a while she misses the mark, or so she says. This happens when she tries to paint a portrait. To illustrate her point, she recalls a child who had helped unload some of her paintings from a truck. After seeing a painting of her son, the child asked to be painted too. She agreed, and he visited her five days while she made many drawings. ("Not enough sessions for my way of working.") At the time, Ruhtenberg felt that his family would appreciate a good likeness better than an expressionistic study. Now, although the finished portrait looks like the child, it does not please her: "It has no magic." But her efforts weren't wasted. Freed from the restrictions of a realistic portrait, she will now turn the drawings into paintings that will express the subject better.

All of Ruhtenberg's subjects are real people, but she does not pose them. She might, for example, be inspired by musicians at a concert or boys riding their bicycles down the street. One of her best models was a little boy who used to drop by her house in the afternoon for peanut butter and crackers. She drew while he, totally unself-conscious, amused himself.

Another favorite subject is her husband, the painter Jules Kirschenbaum. Years ago they drew each other for one hour a day as a disciplined exercise. "It was great practice; we should still do it," she comments. Now she no longer strives to duplicate reality, as she did in the life studies; instead she paints in order to capture the quintessence of her subject.

Take the *Portrait of a Man*. Great liberties have been taken with the perspective, and the darkened

Boy with Gyroscope, 1972, acrylic on canvas, 30 x 24. Photos courtesy Forum Gallery. Note the relationship of shapes and tonal values that separate the figure from the background.

Portrait of a Man, 1968, acrylic, 48 x 33½. Courtesy Forum Gallery. By darkening the figure's face, Ruhtenberg distracts the viewer's eye from an interest in likeness and focuses it on the movement of light and dark.

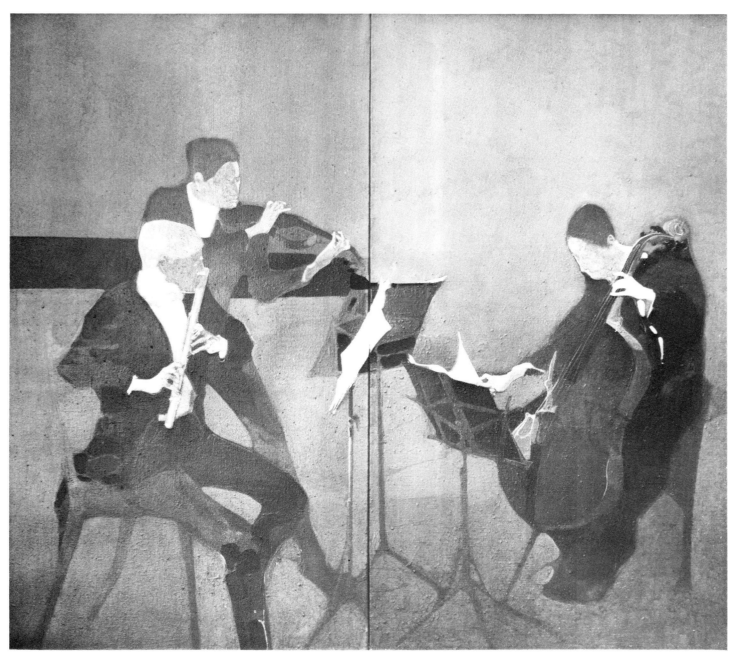

Concert II Trio, 1968, oil, 48 x 52. Courtesy Forum Gallery. Ruhtenberg uses two panels of equal size framed together to heighten the illusion of separate but harmoniously related parts.

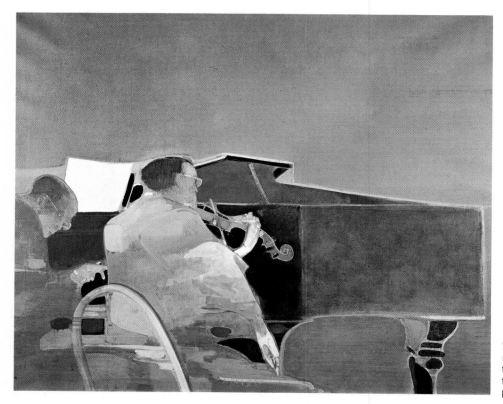

Violinist, ca. 1971, acrylic, 40 x 48. Courtesy Forum Gallery. Ruhtenberg transforms the performers into ''a paradigm of music.'' By laying tonal glazes over dark or light, the surface of the painting seems to vibrate.

Father and Son Building a Model, 1972, acrylic, 42 x 38. Courtesy Forum Gallery. The artist juxtaposes masses of pale tones with dramatic color shapes.

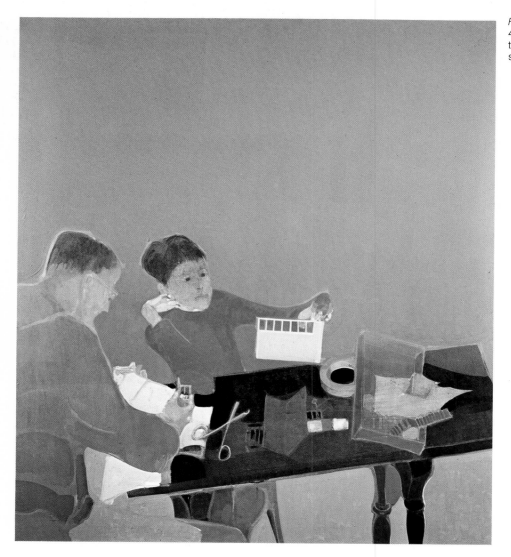

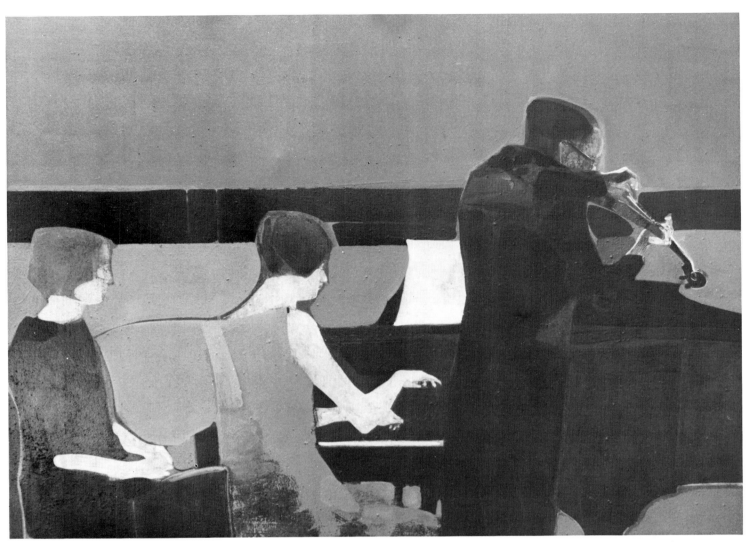

Violinist, 1969, 40 x 48. Private collection. Photo courtesy Forum Gallery. Details of likeness are subordinated to the fluid relationship between shapes.

face is nearly lost in the picture. The emphasis is on the movement of light and darkness; light carries the eye from the dogwood blossom to the hands and in and out of the face. By distracting the viewer's eye from the face, the experience of seeing in a new connection is gained, and this connection is the essence of the painting.

Recently Ruhtenberg set herself an even more difficult task than capturing the quintessence of people. She has been drawing and painting baskets. Baskets, the painter feels, are mysterious and possess an inner strength. "They are a beautiful symbol for something held together yet, at the same time, trying to break out." A whole year was spent learning to express this quality. "Just to make a basket is dull. If you paint a figure, the face alone adds some interest, but a basket has nothing unless you can articulate the inherent opposing tensions." Then it has life and meaning.

The ancient Chinese gave life to their landscapes through the graceful curves of their meticulous brushstrokes. Ruhtenberg seeks to animate her objects in a similar way. "I work on each shape—say the curves of a teacup or a musical instrument—until it comes alive. Sometimes I go too far or not far enough.

I don't want to sound as if it's a miracle when I make an object seem just right, but frequently when I am looking for a particular quality—and even if I have done it—I may not see it."

It's hard for others to recognize this quality or lack of it, too. John Canaday, one of *The New York Times* art critics, for example, praised a particular painting of hers at a show not long ago. She was more critical; she felt some of the shapes were a little tired.

Ruhtenberg's paintings can be described as serenely dynamic. Under a calm surface they surge with life. There is constant movement of subtle light and dark areas. Creating this effect is an obsession with her. Here's how she works at it: Light and dark masses are placed on canvas. These areas are then muted by glazes. For example, a yellow glaze is laid over black-and-white areas. "The original colors come close together but at the same time are strangely removed." If the glazing is not done right, the painting looks like linoleum or oil cloth, according to the painter. The danger is in making things disappear without the paint becoming murky. But if it does work, the surface is transfigured and comes alive. The dark and light areas move like molecules

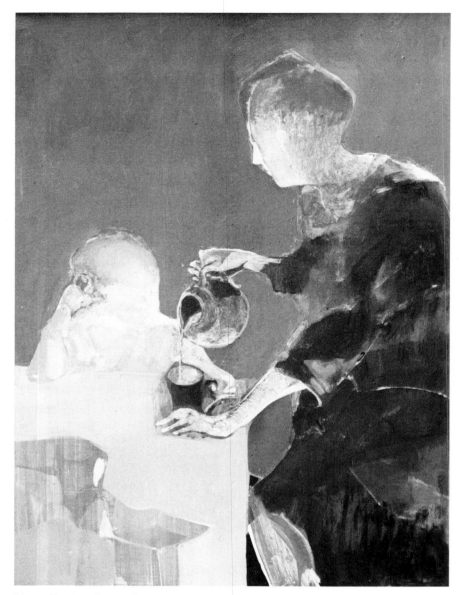

Woman Pouring Milk for a Child, 1969, acrylic, 32 x24. Courtesy Forum Gallery. The artist's loose treatment of the figures contrasts with the more detailed rendering of the pitcher and glass.

trying to push away the exquisite skin-like quality of the glazes. Yet you can't see how the painting is done—it all looks so simple.

This process of transfiguration is extraordinarily time-consuming. She applies glazes many times until she gets the effect she wants, but what may be beautiful in one section may be all wrong in another. "I paint and repaint. Sometimes I may find the face is all right, but I lose the rest of the figure, and so I start over." When she first started painting, she used tempera and slow-drying oil glazes. Then she switched to egg tempera, but this was not a solution, either. She had to scrape out glazes that didn't please her. Finally, she tried acrylics and found they suited her perfectly; no more scraping or waiting for the glazes to dry.

And she became a master of her medium. Says an admirer of her work, "She shows what can really be done with acrylics. She doesn't just slap on paint right out of the tube; she may work as many as five tones into a face. Her sense of tonality and her expression of it through acrylics is amazing." Unfortunately, the subtle tonal qualities are almost totally lost in black-and-white reproduction. Even color reproductions do not give a good indication of how her paintings really appear.

Ruhtenberg is a soft-spoken woman filled with enormous suppressed energy, which she releases in her passion for painting. After immigrating to the United States while still in her 20s, in 1948, she achieved almost instant success with a one-woman show held in New York a year later. Early success didn't spoil Ruhtenberg, however, or dilute her enthusiasm for work. Nearly every day has been devoted to painting, no matter where she has lived: New York, Italy, or a farm in the rolling countryside outside Scranton, Pennsylvania. Life on the farm proved an ideal location for pure concentration; with no distractions such as telephones, television, or radio, she and her husband gave themselves over completely to painting. The birth of a son changed the routine somewhat. It was also changed when Kirschenbaum took a teaching job at Drake University in Des Moines, Iowa, where they have lived for several years—with the exception of trips, sabbaticals, and summers in Pennsylvania. But still the days of hard work continue.

Des Moines is a far cry from New York, and certainly out of the mainstream of American art. Does living so far from the art capitals of the world present any problems? Does she miss being with other artists, or find it difficult to be so far from her market?

For Ruhtenberg, life in Iowa is pretty much the same as it would be anywhere else, since her work has always taken precedence over exchanging ideas and socializing with other painters. And if Des Moines isn't a hub of artistic activity, she is fortunate to be married to a painter, and a painter whose style is completely different from hers. Kirschenbaum's work tends toward Surrealism and Magic Realism, so stimulating conversation about art is never lacking.

Being over 1,000 miles from her dealer is no problem either. Before moving to Des Moines, Ruhtenberg went with the Forum Gallery in New York, and just about every three years she has a one-woman show there. She has also exhibited at The Metropolitan Museum of Art, Museum of Modern Art, National Academy, National Institute of Arts and Letters, Corcoran Gallery, Chicago Art Institute, Pennsylvania Academy of Fine Arts, and Springfield Museum.

Although she does not feel isolated from the mainstream of art, she feels her work may suffer from a lack of identity: "Because my paintings don't resemble anyone else's, critics don't quite know what to do with them." People can't fit them easily into a niche in the framework of modern art. But why bother? It seems to me they could be comprehended in the same way Berthold Laufer explained Chinese art (A Landscape of Wang Wei, Ostasiatische Zeitschrift, 1912, p.54): "We shall better appreciate Chinese painting if we try to conceive it . . . as being akin to our music. Indeed, the psychological difference of Chinese painting from our own mainly rests on the basis that the Chinese handle painting, not as we handle painting, but as we handle music, for the purpose of lending color to and evoking the whole range of sentiments and emotions of humanity."

If you were to substitute the name of this painter from Iowa in place of the references to Chinese painting, you would have a description of the tonal music of Cornelis Ruhtenberg. Her music succeeds in capturing the vital essence of the most commonplace object, whether it be a basket or a flower, to give it a more profound meaning. For as Ruhtenberg says, "You can look at a flower and see a decoration or a little bit of color, or you can look at a flower and see the whole world."

MARGERY RYERSON

BY CHARLES MOVALLI

JUST A FEW BLOCKS from the National Arts Club in New York City, a church—looking like a refugee from an English parish—is surrounded by blackened warehouses. Signs bristle everywhere. Trucks are parked against the curb, and men puff behind heavy carts while others sit on a stoop and joke. Meanwhile, the trees are still bare in nearby Gramercy Park.

Across from the Park, the Players Club, home to theatrical people, and the National Arts Club huddle side by side, comforting each other as New York continues its endless changes. The Players Club is dramatic. Red and plush, it's filled with portraits, theatrical memorabilia, talk, and the click-click-click of billiard ball against billiard ball. The National Arts Club is quieter. Corners are mysterious and deep. Here and there a head sticks above the top of an over-stuffed chair. Huge framed paintings look as if they've been hanging on the walls forever. And all the rooms have a unique resonance. The corners are murky; the gold frames have lost some of their luster—but it's clear that art is still in residence.

Art is particularly at home on the building's fourth floor. That's where Margery Ryerson has her studio. Paintings are piled all around the room, against the walls, against the chairs, and against the fireplace. The mantelpiece holds bits of sculpture by Ryerson's mother: a copy of Rodin's head of Balzac, a small design for a fountain, a nude figure crouching. On the back wall is a bright, luminous watercolor by Charles Hawthorne. "That's a fine painting," she says, briskly and authoritatively. She knows what she likes. And there aren't many who'll argue with her. After all, she's not only a respected artist, but was also the prime mover in the creation of two of America's most famous and ageless art books: *The Art Spirit* (by Robert Henri, published by Lippincott) and *Hawthorne on Painting* (published by Dover).

Ryerson leans against a tall, white stool, her hands folded. "Write about me," she says, "but don't make me into a character." She looks down at the floor. "I've never cut off an ear. I'm not Grandma Moses. And I'm not a curiosity—just a painter." She laughs a laugh that's a public act, asking you to join in. "Let's talk about what counts: let's talk about art!"

There's artwork everywhere. You can't sit without having to move something from one pile to another: portraits, landscapes, oils, watercolors, etchings. She apologizes for the lack of space. "I like to live simply," she says. "That's the best way for an artist. Learn to economize, and you'll be able to do the kind of work you want to do. Live grandly, and you'll have to spend most of your time trying to support yourself. I've always thought it best to concentrate your abilities on a few good things, to do work that's worthwhile and create a reputation that means something. Do you know what I mean?" The question is partly rhetorical—an accent for a point she is anxious to make. "You'll find that most real artists don't think about money. They *talk* about it a lot—but that's because they never have any! Their real joy is in the work itself. And in art, fortunately, there isn't any 'idle class.'"

She points to a small etching on the wall, a child drawn with a few carefully-placed lines. "I had to make a living when I started out," she says. "No one was doing children. So, before I knew it, I was in the thick of the etching game, writing about etchers, selling my own—living off them in the days when my oils couldn't get in any of the exhibitions." She shrugs her shoulders. "There's nothing wrong with being practical. From the etchings, it was an easy step into children's portraits in oil."

She pauses, but only for a second. Her voice is firm and clear, partly an inheritance from her father, a lawyer who taught elocution. But it's not a theatrical voice. Her diction is sharpened by horse sense and a no-frills terseness. "I don't like 'sentimental' pictures of children," she continues. "When you've taught school, as I have, you know what children are like. You don't have any illusions about them." There's another pause for emphasis. "But they're unsophisticated and lively, and you can paint them without ending up with something that looks posed. You know what I mean: the kind of picture that says, 'This is a portrait.' You just have to learn to paint children on the move; and that's something they don't teach you in art school." She nods her head; "Of course, you could get professional models, but I don't like

Portuguese Child, oil on canvas over board, 24 x 22. Says Ryerson, "I begin a painting with four spots of color: the hair, the background, and the face—two for the face: one for the light, and one for the shadow. The flesh is what the painting is all about, and then comes whatever looks good against it."

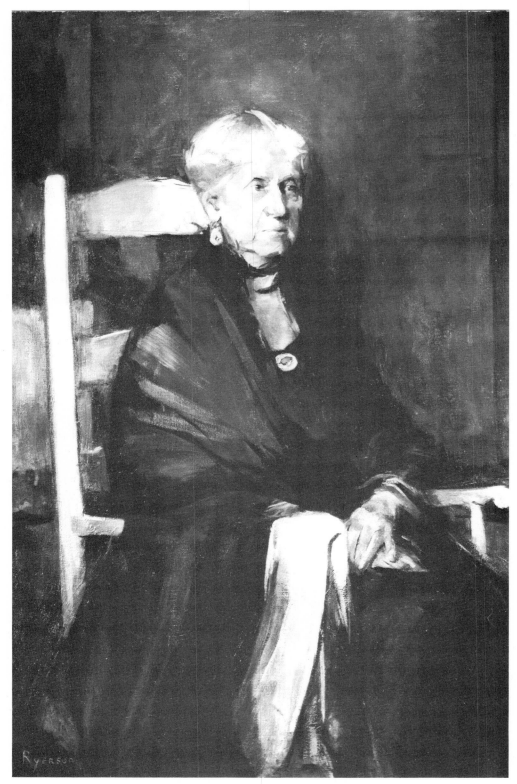

My Aunt, oil on canvas, 50 x 30. ''When you paint a member of your family, every little while it resembles other members of the family until it finally looks like the person you're painting.'' Ryerson saw her father and grandmother in the face of her aunt.

them. That's all they are: models. I'd go to settlement houses, nurseries, music and dance classes and paint the children as they were. Many of my former classmates at Vassar would also lend me children. Young, artistic, and intelligent couples, their children would always be interesting to paint. And I wouldn't have to worry about getting a likeness. I'm not especially interested in getting likenesses," she says, firmly. "When that's the main concern, the work is usually pretty boring."

Ryerson rummages through a pile of magazines and pulls out a few of her articles on the art of painting children. She points to one piece, praises the quality of the color illustration—"they didn't use a black plate here"—and begins to talk about her procedures. "A painting of a child usually takes about three sittings, each a week apart. The first four of the first sitting is the best—that's when we're both fresh. The second sitting isn't as good. And the last sitting is almost always the worst. Parents come and entertain the child, since I can't paint and entertain too." She pauses again. "Personally, I don't like to get acquainted with the subject. If we become too friendly, we lose a formality that's helpful in keeping the child still. It's the same with older people. I don't want to live with them for a week. I just want to paint them." She thinks about this for a second. "I don't often paint the famous. They're a problem. The society painter always gets his clients a little too late. They're shot. They've been famous too long and want to be painted so they look famous. Ten or 20 years earlier, such people would have made interesting studies."

When asked specific questions about her methods, Ryerson becomes visibly uneasy. She doesn't like rules and doesn't want to give recipes about how to paint. She notes that one of her first instructors, Charles Hawthorne, was a great teacher, yet he ran his classes on an idea rather than a list of rules. "Everything depended on learning to see 'color notes' in nature," she says. "Hawthorne wanted us to recognize how one color and value was related to another without worrying so much about what each note represented. Don't see a barn; see a spot of red. For our first summer at his Provincetown class, he made us use a palette knife; all we could get were the big areas of color."

Ryerson puts on a blue apron as she talks and begins to move a few paintings aside. She pulls two "starts" from a corner—paintings that were never brought to a conventional state of completion. "I often like my beginnings better than my endings," she says as she looks at a colorful portrait and a long, thin landscape. "I've always liked these two; they're good examples of what Hawthorne was talking about. The subjects may be different, but the method is the same. They show that you don't need rules; you just need to use your eyes."

She props the landscape against the wall. A few simple bands of color run horizontally across the canvas. "I wanted to record how the notes came together: how the sky was related to the land and the land to the water." Looking carefully at the simple sketch, she's reminded of her student days: "I can remember taking a train around Cape Cod with some other students. We'd look out the window and get excited by the way the color of a tree came against the color of the sky. But we wouldn't have noticed the relationship if it hadn't been for Hawthorne's teaching. He suggested a way to see. Then we had to drill ourselves." She again looks at the floor, thinking. "A painter trains his eye just as a pianist trains his fingers. The more you practice, the more subtle the distinctions you can detect."

Ryerson looks at the landscape for a few seconds and then leans her portrait sketch against it. You can see a few preliminary paint lines. She prefers to "draw with the brush" and correct with turpentine. She doesn't use charcoal. "Once things are placed on the canvas," she notes, "you can begin to put down the main color spots. It isn't necessary to record every change in the planes of the head. Most people put too much in. Just think in terms of a few large areas. There's the hair in shadow and the hair in light; and the skin in shadow and the skin in light. Watch how these color notes come together, and you'll find that the features take care of themselves."

She again leans against her white stool: "If I'm after a likeness, I usually put the notes for the eyes down early and then use the dominant eye as a pole star. The eye is usually the stillest part of the face and is useful when you map the other features: how far is the chin from it, or the forehead, or the mouth?" She pauses. "I feel I'm on the right road when I begin to see the parents in the child's portrait—when it begins to look a little like the mother and a little like the father."

She thinks that photographs can be a help to the portrait painter, but the artist must learn to "use photography and not be used by it. Learn facts from the photograph," she suggests, "but paint from the model. I might take four or five photos of a subject and then study them when the sitting is over—they help me figure out where my likeness is off. Sometimes I also take a black-and-white photo of the painting. That way, the color doesn't distract me—I can actually see the picture better." She climbs onto the white stool. "My backgrounds are usually very simple. I don't like backgrounds that *mean* anything—doors, books, that sort of thing." She points to a figure study. "I wanted to accentuate the silhouette of the child's back, so I brought a large dark area behind it. That dark could be the trunk of a tree or a hanging cloth. It's there first to create the silhouette; I don't worry about what it is." Another portrait has a lightly-stained background. "A loose background like that one," she continues, "is always a nice contrast to a solidly-painted head. And its simplicity doesn't detract from the figure. Of course, some people might say that it doesn't look 'finished.' " She thinks about the word. "A picture is finished when there isn't anything more you want to do to it."

As she talks, her eyes rest for a second on the

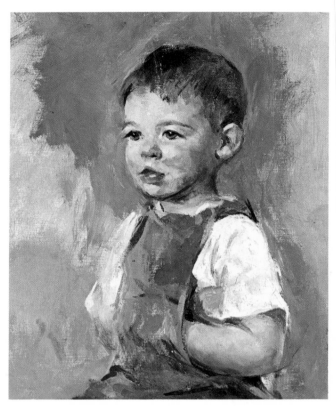

Steve, oil, 20 x 16. Collection Mr. and Mrs. William Mayer. Ryerson blocks in large masses with a palette knife.

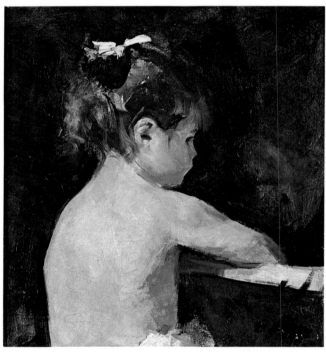

Back of Girl, oil, 21 x 18. Here Ryerson captures the likeness without recourse to the individual's features.

chipped corner of one of her frames. "What do you think of my frames?" she asks, suddenly. "I've met a lot of people who worry about them." She looks intently at the molding. "As long as the frame is related to the picture, I think it's all right. It doesn't have to be fancy." There's another pause—an intense one. "I've seen too many elegant frames—on terrible pictures!"

She laughs and moves her hands, till now resting in her lap. They hold copies of her Henri and Hawthorne books, and as she turns them in her hands, she thinks about how they came to be published. "I started the *Art Spirit* idea," she says, "because I'd always enjoyed things like Leonardo's *Notebookes* and William Morris Hunt's *Talks on Art* [reprinted by Dover as *Instructions to Art Students*]. I should have his ideas down on paper. Fortunately, Mr. Henri was alive when we did *The Art Spirit,* so I could always check wordings and organization with him." It's obvious that this wasn't an easy job. "I didn't dare add any words of my own. And his ideas about the organization of the book were fairly firm. I spent a lot of time arranging it by subject. But he didn't like that. I remade it in its present, looser form. The free style is planned—and all the repeats in the text are there for a reason." She turns the book in her hands and wonders aloud if anyone reads it anymore. The question seems strange, and she's pleased to hear that the book is the closest thing many painters have to an esthetic Bible.

"I worked half a year with Mr. Henri," she continues, "pulling all his material together. We had notes, articles, and letters he'd written to his class. These letters were long and very useful. Remember," she explains, "that his class only saw him once a week at The Art Students League. He'd go from canvas to canvas without feeling that he had to give everyone a critique. 'I'm not a pill dispenser,' he used to say. He wouldn't talk to you if your palette was messy—or if he thought you were trying to imitate him." She breaks the narrative for a second. "A student shouldn't imitate his teacher," she says, her voice gaining an added strength. Then she resumes her story.

"When Mr. Henri couldn't make the class, he'd have someone distribute a mimeographed letter filled with his observations on art. There were lots and lots of these letters." She pulls a battered notebook from a nearby box. "Finally, there were my own notes." Leafing through the volume, she pulls a loose piece of paper from near the front cover. "This is interesting, it's the original list of titles that I read to him over the phone. He wanted to call the book *Comments on Art*—but neither Mrs. Henri nor I liked the idea. We asked him to choose something from this list." Penciled on the paper are names like *Art and Life, The Spirit of Art,* and *Life and Art.* "As soon as I read *The Art Spirit,* he said 'that's it!'" She smiles at this memory.

"You know," she adds, "that no publisher was interested in the book after it was written. I tried New

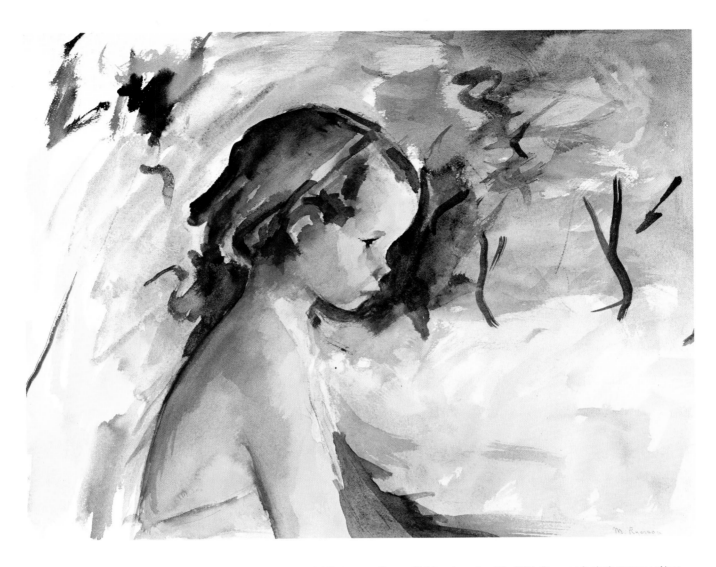

Above: *Child,* watercolor, 18 x 22½. Ryerson feels that many of her best watercolors come from reinterpreting oils of the same subject.

Left: *Kindergarten,* oil on pasteboard, 30 x 24. Ryerson was commissioned to paint the president of a college. Between class sessions, when he was too busy to pose, she would take herself to the nearby kindergarten and make sketches of the children.

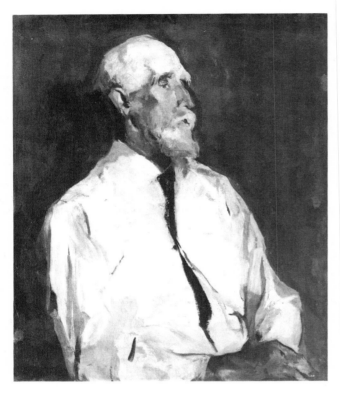

Captain Cook, oil, 34 x 30. This is an early painting Ryerson did in Hawthorne's class in Provincetown. Cook was a sea captain who used to pose for Hawthorne's students.

York firms for a year without success. One looked at it and said, 'Wouldn't it be nice if we could all publish our rough notes?' " An incredulous look quickly crosses her face. "A friend suggested that we put the book out in a special limited edition. Then when it sold out, the price would go up, up, up." She raises her hand to indicate the rising price. "But Mr. Henri wouldn't have anything to do with that. He wanted the poorest student to be able to buy it." There's no doubt that she believes in the rightness of Henri's position. "I finally went to Philadelphia in search of a publisher. And that's where I was lucky. The art editor at Lippincott was not only an amateur painter, he was a great admirer of Mr. Henri. He snapped it up. After that, the only problem was in getting the publishers to leave the text alone; they kept writing Mr. Henri and asking him if he *really* meant to say this or that. He'd go up in steam. 'They're our friends,' he'd say, 'but they don't understand art!' "

Thinking about the contents of the book, Ryerson suspects that Henri might change his mind today about one subject: the juried show. "When he was working," she explains, "the National Academy was the only show in town. It was too powerful—so he was naturally opposed to it and all other juried shows. But now things have gone too far the other way. Around New York, there must be a show every two weeks. And the juries are lax. The only place they're really tough are at the watercolor exhibits. When I was a student, watercolor was considered old women's knitting. Now the watercolorists put on the best shows in town!"

Ryerson points to a few of her watercolors, all built along what she calls Hawthorne's principles. Mentioning her teacher, she notes that the Hawthorne book was more complicated than the Henri volume; its subject had died a few years before she and his family began to collect material. "I had to edit notes sent from all over the country. I'd take part of a sentence from a Boston student and add it onto the end of a sentence from somebody in Philadelphia. If Mrs. Hawthorne and I had trouble, her son, Joseph, would always have the solution. He knew just what word would make the text sound like his father." To Ryerson, this is a real and rare talent.

Somewhat hesitantly, she says that "the only thing that bothered me about Hawthorne's class was the way he favored the men. I'd often get angry with him for that. The troublesome thing was that you sometimes thought he was right. The men usually went on to careers in art; the women hardly ever did. Yet they [the women] were often more talented! I can remember a dealer who helped promote a woman artist, giving her shows and all sorts of publicity. Just as she was catching on her husband got a job out West and she moved away from the city. She still sent the dealer work, but he didn't have the same opportunities he'd have had if she were still in town." She ponders this problem for a second. "There was a time when I was crazy to teach at one of the local art schools. But I couldn't get in because classes run by

women were never filled. The men didn't like studying with a woman. And many of the women found a male teacher more exciting. I once had an etching class prepared—but when the students discovered a woman was teaching it, they evaporated." She shrugs. "That's the way it is—though I think things are getting better."

Moving a picture, Ryerson is surprised by the amount of dust that rolls lazily into the room. She says she'll do some sweeping later in the day. In the meantime, the conversation slowly returns to her two principal teachers. "Hawthorne and Mr. Henri thought a lot alike," she continues. "Their main difference was one of character. Mr. Henri was a gentleman of the most perfect Southern manners. He had what he called a 'Southern brogue.' He was very tactful—and extremely eloquent. He was also a man of enthusiasm. He cared about social causes and, of course, he was deeply interested in the complicated Maratta color system." She looks as if she could never get involved in Maratta's elaborate mixes, even if they were championed by the Henri and Bellows circle.

"Hawthorne, on the other hand, was a real Yankee. He thought Mr. Henri talked over his students' heads. He was lean and plainspoken. He'd think a bit before a student's picture and then perhaps say only one sentence." She pauses and laughs, as if she could clearly hear Hawthorne's dry New England accent. "But that one sentence would solve every problem on the canvas!"

As Ryerson talks, it becomes apparent that there's a physical rightness to her two books. Henri's is thick and wordy—there's room for the teacher to expand, and the teacher takes advantage of it. Hawthorne's is thin, and the sentences are sharp and concise. She wanted to make the books match the men, and she succeeded.

"They were both alike," she insists, "in their refusal to make rules about painting. They never told you to paint a roof blue because the sky reflected down on it. They wanted you to train your eye and then look for yourself." She laughs softly. "A mother is proud of her baby and decides she'll buy a book and learn how to paint its picture. But it's not that easy. After all these years, I'm convinced that there just aren't any fancy rules to painting—at least none that are worth anything." She points to a portrait that leans against the doorjamb. A dark swatch of color moves irregularly behind a girl's light, pink face. "There's no rule for determining the shape of that dark mass," she says. "Don't ask me why I put this or that color in this or that place. It's all a matter of taste." She moves slightly on her stool. "And I've worked to see that my taste is fairly good."

She looks as if she wants to make the point more clearly. How, after all, do you get "good taste?" "If you're around good things," she adds, "you come to appreciate the best. I think part of talent is simply the ability to distinguish good from bad. I'm tone deaf—I can't tell one tune from another. But I'm lucky when it comes to art. My mother was present at the founding of The Art Students League, and I grew up in an artistic environment." She pauses, and the light from the studio window pours down on her, on her mother's sculptures, on the boxes full of art magazines, the piles of paintings, and the manila envelopes full of drawings and etchings. A black folder bulges with photos of her work. A heavy gold frame sticks up in a corner, and the edge of a huge landscape can be seen against a far wall. "Look at it this way," she concludes: "Art is contagious." She pauses and almost winks as she lets the well-honed phrase sum up a career—and a philosophy. Art is contagious —and Margery Ryerson has a sublime case of it.

JOHN HOWARD SANDEN

BY DOREEN MANGAN

"THE FIRST THING I plead with you to do is really do nothing. Just look at the model for a few minutes. Study him before painting. What we are after is our commentary on him."

The speaker is John Howard Sanden, portraitist; the place, Studio 15 at the Art Students League, New York City; the occasion, Sanden's Friday evening class. The studio on this February night is jammed. Word has spread: Sanden is giving a demonstration, always a crowd-drawing occasion. In addition to his 40 students, a number of visitors sit on stools or stand at the back of the room.

The artist, an earnest looking young man in a blue smock, speaks with almost boyish enthusiasm as he works. Yet his approach is all business. He is stressing method and order in painting a face, rather than a "hit-or-miss" attempt: "I don't make any apology for too much method," he says.

"Establish size and placement right in the beginning," he instructs. "Then the 'gesture' of the pose: how the model sits and what the relationship of his head to his shoulders is."

He begins to outline the head—a rough drawing—in pale neutral gray applied with a No. 6 bristle brush. "Seventy-five percent of the success of a portrait is in the drawing," the artist is convinced. "But it should be kept simple. The few strokes that do go there should be accurate." He discusses the problem of getting the drawing out on top of the paint: "As you impose paint, you must be able to visualize the drawing in your mind. Yet you must be able to let go of the drawing under the painting. It's like the fear of swimming: of being set adrift." He reassures the students that if they can put the drawing there once, they can most certainly do it again.

Sanden is articulate and keeps up a running commentary as the work progresses. For instance, "We must paint wherever we see shadows; get that done before we go on to the halftones." And when he does get to halftones: "Most of his face is a halftone; those are just as complex as shadows."

He answers questions: "Is that pure black?" a student asks, referring to the color Sanden is painting the hair. No, he explains, it's a mix of black, alizarin crimson, and burnt umber. "But if the hair were pure black there would be no reason not to paint it pure black." He goes on to point out the cast shadow behind the head. "Many students ignore this. It's a mystery to me why."

And he cautions, "Take care that the soft edge of the hair against the background is there right away. Later is too late." Softness is something the artist stresses throughout the evening. "One thing we don't want is the ugly effect of hard edges," says Sanden, yet he doesn't believe in blending; that is, "knocking one color into another" to achieve softness. "The painterly way is to use enough transitional tones." Occasionally, when speed is the question, he will use his finger to smudge an edge, as he does now in his demonstration.

The head up to now has been painted as a basic form, without features, like a wigmaker's block. After a break of a few minutes the artist begins to refine the shape. "We are not painting features," he says. "We are painting light falling on forms, resulting in highlights, halftones, and shadows."

At this point he is down to details. Deftly the eye socket, white, iris, brow are painted in. Then the nose: "We are not painting nostrils, we are painting shadow," he states.

The session is almost over now. A hush falls over the students. Their attention is complete, as the blurred image on the canvas suddenly sharpens into the face of the model. Every eye is riveted on the teacher. He works rapidly, not speaking, as he applies the finishing strokes. Occasionally he steps back, squints, makes a face, leans forward, and touches a thumb to the canvas. Suddenly, it's done. The time: approximately one hour and thirty-five minutes.

Students cluster around the easel, comparing the painting to the model who holds his pose a few minutes longer. They examine Sanden's palette, make notes of his mixtures, finger his brushes, discuss technical points. One young man even photographs the painting. Admiration is evident—obviously a devout following. And no wonder: Sanden is an excellent teacher. "He's so explicit," marvels one student. "How did you improve so much?" another student

Step 1: The drawing is made directly on the white canvas ground with a No. 7 bristle filbert brush, using a pale neutral gray mixture of white, ivory black, and yellow ochre. The drawing is kept deliberately simple. Size, placement, and the distance between points are principal concerns at this stage.

Step 2: The background is suggested by a vignette of warm gray, and the basic tones of the hat and hair are struck in. The shadows are then painted throughout the entire portrait: the side of the face, in the eye sockets, under the nose and chin, and on the collar. The end result is aimed at from the first brushstroke.

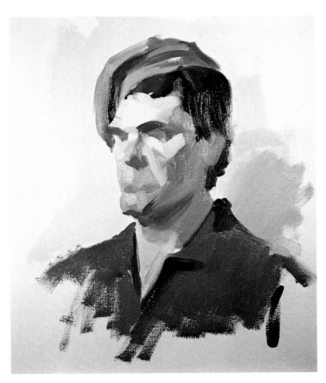

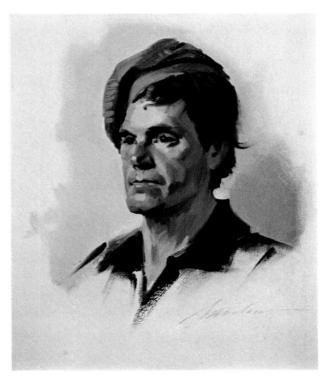

Step 3: Now the halftones are added, starting with the tones around the mouth, then the chin, the nose, and the cheekbones; after this, the halftones of the forehead and neck. Finally the areas of direct light are added in rich, opaque paint. Sanden models the form, the basic masses, as fully as he can while keeping his statement simple and direct.

Step 4: *Portrait of Neal Morton.* Up to this point Sanden has been concerned with color and value, applying the paint in bold patches as he blocked out the masses. Now he turns his attention toward refining the form: softening an edge here, refining a contour there. He is continually restating his values and refining the drawing. At the very end the features are painted boldly, directly into the wet paint.

asks a classmate. "Because I listen to him," she replies.

Hard as it is to believe, only a few years ago Sanden himself was numbered among the students in Studio 15. His teacher was Samuel Edmund Oppenheim. "A master teacher," says Sanden, and he speaks the word with a capital T. Sanden had been in Oppenheim's class for two years when the revered teacher retired, "much to my dismay," says Sanden. "I wasn't nearly finished with him." But Sanden's dismay was even greater when he was asked to take over Oppenheim's class. "Overnight I was promoted from buck private to colonel. And let me tell you, it was deep water."

Deep water it was. For the soft-spoken, inexperienced Sanden, Oppenheim was a hard act to follow. Although a "quiet, sweet man," outside the classroom, inside Oppenheim was tough and harshly critical with his students. The sensitive went home in tears, some never to return. Nonetheless, Sanden met the challenge, but not without a great deal of apprehension. Once he got started, he developed a tremendous urge to be a good teacher. "I wanted to find out how to do it well and I discovered that I had a kind of knack for it. My classes started to grow in number. It was kind of heady! I even began to enjoy it."

Sanden's teaching methods are based, as were Oppenheim's, on observation and artistic integrity. Getting the students to relax and paint what they see is at the heart of his "syllabus." "I discovered something interesting in my classes," Sanden relates. "Everybody, even the beginner, paints the background, shoulders and collar quite well, in a free, untroubled way. That's because the background doesn't matter so much; they're a little loose about it. Secondly, they haven't made a study of shirt collars the way they've made a study of noses, so they simply paint what they see. If they see a shadow, they put it in; if they see a light hitting one side of the collar, they put it in and it has a direct, unsophisticated look. But they get uptight about the face. They've read somewhere about muscles, cartilage, irises and such, and feel they have to add knowledge to what they see. I tell them, 'don't use your brain or what you've learned elsewhere; use your eyes."

Visual acuity alone is not enough for the student painter. He must learn how to make the wisest use of his medium. And it is Oppenheim speaking as Sanden tells his students about economy of effort; about always reaching for the biggest possible brush that will fit the area being painted—even to the point of feeling clumsy. "Oppenheim would stand by your easel and count the number of brushstrokes on a cheek," Sanden recalls. "He would ask you, 'why this one? why this one? why this one?" Then, with his thumb, he'd smudge the strokes together into one. To achieve a fact with the least possible number of brush strokes—that was the thing. If you could make one stroke do what 15 had done, fine. Eventually you'll make one stroke do what 30 had done."

Economy of effort, though, is not to be interpreted as a quick means to an end. Sanden cautions his students against hastening to finish a painting. Instead

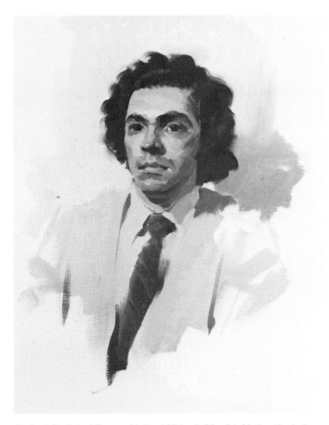

Portrait Sketch of Ramon Majia, 1974, oil, 30 x 24. Notice the hair against the background. The artist achieves softness by using transitional tones or blending with his finger.

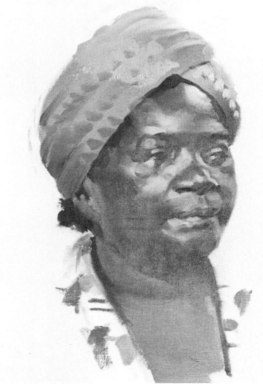

Portrait sketch, 1972, oil, 18 x 14, Sanden feels he is not painting features, but light falling on forms which results in highlights, half-tones, and shadows: not a nostril, a shadow.

he stresses beginning after beginning after beginning. He prefers that instead of spending four nights a week on one painting, they start a new painting each night, even if it's the same model and the same pose. "In the first half hour you spend on a painting you're on your toes, working hard," he claims. "But with each succeeding period that you work, you're making smaller and smaller decisions, and by the fourth day you're making tiny, meaningless decisions and not learning anything. So I encourage people to start a fresh canvas each evening." Some students, naturally enough, do worry about finishing a painting. "There's no such thing as *learning* to finish," their teacher emphasizes, "you should be always beginning—right up to the last minute. Eventually you'll discover that you *are* finishing." Here Sanden is echoing the thoughts of a great man from an earlier era of the Art Students League, Robert Henri: "The value of repeated studies of *beginnings* of a painting cannot be overestimated. Those who cannot begin do not finish."

There's a highly practical reason, too, why Sanden stresses the state of beginning throughout a painting: The student's state of mind is more conducive to correcting errors; that is, he or she ought to be prepared to make an enormous change in the last five minutes if the need suddenly presents itself. "For example," explains Sanden, "you might get all done with a portrait and discover the nose is too long. You have no moral right to do anything else except wipe it out and change it. If you see an error and leave it, you've lost a great moral and psychological battle, and you've damaged yourself enormously. The next time you make an error it will be even easier to overlook. What's more, you'll be damaging your critical faculties." Correction is a reason, too, why Sanden stresses the use of intermediary tones rather than brush blending to achieve softness. If the strokes are laid side by side, the student is more apt to make corrections. But when the paint is blended, he gets a finished feeling and may just leave it alone, much to his misfortune.

Sanden is as hard with himself as he is with his students about correcting mistakes. In a commissioned portrait he finished recently, he noticed that one hand was too small. He changed it, even though the portrait had already been approved by the client. "I struggled with my conscience and my conscience won," he says. "I would never have been satisfied, even if no one else noticed."

This pride of workmanship, along with his ability to produce strong, superb likenesses, contributes to Sanden's success as a portrait painter. His approach to what goes on in the classroom, though, differs vastly from his commissioned work. In the classroom he demonstrates, and his students paint in the direct or *premier coup* method—defined as "a first stroke—aiming for success in the initial attack." *Premier coup*, Sanden feels, is an intense and valuable learning experience. The drawback to its use in commissioned work is that it depends on the inspiration of a moment. It can produce a highly spirited painting, or one that just doesn't make it. And here lies the divid-

Portrait sketch, 1972, oil, 18 x 14. The artist stresses soft edges in his classes and in his own work. "One thing we don't want is the ugly effect of hard edges," he says.

Portrait sketch, 1972, oil, 18 x 14. Sanden does a head and shoulders study for each portrait commission. This is used to establish colors and familiarize him with the sitter's expression.

ing line between Sanden the teacher and Sanden the professional portraitist.

He compares a commission to a singer's performance. She has to be as good on Thursday and Friday as she was on Monday, Tuesday, and Wednesday. She has to please an audience who paid to see her. And Sanden has a client to please. He spares no effort to do so. "I've used the direct method in some commissioned works," he explains, "but with varying success. As Mr. Oppenheim used to tell us, 150 things can go wrong with a painting—beginning with what you had for breakfast. It all has to do with that moment." Whether he will do more direct painting in the future remains an open question. "I've always felt I'd get better results with a lot of preparation," he says. "Now all of a sudden the results are getting to be more interesting with less preparation. I'm trying to feel my way into what I should do."

For the present, though, his preparations are elaborate and thorough, involving photographs, sittings, studies. At the first meeting with a sitter "we just talk about what we want the portrait to look like, in terms of size, clothing, background, and so on." Then Sanden the photographer takes over. "I often shoot as many as 80 pictures of the subject, rapidly experimenting with different poses. Then I develop and print them and show them to the client. There's always one pose that's very clearly the right one. It just jumps off the contact sheet right at you."

When the pose has been selected and the camera gear put away, the artist allots two sittings to doing a study in oil; this is to establish composition. Certain other variables are resolved at this point. For instance, the study for the portrait of Dr. Weinhaus, director of the Fels Research Institute at Temple University in Philadelphia, showed the sitter posing in his shirtsleeves. But his colleagues who comissioned the portrait thought he should pose wearing a jacket. So Sanden painted a jacket on a piece of acetate, which could be placed over the study, so that both effects could be easily compared. The final decision was in favor of the shirtsleeves—a more informal pose favored by Dr. Weinhaus.

Once the composition is established, Sanden does a head-and-shoulders study on a small canvas to establish colors and familiarize himself totally with the expression.

When the sitter is present, Sanden establishes rapport effortlessly. His manner is sincere, eager, undisguisedly enthusiastic. "If you don't talk to the subject," he says, "he tends to get tired and slump." In a sitting with Dr. Weinhaus who had just returned from a lecture tour in the Orient, the conversation topics ranged from the difficulties of getting a taxi in Tokyo to the decline in popularity of abstract art. Drug abuse, cancer research, and city life as opposed

The J.D.A. Barr Family, oil on canvas, 81 x 85. Collection Mr. and Mrs. J.D.A. Barr. First the artist made a careful pencil drawing of the brocade pattern, working it out in precise detail. Then he painted the dress completely, without the design, and finally traced the pattern onto the painting and painted it.

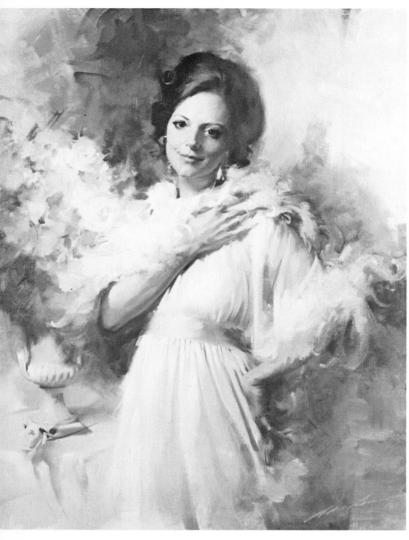

Portrait of Sunny Griffin, 1972, oil, 42 x 34. Collection the artist. The artist sees his free execution of flowers—rather than a petal-by-petal rendering—as an example of how his style loosened up under the influence of Oppenheim: "Before that my style was very tight and overworked."

to suburban life, were also touched on. And, since Dr. Weinhaus could watch the progress of the study in a mirror behind the easel, Sanden occasionally explained what he was doing and why.

When the head study is finished the artist is ready to commence the actual portrait, most of which is done without the sitter. By that point he has accumulated a lot of reference materials: the studies and the mass of photographs.

Sanden works in oils. His palette consists of no more than 13 colors, with the earth colors (which he uses most frequently) on the right of the palette, cadmiums in the middle, and cool colors to the left. The palette stand is to the left of the easel. Before he begins he mixes flesh tones for areas of darkest shadow, general shadow, halftone, basic flesh, and direct light, from combinations selected from white, yellow ochre, burnt sienna, cadmium red light, cadmium orange, viridian, and cerulean blue. During the course of the painting these pre-mixed colors are mixed with other colors in answer to the actual flesh color of the model. Sanden also pre-mixes three shades of neutral gray from combinations selected from white, black, raw sienna, and yellow ochre, "The grays are a quick way to lower the intensity of a color," he explains. However, his practice of pre-mixing flesh tones is slightly controversial at the League. "Some people consider them dependency formulas, he says. "But I disagree. I would have to mix them anyway as I go along. I do it to save time."

His brushes for 95 percent of the time are filberts, ranging from No. 2 through No. 12. A No. 7 round sable is for the highlights in the eyes. And on occasion he selects a fan blender for the hair. "This is a dangerous brush," he cautions. "It can produce awful manneristic effects if not used properly." Sanden's medium is copal painting medium (light). He uses it as a watercolorist uses water. All told, it usually takes about 40 hours of standing before the easel to produce the final portrait—the equivalent of a white-collar work week.

How does Sanden deal with the question every professional portraitist must come to terms with: the question of flattery—of making someone look prettier or more handsome than she or he really is. Actually, this is a problem he rarely encounters: "Nobody has ever suggested that I paint them other than as they are. In fact, the criticisms I've encountered have been only criticisms of departure from fact. For example, if a man has a mole on his left cheek, he's usually very disappointed if the mole is not in the portrait. Almost everyone expects to be seen as he is."

But what about wrinkles, those traces of age that very few find flattering? Sanden, without compromising himself, treats this matter in a sympathetic and humanistic way: "In a very aged face, I feel there are some things you can overlook." He describes a portrait he painted of a woman in her 80s. "She was a lovely woman at one point, and was still lovely, but by a different standard. I made no alterations in her face; I simply overlooked some of the cruel effects of

time." He did not, of course, make her look 50 years younger. He simply omitted deep lines parenthesizing the mouth and a network of wrinkles on the forehead. He says, "I was entitled to do that because the wrinkles on an aged person's face are really insignificant; the shape of the face is still there." He takes into consideration the fact that it's not the person's fault the portrait is being commissioned late in life.

There are those who sneer at portraiture, who consider it a lesser art, a prostitution of the painter. To such critics, Sanden has this rebuttal: "The world's great paintings that you and I know and have grown up with were simply commissioned portraits, executed with enormous distinction! Those paintings by Rembrandt, Velasquez, Frans Hals, were all commissioned works. Those artists were faced by the same problems portraitists today are. The husband of the sitter would come in and say the artist wasn't painting his wife's mouth right and that he thought the shadow on the back of the hand was too deep. A man like Hals was facing exactly the same problems a painter today faces, and his answer was so magnificent that 400 years later we still go to the museum to look at it."

Sanden himself is a portraitist because, "I think the human face is the most dramatic subject in the world. There's enough of a challenge there to occupy several lifetimes. The face has clearly been the central theme of art through the centuries." He continues, "If you walk through The Metropolitan Museum of Art and categorize the paintings, you'll find that the majority are portraits."

Sanden is a good-humored young man with a conservative haircut who always wears a tie, even under his smock, and quotes Billy Graham in the same breath as Robert Henri. He has been exploring the human face since he was a small boy in Austin, Texas. His father, a Presbyterian clergyman, one day handed him The Pictorial Life of Abraham Lincoln, a fountain pen, 8½ x 11-inch (22 x 28 cm) white paper,

and instructed him to copy every picture. The six-year-old boy obeyed, down to every last mole and whisker. When that task was done, the next assignment was from The Life of Christ Visualized. That was when Sanden's love of portraiture began, and he hasn't strayed from the subject since.

The family moved to Minneapolis, and the young Sanden attended the Minneapolis School of Art (now the Minneapolis College of Art). "That was in the 1950s" Sanden recalls, "and Abstract Expressionism was in the saddle in the Midwest. If you liked to paint what you saw, you kind of kept it to yourself. You hid behind the barn door with your easel," he confides with a grin. "So I stumbled around for a long time without pursuing what I wanted to pursue."

In spite of his stumbling he became a successful illustrator. In fact he spent six years doing portraits for Reader's Digest of people he had never seen. "They'd send me a bundle of pictures of someone, and I'd do the painting, enjoying every minute of it. But I began to think it would be exciting to actually see the people I was painting." Then one day in 1969 Sanden took the big step. He chucked it all. "I sold the house and the Chevy, gave up the studio, and came to New York to study at the Art students League. It was absolutely the best thing I ever did in my life."

John Howard Sanden found success in New York City. In a few short years he has become a sought-after portraitist and teacher—so successful that he has recently initiated classes in his own studio, calling his group The Painters Club of New York. Additionally, his book Painting the Head in Oil was published by Watson-Guptill. And he will probably spend the rest of his life painting faces.

"I feel like Sir Winston Churchill," he says, "who said that when he died and went to heaven he would spend the first million years painting, in order to get to the bottom of the subject." And like Sir Winston, Sanden is eager to get to the bottom of the subject.

ANDREW SANDERS

BY JOAN TOMCHO

ANDREW SANDERS was born in Erie, Pennsylvania. He graduated from the Philadelphia Museum School of Industrial Arts (now The Philadelphia College of Art); taught for ten years at The Ringling School of Art in Sarasota, Florida, and three years at The Columbus College of Art and Design in Columbus, Ohio. In 1964, he started the Art School in Erie, where he is still its director.

Sanders has had several one-man and group shows and exhibited in numerous regional and national exhibitions, such as the Southeastern Annuals in Atlanta, Georgia; Mississippi National Watercolor and Oil Annuals; Delgado Museum, New Orleans; Fifty Florida Painters, Ringling Museum, Sarasota, Florida; Houston International Gulf Caribbean, Texas; National Museum, Havana, Cuba; Smithsonian Institute; Pennsylvania Academy of Fine Arts, and The American Watercolor Society.

His awards include Certificates of Merit from the National Academy of Design and The Painters and Sculptors Society of New Jersey in 1974, the Edward C. Roberts Memorial Prize at The Connecticut Academy of Fine Arts in 1973, and an Honorable Mention in Mainstreams '72.

A member of Audubon Artists, Sanders has consistently exhibited in their annuals as well as those of the Butler Museum of American Art's Mid-year Shows, Allied Artists, Knickerbocker Artists, and The National Arts Club. His paintings and drawings are in many private collections in major cities throughout the world: New York, Philadelphia, London, Paris.

The following interview by Joan Tomcho took place in Sanders's studio.

Tomcho: As I sit in your studio looking at the 16 preparatory drawings and designs for your painting *Nancy in White* and the group of nude figure drawings in pure line, I am impressed by the variety of media and styles you use in working from the model. Would you like to comment on the reasons for these differences?

Sanders: The difference between the preparatory and independent drawings is one of purpose: The preparatory drawings are studies. They represent my search for a painting idea, and therefore the drawing techniques I use must allow as much freedom and flexibility as is possible while carrying out that search. The pure line drawings and occasional tonal drawings, on the other hand, are intended to be an end in themselves. They serve no purpose other than expressing their own esthetic statement. If I used the method of pure line in my preparatory studies for a painting, the style would, obviously, be too restrictive.

Tomcho: Then you never do a pure line drawing in preparation for a painting?

Sanders: I would say hardly ever. But if I did, it would be the exception to the general methods employed. However, the creative process is extremely complex and unpredictable. If I felt that no other medium or method was working I might do a line drawing if only to grasp a sense of what I was about.

Tomcho: Does posing the model present any special problems?

Sanders: Yes, because I must arrive at a pose that will be characteristic of the model, express an idea, and create an unusual design. Sometimes it is helpful to discuss the idea with the model; at other times, it tends to make him or her self-conscious.

When Nancy agreed to pose for me, I had a general concept of what it was I wanted to express about her and through her. Beyond that, I entertained only nebulous images.

Tomcho: So where do you start?

Sanders: With the costume. I knew I had to paint Nancy wearing white, but had no idea what kind of dress it would be or how she would pose. Fortunately, Nancy—who loved period dresses—knew of a local shop owner who collected them. After trying out three different dresses, I found one that was satisfactory.

Tomcho: Yes, I see two drawings of one; six drawings and designs of another; and eight drawings and designs of a third dress. And for the five poses, you have

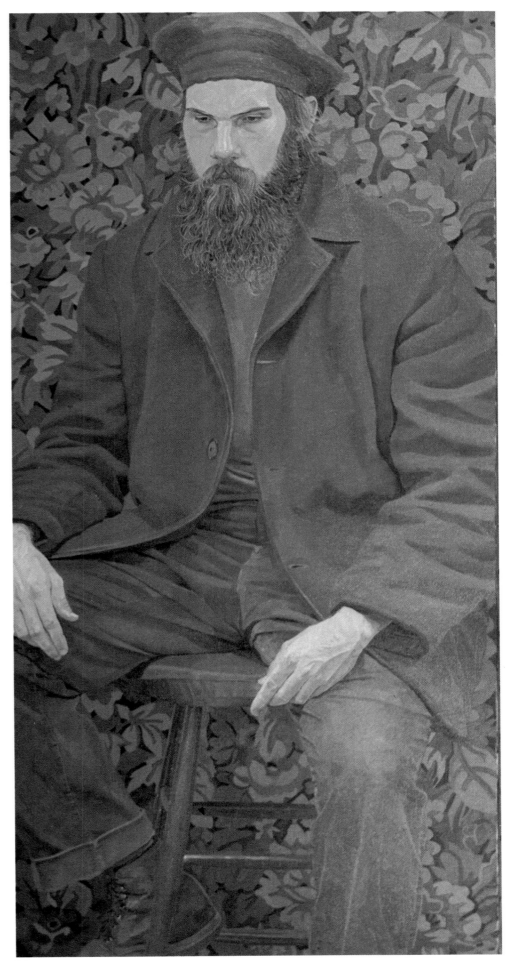

Opposite page: *Self-Portrait with Model for Nancy in White,* © 1972 Andrew Sanders, charcoal pencil, 11 x 7¾. During a relaxed moment in his studio, the artist glimpsed this reflection. Inspired by the scale relationships and overall design, he drew it then and there.

Richard Brown, oil, 40 x 20. © 1973 Andrew Sanders. The bulk of the figure contrasts with the delicacy of the beard and decorative background.

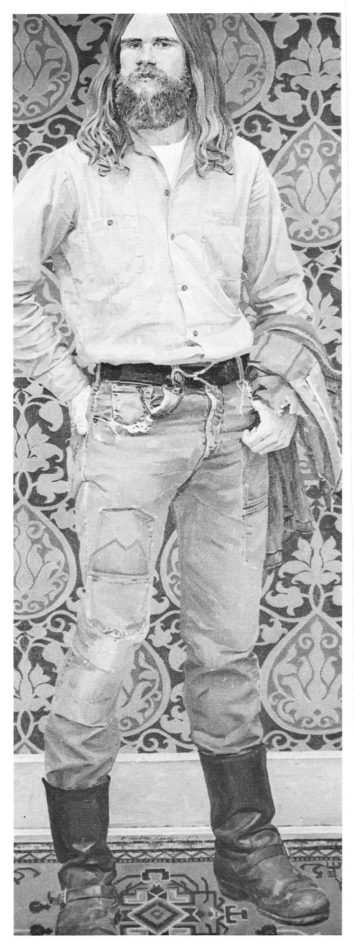

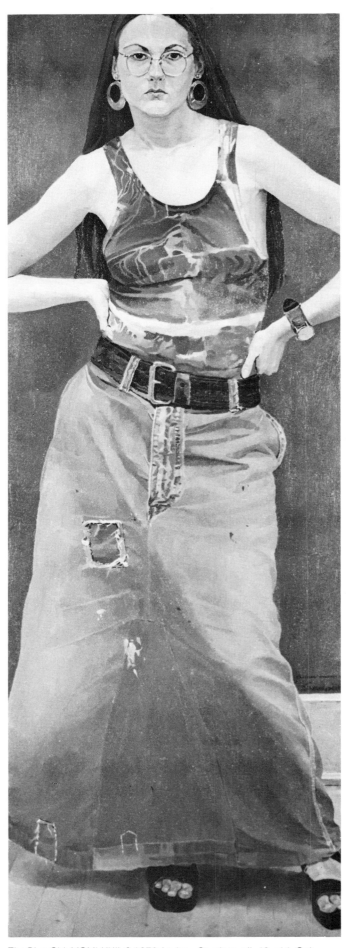

The Blue Boy, MCMLXXII, © 1972 Andrew Sanders, oil, 40 x 14. Collection the artist. Although Sanders dresses the model in present-day fashions, the title suggests his timelessness.

The Blue Girl, MCMLXXII, © 1972 Andrew Sanders, oil, 40 x 14. Collection the artist. The artist rarely paints anyone he doesn't know.

140

used different drawing styles and worked with several media. These seem like unusual preparatory methods for a highly refined painting.

Sanders: To me, the concept, drawing, and design are essential to a successful painting. Since the structural and harmonious use of color during the process of painting provides its own unpredictable complexities, it's necessary to solve the essentials in black and white separately from the execution of the painting. And because the esthetic objective of the painting differs greatly as an end result from that of preparatory drawings and designs, the styles and methods also differ. Also, I seem to have been blessed (or cursed) with versatility and a compulsion to search creatively; once one discovery is realized, another search is begun.

More specifically, in the case of the preparatory studies for *Nancy in White,* as with most of my preliminary work, I mainly use lead pencil and felt markers. The markers help suggest an idea quickly when drawing, and are very suitable for two-dimensional designs when pattern is to be emphasized. Although the pencil is sometimes used for this purpose, it's usually reserved for complete trial studies prior to the actual painting.

Tomcho: What grade of pencils do you use?

Sanders: The range is from HB, the softest, to 9H, the hardest. Interestingly enough, when working with these high key pencils, I never think of pencil technique per se. What I am aware of, however, is the surface appearance of the drawing. It's very necessary for me to achieve a dark value without creating a shiny, lifeless area. I find that an esthetically pleasing surface can be accomplished by building up a dark value in layers with pencils in the H degrees rather than direct application with a 4B.

Tomcho: Even though it required 16 drawings and designs before you were able to finalize your idea, it seems as though the preliminary work falls into three stages: the felt marker drawings; the marker designs; and the final pencil drawings. Does each stage or medium have a specific function? And, if so, how do they relate to each other?

Sanders: I didn't always draw with felt markers. One day, while working in my studio, I became impatient with the slowness of trying to make spontaneous drawings and designs with lead pencils and tried a set of markers. That was five years ago, and I've been using them ever since. I especially like the two values of gray for blocking in a figure and the black for linear and structural emphasis. I would like to point out that in this preliminary work, the felt marker drawings are rarely considered an esthetic end in themselves, even though there are occasions when I do use them for this purpose.

There are a total of four two-dimensional marker designs: two for the seated pose with the upraised leg; one for a rejected seated pose; and one for *Nancy in White.* The most important aspect of these designs is

the esthetic value of the postive and negative areas.

The design was also turned upside down and sideways so that I could disassociate myself from the subject matter, which in these positions could then be viewed as a combination of abstract shapes. This exercise requires the ability to visualize a finished painting while working with black-and-white pattern.

An example of this visual anticipation would be the cropping of the chair legs in *Nancy in White.* I realized that an undesirable three-dimensional platform—the chair—would adversely affect the quality of the two-dimensional pattern—the picture plane—as well as create depth beyond the picture plane. However, by cropping the chair legs and leaving out the floor, a three-dimensional figure (Nancy), supported by a three-dimensional chair, now had nothing to support them. Deciding whether this would work visually or not could not be solved through the use of mental images alone. Only a finished drawing, cropped exactly as the finished painting would be, could provide the answer.

When the completed drawing was cropped, it demonstrated that two illusions would provide the necessary visual stability: The cropping of the figure at top and both sides suggested that the figure was somehow attached to the boundaries of the frame, while the floral pattern in the background continued beyond the bottom of the frame to an assumed ground level, creating, I think, an ethereal illusion rather than an earthbound one.

Tomcho: Besides verifying a two-dimensional design, what other purposes does the finished drawing serve?

Sanders: The final value drawing in lead pencil serves a twofold purpose: It solves the usual drawing problems as well as the anticipated painting problems. Besides undertaking the solution of movement, structure, and value, the refinement of the position of a hand; the relationship of fingers to each other and to the hand; and most importantly, the characterization of the model and an expression of the symbol she represents; the drawing must convince me that a statement of my envisioned idea is possible in paint.

Tomcho: Do these finished drawings ever become an end in themselves?

Sanders: A complex question. Even though the answer is yes, I'll have to qualify it. It is almost impossible for a competent draftsman to work 15 to 20 hours on a drawing without that drawing reaching an esthetic level. On the other hand, even though I sometimes realize that the stage of the drawing has answered all of my preparatory questions, I carry it past that point. It is then that I am aware of developing the drawing beyond the study to that of an independent work of art.

Tomcho: Once the exploratory process is complete, what is your next step?

Sanders: I transfer the outline of the drawing to Bel-

1. *Standing Figure,* © 1972 Andrew Sanders, pencil line, 23 x 8. Each drawing is carefully labeled with its title, medium, size purpose, disposition, and the model's costume.

2. *Seated Figure,* © 1972 Andrew Sanders, felt marker on tracing paper, 19 x 9. This was the model's second costume and Sanders's fifth drawing. The pose was considered "possible."

3. *Seated Figure,* © 1972 Andrew Sanders, felt marker on tracing paper, 19 x 7½. Sanders considers the abstract design of the second dress as a wide shape.

5. *Seated Figure,* © 1972 Andrew Sanders, felt marker line, 23 x 10. Here Sanders considers a third dress and searches for a new pose and idea.

6. *Seated Figure,* © 1972 Andrew Sanders, felt marker on tracing paper, 14 x 8. Here Sanders's purpose was to explore the pose's abstract design. It was subsequently rejected, "unsuitable" to Sander's intent.

7. *Seated Figure,* © 1972 Andrew Sanders, felt marker on tracing paper, 22 x 8. Here again the abstract design is studied and a new pose considered.

4. *Study for Nancy in White, No. 1.*
© 1972 Andrew Sanders, pencil, 20 x
10. Not used because the model had
difficulty holding the pose and the
folds would not repeat themselves.

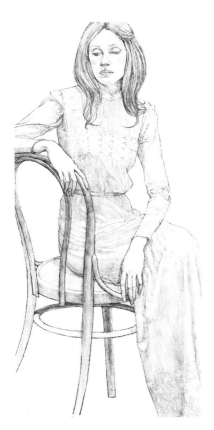

8. *Study for Nancy in White,* © 1973
Andrew Sanders, Pencil, 23 x 10.
Pose accepted. This is Sanders's
finished ''preliminary'' drawing.

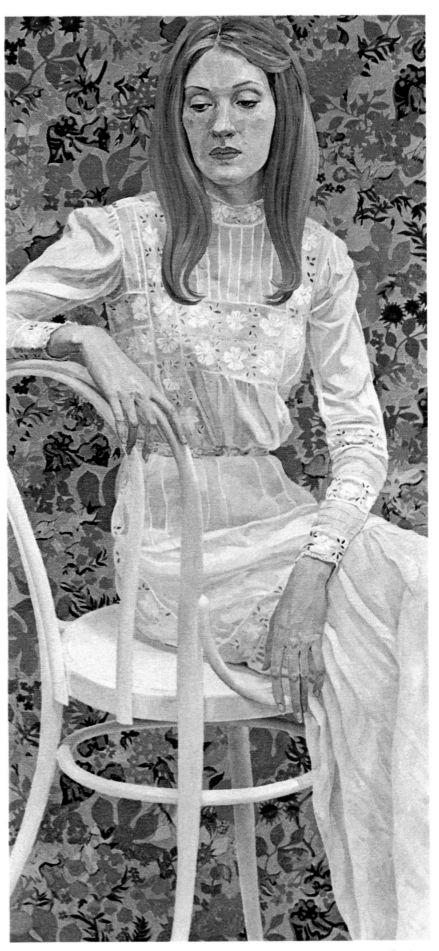

Nancy in White, oil, 36 x 16. © 1973 Andrew Sanders. Collection of the First National Bank
of Pennsylvania. The rhythmic fragility of the subject creates an ethereal state of fantasy.

gian linen canvas. The design is critical and the transfer is made essentially to assure accurate placement of the drawing on the canvas. Methods vary. In the case of *Nancy in White*, I made a photostat of the final drawing, projected it on the canvas with the aid of an opaque projector, and drew in the outline with charcoal pencil.

After the outline was placed satisfactorily, I resumed drawing from the model, for the image at this stage is only diagrammatic. This was one of the most difficult of transitional stages because I had just reached an esthetic high with the finished drawing and now I had to face a lifeless outline. In addition, when you start from scratch, a drawing is always developing until it's finished. In this case, as I was starting with a diagram that had no esthetic quality, a tug of war ensued until the diagram showed signs of becoming a drawing; or in other words, until it reached the same beginning stage of an original pencil drawing. Then I developed it in the same manner as the pencil drawing to which I constantly referred. I don't want to give the impression that this process of redrawing the figure with charcoal pencils on canvas is a mechanical procedure requiring accuracy alone. Because of its much larger size and different intent, the tonal drawing on canvas is a new drawing, requiring new modifications and refinements. After it was finished, I sprayed it with fixative.

Tomcho: I know that artists never like to think of their work in terms of time, but do you have an approximate idea of how long it took you to redraw on canvas as well as to complete *Nancy in White?*

Sanders: Like most other artists, I dislike having to think of the quality of my work being evaluated on a time basis. I am no exception to the rule. On the other hand, model fees do represent a financial investment for the artist which, like the cost of materials and overhead, become part of the monetary value of the work. Therefore, I do keep a record of time spent on my work and can answer your question rather accurately. Including the preparatory drawings and designs, the canvas drawing required 37 hours, while the actual painting *Nancy in White* required 171 hours, which represents 57 three-hour sittings. And because Nancy worked and could only pose part-time, I worked on the painting over a period of six months.

Tomcho: All of the drawings you have been discussing so far have been preparatory to a painting. I would like for you to now turn your attention to your independent line drawings by first explaining what you mean by a conventional drawing and how it differs from your line drawing.

Sanders: All of my preparatory drawings for *Nancy in White* were drawn in the conventional manner; that is, the figures were blocked in with several action and construction lines, then developed structurally—and in some cases tonally. But in my pure line drawings, there is no preliminary work of any kind, and there are no erasures. Each application of the charcoal pencil is final. Therefore, to answer your question, in the conventional method, the blank paper in a short while contains several points of reference to be developed and modified. In my pure line drawings, the first mark must be made on an absolutely blank paper without even one preliminary construction line to refer to. And as the drawing develops it is necessary to relate to the drawn areas and to visualize in the blank areas as well.

Tomcho: For your preparatory drawings you use mainly lead pencil and felt markers. What are your line drawings done with?

Sanders: I use HB charcoal pencils on 100 percent rag paper. Since a consistency of line is essential, both in width and value, I sharpen about six pencils before beginning a drawing and keep them sharpened during model breaks.

Tomcho: One of the things I think is so unique about your pure line drawings is your choice of medium. At first glance they look like pen and ink or etchings, and if they were lighter in value, silverpoint. Why did you choose charcoal pencils?

Sanders: Because I can sense the contact between the paper and the pencil and can control the value by pressure. All I feel with silverpoint is a piece of metal gliding over a clay coated surface. I like pen and ink very much; however, since for my esthetic requirements I draw with a size "O" technical pen, the size of the drawings are limited. Also, the friction between paper and pen point is too great to permit the free flowing line I prefer. I have never tried etching.

Tomcho: Is your procedure of posing the model for a pure line drawing similar to the method you use for a painting?

Sanders: Yes and no. A painting is a more complete statement of an idea; therefore, it requires greater preparation. Procedure is affected by this. For the pure line drawings, the preparation is not nearly as extensive. In addition, it depends on whether the model is in costume or nude. Because the anatomical shapes, rhythm, and proportions of the nude differ considerably from the costume model, the merits of a pose would have to be judged independently.

The well-trained nude model knows how to move; to sit, stand, stretch, bend, twist, recline and so on. In my pure line drawings of nudes, I prefer the model to initiate the content of the poses and then make my selections.

Tomcho: What are you looking for in a line drawing pose?

Sanders: Unusualness; a pose that is not commonplace. After doing hundreds of my own drawings and posing innumerable nude models in figure drawing classes for 25 years, one realizes that there are just so many ways the human body can sit, stand, or recline. So I try to encourage my models to work within that

small range of positions that have not been worn threadbare through endless repetition.

Tomcho: Since in your line drawings you apply the line directly, with no preliminary construction, just where do you start?

Sanders: Almost invariably with the head and then I progress to the feet. In an unusually foreshortened pose, however, it might be necessary to start elsewhere. But since the size of the head—as in conventional drawing—determines the size of the figure, and since I am concerned with the size, shape, and pattern of the figure, the head is the most logical place to start.

Tomcho: Would you describe how you develop the drawing?

Sanders: Naturally, there are many variables. The hairstyle, position of the head, and whether there is a hand near the face, can determine which problem should be solved first. There are other factors as well. Because each line is so critical, it's necessary to keep in mind those areas that cannot be left unfinished when the model rests. Fingers, long hair, an expression of the eyes are impossible for the model to resume in the exact same manner in a repeated pose.

Therefore, I try to solve as many essential problems before a model rests as possible. Sometimes, I work from the inside of the head outward as I complete one feature at a time and then I build the head around it. On other occasions I may draw a hand first, relate the features to it, and then draw the shape of the head. Because there are no reference points on paper and erasures are not permitted, this process of analyzing, visualizing, and resolving continues in its unpredictable way, line-by-line, area-by-area, until the drawing is considered finished.

Tomcho: I have noticed in almost all of your line drawings that you leave an unfinished area.

Sanders: There are several reasons for the incomplete area: evidence of the process, visual tension, economy of means, and design. In my totally complete line drawings I began to notice that the final result looked as though it had been effortlessly achieved. When a section of the drawing was left undrawn, a degree of the difficulty required to complete the drawing became apparent. Furthermore, when the viewer is obliged to optically complete the undrawn line, he experiences a visual tension between the two connecting ends of the imaginary line, which acts as a counterpoint to the drawn areas.

I also discovered, while drawing, that I was constantly evaluating whether or not the line I was about to draw was necessary. If it wasn't, the drawing would be saying more with less. And finally, the elimination of a line or lines can contribute to the esthetic quality of the design.

Tomcho: As you describe your method, it's apparent that you don't draw with the one uninterrupted line that your drawings suggest, and yet you no doubt intend to achieve this result. Why?

Sanders: I am interested in creating an undulating unbroken line that flows rhythmically throughout the figure, and I'm also interested in designing abstract shapes and patterns. In addition, I find the unencumbered simplicity of the curved line esthetically stimulating.

Tomcho: Your method runs the risk of error during any stage of its development. Do any of your drawings fail?

Sanders: Fortunately, not very many, but when they do, they are destroyed immediately; the price of aspiring perfection.

Tomcho: Both your drawings and paintings suggest a high degree of manual skill and intellectual control, and yet I surmise that you're emotionally involved while working.

Sanders: That's the paradox of my work. Although the tools and media are not used expressionistically, the content is expressively stated. The dominance of this content over the surface appearance of the work is essential. Although the esthetic qualities of the medium should reveal the artist's imprint, I believe the procedure should remain a mysteriously invisible core of the visual statement.

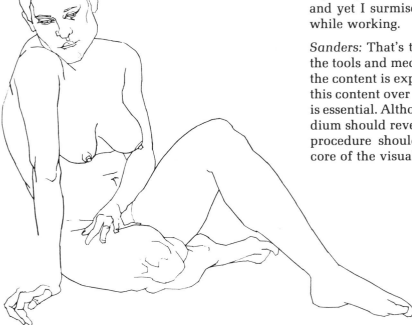

Seated Nude, © 1974 by Andrew Sanders, charcoal pencil, 12 x 11. Sanders looks for unusual poses in his line drawings.

WILLIAM E. SHARER

BY BARBARA WHIPPLE

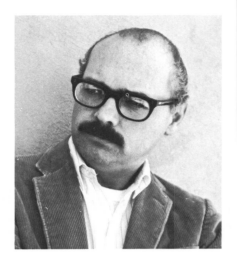

BILL SHARER now lives in Denver, Colorado after having lived for several years in New Mexico. In his studio a wheeled easel dominates the work area. Bill Sharer has combined the easel itself with a cabinet that has three drawers which hold, respectively, paints, brushes, and rags. This cabinet is the support for a large glass palette. Easel, palette, and cabinet form one complete, movable unit, although the cabinet can be moved over to one side if space for a large canvas is required on the easel. A wheeled model stand, about 5 x 8 x 3 feet (1.5 x 2.4 x .9 m), is piled high with a vast collection of materials and pillows. It also serves as a large storage chest.

The orderly arrangement of everything within the space itself creates an almost monastic impression: one of great order and discipline. Why is this the kind of space Bill Sharer has created for himself to work in? "Convenience," he says. "I like to keep everything at hand and know where everything is. Painting is hard enough as it is; why make it any harder?"

Life for painter Bill Sharer hasn't always been so convenient and easy. This new studio of his is the result of many years of tough-minded discipline, hard work, and real deprivation. Raised in Roswell, New Mexico, on his own from the age of 15, he joined the Marine Corps right out of high school. He thoroughly enjoyed the rigors of boot camp and combat training. He was assigned to sea duty and traveled around the world twice, doing things he admits he wouldn't have the nerve to do today. He considers his Marine experience to be the first really big thing that happened to him and, in fact, once seriously considered making the Marines his career. But he felt there must somehow be more to life.

Although he can remember making, as a youngster, some big, black crayon drawings on newspaper, there had been very little art in his early life. While in the Marines, he was interested enough in drawing to make an application test for the Famous Artists School. Their response had been encouraging, but he didn't follow it up. Instead, when he resigned from the Marine Corps, he came back to Roswell and made blueprints for oil companies for a couple of years. The realization that his GI Bill-funded schooling op-portunity would run out pressured him into making a decision about his future. He started looking at the advertisements by art schools and sent off for all the catalogs. After looking them over pretty carefully, he decided on the American Academy of Art in Chicago, which, he decided, had put out the best looking catalog. "It seemed to me," Sharer says, "that if it put out the best catalog, it ought to be the best school." He had only been a student at the school for a couple of days when he knew that this was "*really* the thing."

The Marine experience was the first "big" thing that had happened to Bill, and the American Academy was the second. As a first year student he divided his time between life drawing and learning basic fundamental skills in handling different media. In the second year he concentrated on painting and had the benefit of being taught by William Mosby, who had trained in Antwerp and was thoroughly familiar with all aspects of painting. Mosby also had a wide range of interests and could communicate well with his students. He had a knack for saying things so that they would "stick." He did not attempt to promote a particular style but, instead, helped his students find their own individual direction.

Sharer's abilities were beginning to be recognized, and when his GI Bill assistance ran out after two years, Frank Young, the director of the Academy, gave him a full scholarship for as long as he wanted. Sharer also earned money by working in the school store and doing other odd jobs. He knew he was being subsidized by the school and admits this made him feel "very good."

The days at the Academy were divided into life drawing in the morning and painting from life in the afternoon. On weekends, if he had time, Sharer used to go out and do landscapes and bring them back for Mosby to criticize. "Of course, they were terrible," Sharer says. "Landscape is *really* hard. There is so *much* of it, and you don't know what to do. Even after I got out of school, for four or five years I kept trying to paint landscapes, and I really didn't have any results. One out of 50, maybe, I would use."

After being at the Academy for three years, he re-

Tapestry, pastel, 25 x 19. Pastel is a medium ideally suited for Sharer's gossamer-like atmosphere surrounding the figure.

Dama de la Noche, oil, 13¼ x 18. Photo Martin Weil. A subtle interplay of lights and darks skipping over a variety of textured surfaces creates an unusual effect.

treated for six months to the mountains of Colorado in an isolated cabin that had belonged to his mother. Working from the studies and sketches he had done from the models at the Academy, he experimented in placing them in landscapes in various ways, a manner of working he continues today. Also, he continued his struggles with landscapes done on the spot. In this way he sorted out many painterly problems and, equally important, got himself together. "Because," Sharer says, "when you get out of school, you really don't know what's going on."

In 1962 he brought some paintings to a gallery in Taos, New Mexico, and they liked them. With this encouragement he and a friend from Colorado Springs moved down to Taos. The Colorado Springs friend helped share expenses for awhile, but this didn't last long. Things got pretty tough, and there were times when he did not know where the next meal was coming from. Sometimes he would trade paintings for meals at a local restaurant, and someone lent Sharer a guest house in exchange for some paintings. "People don't believe it," he says, "but I lived for two years on only $600."

During these lean years he decided against taking a part-time job. The friends he had seen do this had not returned to their painting. And he refused to consider any commercial work in either illustration or adver-

tising design. "I'm stubborn," he says. "I guess that made it easier for me." The second winter, a studio at the Harwood Foundation (a non-profit organization in Taos that is part of the University of New Mexico) became available, and he rented it for $45 a month. Friends helped, and slowly things began to pick up. As his work improved, so did his sales.

He sent off work to the important shows, and it all came back. In fact, one national art show not only rejected his work two years in a row, but returned his paintings with holes in them. Of course, this made him angry, but Sharer made a joke about a hole through a painting being the "stamp of rejection."

In 1968 Sharer moved to Santa Fe, where his work had such good acceptance that he continues to have difficulty assembling enough pictures to make a show. In 1969 he was accepted in the Allied Artists show. Increasing his pleasure was the fact that the portrait not only won an important cash award, but was also purchased for the permanent collection at his Alma Mater, the American Academy. Again, in 1972 he received another major award at the Allied Artists show. Certainly, being stubborn and determined has paid off for Bill Sharer.

Because of his excellent training, Sharer is equally at home in pastel, watercolor, and oil. He finds it relaxing and stimulating to shift from one medium to

Hans Paap's Daughter, oil, 20 x 16. The simplicity of this composition is deceptive. In fact, the artist has carefully arranged light and patterns in a most sophisticated fashion.

149

River Bank, Mexico, oil, 24 x 36. Courtesy Sandra Wilson's Fine Arts Gallery. With a strong sense of color, Sharer has created warmth in the blues and greens to unify the painting.

another and from one type of subject matter to another. For the same reason, he enjoys doing some of his own framing; it gives him a change of pace. "I would hate to think that I had to do just one thing," he says, "Boy, would that ever make you get old in a hurry!"

Whatever his subject, he selects it because he likes it. Models are commissioned to pose for him when he finds something interesting in their face or movement. He starts out by doing one-minute poses for a couple of hours to acquaint himself with the model and her natural types of motions. From these quick sketches he decides on a pose and that might works some value contrasts into the drawing. He also decides on the shape of the canvas and the placement of the figure within the canvas. When work begins the next morning, he poses the model from the sketch and makes a total environment around her, using the materials and pillows that he has on hand and sometimes borrowing items from a nearby antique store. He creates an environment of color and texture that will "look good" around her: "If I can make it look good over there, I can make it look good on my can-

vas," he says. Sharer prefers daylight, although he may use artificial light occasionally for special effects.

The same careful preparatory work is done for a still life. He may take a whole day to set one up, to make it exactly what he wants, and to have the shadows work in just the right way. "Then," he says, "it's up to me. It gets back to 'making it easy for yourself.' Once you get it on the canvas and it's wrong, you have to start changing, and it gets ugly and greasy. So you try to take care of that before you start, so your canvas will look fresh and spontaneous."

He is a master of landscape now and really prefers to complete these paintings on the spot. He has a folding French easel, which holds everything he needs, and he takes this with him on all his outdoor expeditions. He finds that two hours is about the maximum time limit before the light changes too much. Then he brings the painting back to the studio and makes any changes he feels will improve it, or intensifies the mood he perceived in the first place.

There are other paintings Sharer has done that have been worked up from a series of oil sketches

made on illustration board. To simplify carrying these illustration board panels in the field, he has made a dustproof box with slotted sides to hold the boards separated from each other, wet or dry. The illustration board absorbs the oil quickly, so the sketches dry rapidly. They are not intended to be permanent; they are preliminary studies to be used for working up a finished painting.

Paintings done directly are finished rapidly, but paintings that he calls "composites" take a long time.

Sharer prefers to work directly, but he does not hesitate to make creative use of his own photographs. Especially when faced with complicated subjects—a Mexican marketplace, for example—he takes many photographs and does many sketches. Back in the studio, he can refer to his transparencies by using a homemade rear-projection box. Working from his sketches and photographs, he works up his exhaustive preliminary studies. When actual painting begins, he may refer to his slides for specific details.

It should be emphasized here that, although Sharer was trained to paint what he sees, he in no way copies nature slavishly. He feels that copying can be of great benefit to the student, and he paraphrases the words of Harvey Dunn: "You have to know the truth in order to change it; otherwise it's a statement of ignorance." But in his finished paintings it becomes apparent that what is left out is as important as what is included, and much of what is there has been changed in order to heighten the effect.

It should also be pointed out that Sharer attributes his uncanny color sense to the rigorous training he received from his Academy teacher, William Mosby. Mosby taught his students to use what is known as

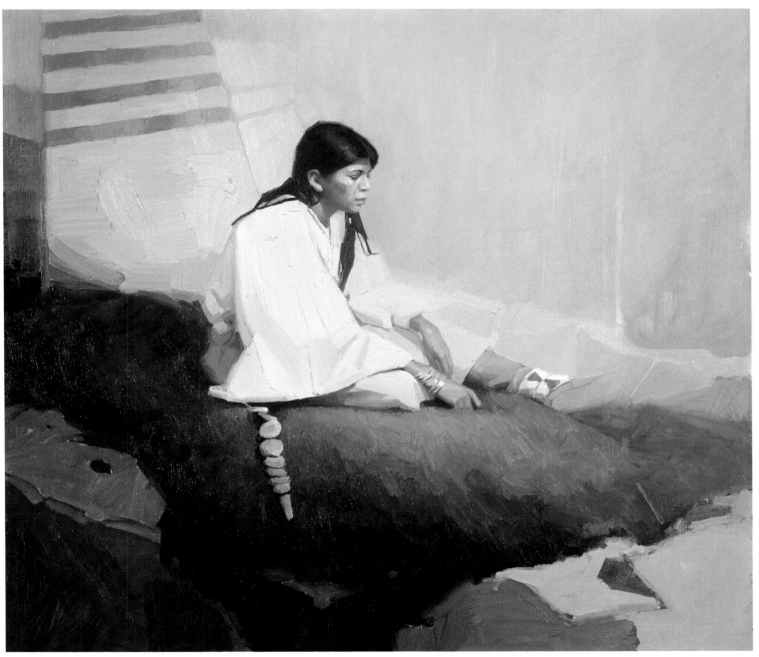

Warm Light, oil, 19 x 21½, 1977. Collection Sandra Wilson. There is a heightened sense of drama created by the sharp division of spaces throughout the canvas.

Man from Cordoba, oil, 16 x 12. Photo Ted G. Trainor. Brushstrokes seem casually applied to this small canvas, a spontaneous and energetic portrait study.

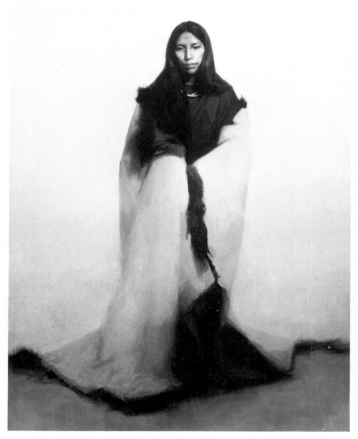

Shoshone, oil, 48 x 36. The entire composition of this canvas is designed to direct the eye to the model's face.

the "Rubens palette" and required his students to make a series of ten color charts using the colors on this palette. The palette is made by laying out the following colors along the top, from left to right: titanium white, cadmium yellow pale, yellow ochre, cadmium red light, terra rosa, alizarin crimson, burnt sienna, viridian, cobalt blue, ultramarine blue, ivory black.

Ten individual color charts were made for each of these colors. These charts had ten spaces across and five down. As an example, the cadmium yellow pale chart would begin reading from the left with pure cadmium yellow in the upper left-hand square. In the five spaces below it, the color was gradually weakened with more and more white. In the second horizontal space along the top, the cadmium yellow pale was mixed with yellow ochre (the next color across on the Rubens Palette), and again, in the five spaces below, the resulting color would be weakened progressively with white. This process would continue all the way across the palette, mixing the cadmium yellow pale successively with yellow ochre, cadmium red light, terra rosa, etc., all the way to black, but keeping this particular chart the 'cadmium yellow' chart, no matter which color it was mixed with.

The second chart (the yellow ochre chart) would be laid out in a similar fashion, with the pure yellow ochre placed in the second square from the left on the top row. The yellow ochre would be successively mixed with each other color in the respective squares at the top row of the palette, and each mixture gradually weakened with white. This process would be repeated for each of the colors on the palette. The end product would be a complete set of ten different color charts, keyed to the ten different colors of the palette, showing all of their combinations, and showing the progression of weakening tints.

Making these charts is something anyone can do; using them is quite another. Each student at the Academy surrounded his easel with these ten charts. Working directly from the model, learning how to see the colors in highlights and shadows, the student could consult his chart to find how to reproduce the exact color he saw. As this way of working was repeated day after day for a couple of years, it is not surprising that a knowledge of color gradually would become internalized. When Sharer works, there is never any hesitation about color; he can reproduce what he sees in an instant. Now the whole process has become instinctive.

William Mosby also trained his students to see "temperature" in paint in an interesting way. While some painters believe that all warms are the red-yellow side of the spectrum and all cools are the blue-green side, Mosby saw that there are cool reds as well as warm reds, and warm blues as well as cool blues. Temperature change is a relative thing and occurs when the cools and warms of a given hue are used next to each other. "If you're just using values, mostly, certainly you can get a big separation between white and black," says Sharer. "But if you

have a temperature change also, you get twice as much difference. You can get a lot more impact in your paintings."

Sharer finds this use of color especially valuable outdoors. "Outdoors, most people paint way, way too dark. It's very bright out there (especially in the Southwest!), and when you look into a shadow you see it's light. To get this difference, without going too dark, you can use a change of temperature. You don't see heavy, dark shadows outdoors. The great American painter, Charles Hawthorne, said, 'Make that shadow so I wouldn't be afraid to walk around in it.'" And in Sharer's paintings you can see enough to walk around in the shadows.

Sharer prepares his own supports. For some of his paintings under 18 x 24 inches (46 x 61 cm), he uses untempered ⅛ inch (.32 cm) Masonite. This he sands many times over, then washes it with a solution of half alcohol and half ammonia. This opens the pores of the Masonite and helps the ground adhere. Then he gives it a thin coat of cold-water gesso. This is not the acrylic gesso, but a true gesso that comes in paste form and can be thinned with water. He brushes on three to five coats in an irregular fashion to build up an interesting and slightly textured surface. After the last coat has dried, he rapidly brushes on a thin coat of shellac cut by about ten parts of alcohol, just enough to slightly reduce the absorbency of the gesso. The back of the Masonite may be sealed with acrylic gesso.

Insofar as canvas is concerned, he may use single-prime linen canvas, but generally prefers to prepare it completely himself, with a couple of coats of glue size, and then a white lead primer coat. He thins his white lead to the right consistency with turpentine, and he tests the consistency by putting the lead primer on his knife and shaking it. If the substance drops off in just the right way, he uses it. (He thinks he uses a thicker lead primer than most people do.) Again, when applying the lead to the canvas, he roughs it up some to create a slight texture by running his strokes in different ways. He only uses one coat, but concedes that it is a pretty heavy coat. Sharer has experimented with the drying time on his home-prepared lead-primed canvases. Some he has let dry as long as a year; others he has used as soon as the surface was dry. He has found no difference at all in their performance.

When Sharer poses his model, he rolls the model stand and easel to the best location in the studio. He selects the type and color of material to arrange around her, and makes sure that she is reasonably comfortable. "Flesh changes color if the muscles are straining," he says. While sketching in the pose with a round bristle brush, he checks the angle in the pose by making a picture frame of his fingers and measuring relative distances with the handle of his brush in the traditional manner. At first the brush explores the pose over the canvas without making a mark. Then, as the painting is developed, he checks it frequently in a big mirror standing in the corner behind him. He mixes his colors unerringly, and gradually the figure takes shape on the canvas.

Admitting to feeling hampered by the presence of a third person in the studio, he says, "Perhaps I'm more emotional about this kind of thing than other artists. When I'm really concentrating, I can draw the brush on the canvas and really feel that my brush is actually touching the contour of the figure. And that's the best kind of feeling there is. That's when you do your best work."

So we tiptoe out of the studio and quietly close the door. As Bill Sharer says, "Painting is hard enough as it is; why make it any harder?"

Franciscans, oil, 20 x 36. Photo Robert Nugent. The figures fade elusively in and out of the atmosphere, creating a sense of Medieval mystery.

MURRAY STERN

BY ANDREW SANDERS

AS A SPECTATOR SPORT, the American game of football provides wholesome and patriotic entertainment. Ritual and drama highlight its pageantry: colorfully-armored giants become hyperactivated by military bands, the exotic baton-twirling cheerleaders, the vocalized national battle hymn, and the exhilarating screams of 80,000 fans.

Murray Stern, an artist from Athens, Ohio, unlike millions of sports-minded Americans, has neither played football nor attended a live game. His closest acquaintance with the sport has been an occasional glimpse of a television game as he paused between channel tuning. So how is it possible for an artist to spend the last two years painting the football scene while remaining indifferent to its existence?

The answer to that paradoxical question slowly evolved as this complex man talked about himself and his work. "I'm not interested in football per se," he said. "I couldn't care less about it as a sport. What does bother me is its violence. Strangely enough, however, as I was thumbing through a magazine during the football season, it was its formal qualities—the activity of a mass of Baroque-like figures—that acted as the original catalyst, rather than the brutal-

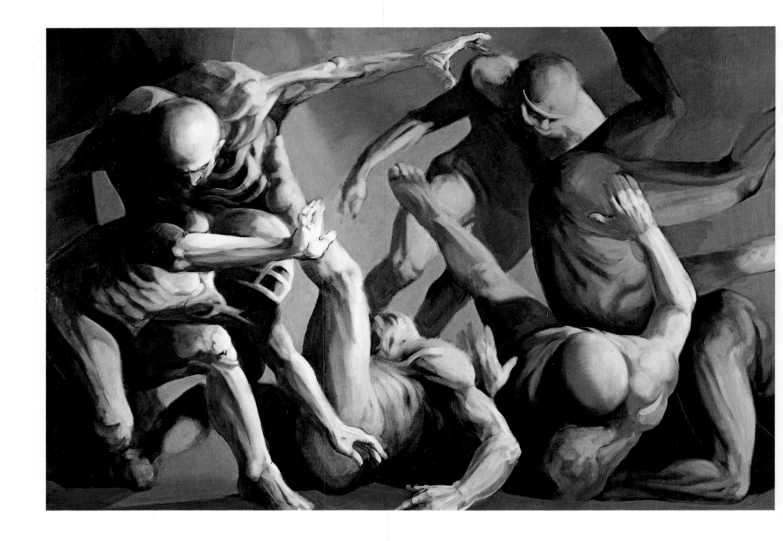

Left: *Self Portrait*, oil, 40 x 60, © 1976 Murray P. Stern. Photo Dave Levingston. Stern painted this work, with its element of the surreal, especially for this article.

Opposite page and below: Untitled diptych, oil on canvas, 40 x 60 (each panel), © 1975 Murray P. Stern. Photo Jeff Coulter. Stern creates an eerie setting: the helmets suggest the game of football, but the interplay of arms and legs contradicts this; in fact, are these really flesh and blood figures at all?

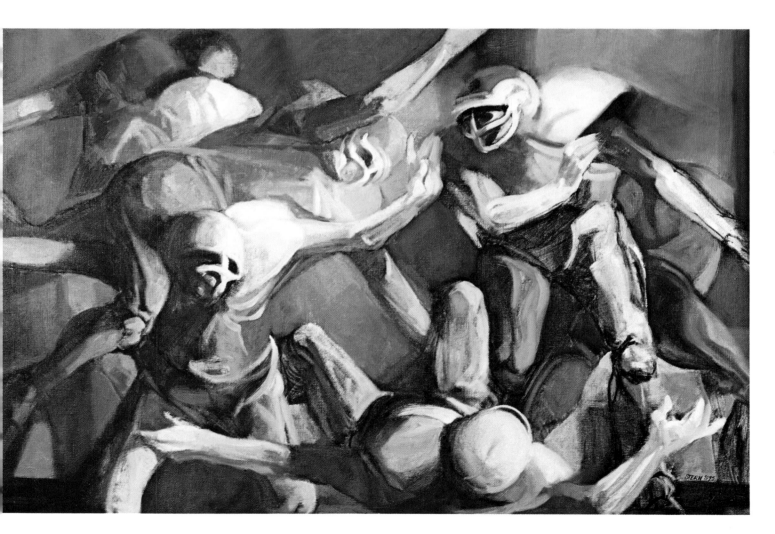

ity of the sport. This concept occurred later, almost subconsciously."

On an impulse, Stern cut out a number of the football photographs and began to rearrange them on a drawing board. His enthusiasm mounted as the overlapping figures turned into a Uccello-like frieze. The key to his imagination was triggered; within two hours he had finished his first football painting—and failed. It was too literally football—too illustrative.

In spite of the detracting elements of that painting, three silhouetted figures in its background—muted blue-gray in color, the negative areas, and the illusion of increased activity—became the impetus for the next painting he did.

Before seriously undertaking a major football work, however, Stern felt a need to do additional research on football uniforms. Once these informational drawings were completed, he did several rapidly executed charcoal studies exploring design problems: light emerging from right to left; the relationship of mass to line; a long shape to mass; something large against something small; something tenuous against something large; and he experienced a predilection for forms and shapes that became the underlying basis for the abstract element of his work.

Equipped with an increased knowledge of football uniforms and visually solved graphic problems, Stern started his second painting. Since spontaneity and discovery were—and still are—essential parts of his approach to painting, he began directly on the canvas without reference to his preparatory work.

As the painting developed, Stern continued to recall the paintings by Paolo Uccello that had impressed him during a visit to Italy: "I kept thinking of how he controlled his space and shapes with masses of figures going on, so I consciously, after the design was worked out, delineated negative areas more. In a complicated painting, everything has to be absolutely telling."

Again Stern was disappointed with the finished painting. He noticed that, regardless of the activity, there was no physical contact taking place between the players. Secondly, he had gone too far: He was using excessive areas of negative space. It was when he turned the painting upside-down that he realized what he must do: In his next painting he would close the forms more.

Preparatory work for the third painting began. Muted pastel studies in umber and white replaced the former color he now considered too saccharine. Forms were almost jammed together, and idea drawings were turned out in abundance.

Following the procedure used in his first two paintings, Stern attacked the blank canvas with only his concepts and instincts to guide him. "Although I've drawn extensively from the model over the years and continue to do so while demonstrating for my students in life classes, I rarely use models for my own work. I'm more interested in the work feeling right

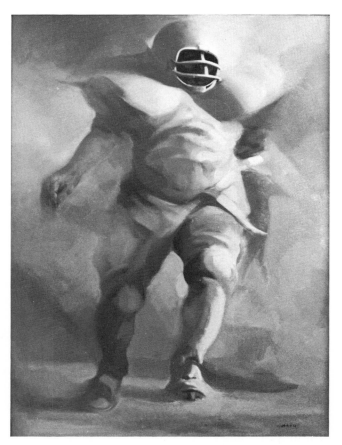

Untitled drawing, pen, ink, wash on paper, 30 x 22, © 1975 Murray P. Stern. Photos this spread Dave Levingston. The voices of Dachau are beginning to come through in Stern's work.

The Spirit, oil. 40 x 30, © 1975 Murray P. Stern. By keeping detail minimal, Stern developed the planes of this phantom-like figure so the upper area would "explode out beyond the frontal plane."

than being right. It also gives me the freedom to draw and paint gestures that are impossible for the human being to do, and, through the development of invented forms, the process of drawing becomes very exciting."

To avoid the immobility of the picture plane in his second work—which he wanted to "twist and turn like sculpture"—Stern began to develop the design of his third painting "almost like a piece of Cubism, from edge to edge." But, while in the midst of work on this painting, he put it aside to begin an oil of a brutish linebacker without making any preparatory studies. "With less and less emphasis on features," he explained, "the mask becomes the skull; the protective bars, the zygomatic arch; the helmet, the cranium. As the figure emerged, I kept thinking of him encased in a monstrous amount of material which fused with his anatomy."

When *The Spirit* was completed, it was entered in "Mainstreams '75," where it won an Award of Distinction. As soon as the exhibition was over, Stern, who rarely considers his paintings finished, changed the upper section of the figure so that "it would explode out beyond the frontal plane."

Considering *The Spirit* much improved by the final changes, he resumed work on his multifigured third painting. Through the use of arbitrary color and the cropping of overlapping figures, he was able to "draw the spectator right into it: to be telescoped into it, rather than allowed to step into it and examine the content."

After three or four months of total involvement, Stern was still not content with the direction in which the subject of football had taken him. Although he was unaware of it, a second catalyst was at work: He was haunted by images in his sleep and hounded by introspective questions during the day. "What do we do to each other as people—not only on a field of activity where it is allowable, under the guise of being a sport—but how do we treat each other in our daily lives? What about the basic immorality of recent national events: Watergate, the CIA investigations, the assassinations of the '60s—the whole world of brutality." Watching TV with his teen-age son and seeing the constancy of violence, and the violence that real people do to each other, he wondered, "Will my son survive in this society? Will I ever be a grandfather?"

Stern's work was about to undergo a profound metamorphosis. The football paintings now seemed superficial. He had always wanted to be a social painter from the moment he felt he had grasped the essence of Picasso's *Guernica* at the age of 22: "I would say that *Guernica* was the major influence in my life. I realized for the first time that Picasso was dealing with themes that I would love to spend my life painting."

This youthful ambition, however, was not to reach fruition until amost 30 years later. Commenting on this formative period, Stern said, "The extent of my formal art training consisted of a year of figure draw-

ing and painting with Moses Soyer and Philip Evergood, a year-and-a-half of figure drawing with Rico Lebrun, and an eight-month philosophical seminar (consisting of informal critiques of unassigned work done outside of class) with Ben Shahn. These first Expressionistic attempts at painting came easily, and I distrusted the results. So my first project, after permanently leaving my classes, was to be several large-group figure paintings in the style of the Flemish Masters."

Disappointed with these unwieldly works, Stern decided instead to develop the skills of Rembrandt, Rubens, Chardin, and Degas. A Brooklynite by birth, he was able to study the paintings of the Masters he admired in New York's museums. "I also read Max Doerner and Ralph Mayer inside-out," he said. "I rendered eyes, noses, mouths, and did portraits until they came out of my ears."

Stern continued working in this vein until the 1960s, when he did a series of paintings on civil rights. Although the work of this five-year period was expressive, it was far from Expressionistic. For reasons unknown to Stern, he returned to doing commissioned portraits and still life paintings, instead of continuing the social theme of his "civil rights" work. It was to be ten more years before football, rather than a moral concern for victimized blacks, would provide the catalyst for his most accomplished work. In retrospect, Stern reflected, "During the formative stages of the series of football paintings, I sensed that the theme was becoming a key to an idea other than the game itself." What he had originally considered appropriate subject matter for the visual exploration of the movement of figures in space was now emerging as a stimulus for a statement of a much greater substantive content: man's struggle for survival in a hostile world.

Even though he was still not clear as to how to express this new impetus, one thing was certain: It would require a new process and method of working. The development of a preconceived concept, through the use of conventional means, was too restrictive. Expunging himself of intellectualized directions, Stern began a series of Expressionistic drawings as an emotional end in themselves. Somehow, he felt, he had to break through all conscious control in order to release the imprisoned subconscious images. The longer he worked, the more the human anatomy beneath the football uniform began to appear. Helmets were becoming skulls; shoulder pads became scapulae; shoes, feet. Football was no longer being played. These tortured figures were flailing away at invisible forces rather than combating each other on a football field. The subconscious of Murray Stern was beginning to surface.

Contributing to this release of inner turmoil was his recollection of a visit to Germany in 1958: "The most shattering experience of my life occurred when I saw the concentration camps in Germany, and I talked with my last remaining relatives from Dachau. When the camps were liberated, there were stacks of

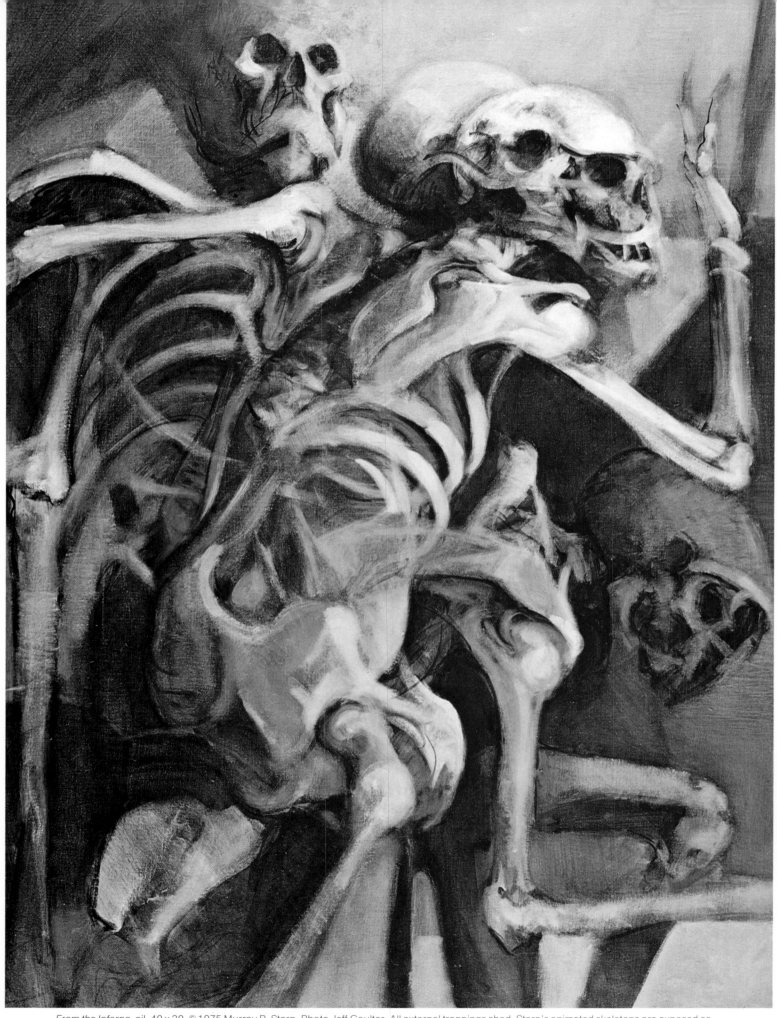

From the Inferno, oil, 40 x 30, © 1975 Murray P. Stern. Photo Jeff Coulter. All external trappings shed, Stern's animated skeletons are exposed as victims expressing the ultimate horror of Dachau.

bones that seemed to come alive when they were plowed under with bulldozers for fertilizer. Well, I don't think that things like that should be forgotten. And since I can't deal directly with the insanity of World War II or the interreligious destruction that's happening in the Middle East and Ireland, as an artist I couch it in terms that are palatable enough to cause someone to question themselves about it."

Just as he was on the threshold of exploring his newly found idea in a painting, Stern's visual transition was interrupted by a family summer vacation. When he returned three months later, he could no longer relate to his work. It was as though it represented a sleeping giant that he was not prepared to reawaken. Instead of immersing himself in the emotionally disturbing search for visual truth, he bathed in the luxury of painting from nature.

"It was summertime," he remembers, "and it was nice to get back to mushrooms, onions, and apples. It's a wearing thing, ripping away and looking for things that are difficult to find, both as subject and form. Besides, it's not easy to live with this imagery all the time. I have to go back to nature for sustenance and fulfillment. In addition, there is always the danger of imitating yourself when not working from models. A return to reality helps to redefine the vision by discovering new keys."

When summer was over, Stern's physical contact with color and paint, during his reacquaintance with nature, had served its purpose: Visible reality had sustained him. It was time to continue the painful search for emotional truth.

First, he did black-and-white drawings of conventionally uniformed football players who were actually blocking, tackling, elbowing, hammerlocking, and piling up. These spontaneously executed works, in pen-and-ink and wash on 22 x 30-inch (56 x 76.2 cm) watercolor paper, dramatized the violence of football through their emphasis on physical contact and the use of strong patterns of light and dark. Although these drawings were much less formalized than the piled-up figures of his presummer oils, they similarly focused on the players by eliminating the background and foreground.

As excellent as these drawings were, they were still football—a subject that Stern felt he must transcend. As he continued to work, his inner voices began to direct his subconscious imagery toward the Dachau concentration camp. An ink and wash drawing of a solitary, full-figure, brutish nude in profile, wearing only a face mask, resembled an executioner. A pen-and-ink back view of a casualty on crutches graphically portrayed a partially flayed male nude still wearing the remnants of football pants. To complete the metamorphosis, an ink and wash drawing of a skeleton, with just enough anatomy to hold him together, stands gazing skyward through a face mask with empty sockets. This human vestige appears to be supplicating a supreme power for the hope of life, rather than symbolizing a football casualty.

Stern, stimulated by these last drawings, put them aside and started his fourth painting. For the first time in one of his oils, signs of the disintegration of the football uniform and the emergence of human anatomy became evident. Nevertheless, the theme of football persists in dominating its imagery. When asked about the apparent paradox between his skeletal drawings and the conventional imagery of the oil, Stern provided this explanation: "I respond to the images as they occur during the process of drawing or painting, without conscious concern for their sequential niche."

His fifth oil was a large diptych, consisting of two 40 x 60-inch (102 x 152.4 cm) canvases. Both the style and the content differ from his painting of piled-up players. It is more freely executed; the negative areas are larger and more numerous; anatomy surfaces through the uniforms; the players' arms flail wildly; and most of the figures look as though they have just been cascaded out of the sky. This is not football per se. The only interrelationship between players is the uniformity of their helmets and face masks. Other than that, each figure is suffering his personal horrors alone. And all have been cast into Dante's *Inferno* for eternity.

Contrary to the first impression his work conveys, Stern does not hate football. If that were the case, he would be guilty of harboring a vendetta for all contact sports, rather than experiencing remorse over the mass enjoyment of palatable violence. He is striking out, not at the gladiators who, in his psyche, become the symbolic victims of man's inhumanity to man, but at a society which equates brutality with manliness and practices human destruction in the guise of noble causes. The catalyst of football, therefore, is as much a result of accident and coincidence as it is of intent.

To some degree his multifigured paintings up to this stage reflect this point of view. However, it is a large, profoundly moving drawing in pen-and-ink and wash that resolves Stern's total concept: his *Guernica*. To his credit, this major work, shown here, is related to Picasso's only as an indictment of human destruction. The graphic means, the imagery, the esthetic and moral content are Stern's. Four of its five male nude figures are half skeletal, half anatomical. The fifth and completely anatomical figure seems removed from the agonizing deathtrap of the other four, both in its human construction and ghost-like delineation in pen and ink. By all of the standards of visual organization, the weightlessness of this figure should have caused the design to be completely unbalanced. Instead, it creates asymmetrical balance through the use of visual tension: weight and movement counterbalanced by ethereal inactivity.

It is difficult to think of the 40 x 72- inch (102 x 183 cm) work as a drawing. Because of its size and visual impact, it conveys all of the qualities of a painting. In this one work, Stern has surpassed everything he had done up to this point. In all of its preoccupation with destruction and death, the drawing still portrays man as being capable of human dignity.

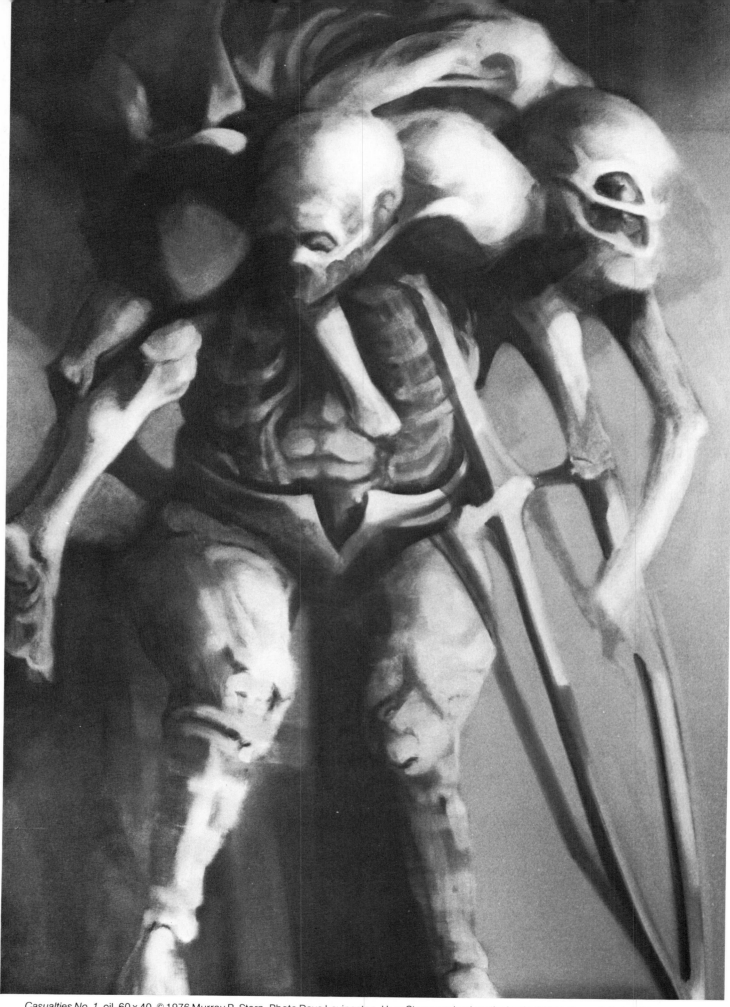

Casualties No. 1, oil, 60 x 40, © 1976 Murray P. Stern. Photo Dave Levingston. Here Stern emphasizes the basic design elements to heighten emotional impact. "Working without models gives me the freedom to draw and paint gestures that are impossible for the human being to do," he comments.

As a victor who had spent his energies, Stern now turned his attention from participating combatants to the victims. Dual figure drawings and paintings were now undertaken. Some returned to the football theme, others did not. But in both, the crutch becomes an appendage of broken bodies struggling under the weight of fellow casualties.

This major change in Stern's concept, directly influenced not only his imagery, but the selection and use of his materials as well. In order to produce drawings that would be equal in size to his large oils, he began purchasing his paper in rolls, 4 feet (1.2 m) wide and 20 yards (18.3 m) long. Always a craftsman about his tools, he says, "My concern for the permanence of materials has to do with the morality of working and an integrity toward the buyers of my work, rather than a desire for posterity."

Adhering to this view, his 140 lb. cold-pressed watercolor paper is 100 percent rag. When cut to size, it is stretched dry over handmade stretcher strips to which a backing of foam board has been stapled and glued. Because of its size, weight, and tendency to re-roll from end to end, the paper is sponge-wet *after* it has been stapled in place. Uneven areas generally dry smoothly after two or three wettings, although occasionally a section needs to be restretched. The completely dry paper (drying takes about a day and a half) receives a thin coat of gesso, which permits greater control of ink washes because they can be wiped off and redone.

Stern begins his tonal drawings by establishing general shapes with charcoal. When he is satisfied, the shapes are wiped off, allowing only a faint trace of the image to remain. The washes come next. Stern selects value and color combinations from several premixed jars of Pelikan india and sepia inks. Working spontaneously, Stern begins with medium value washes. These are followed by the intermittent application of pen-and-ink line applied with an assortment of pens, quills, and toothpicks. From then on, the drawing is developed much like a painting, as the juxtapositions of values, shapes, lines, and textures delineate images and establish visual organization.

No preliminary drawing in pencil or charcoal is used for his linear pen-and-ink figures.

Painting materials, like those used for drawing, are selected for qualities of permanence. Stern applies his own white lead second prime if the Belgian linen canvas he uses is only available in single prime. It is then allowed to dry for six months before it receives a blueish or greenish tone of an umber mixture thinned with gum turpentine and medium. Filbert bristles and flat and round sables in all sizes are thoroughly washed in lukewarm water and Ivory soap after each painting session.

Stern can mix all of his muted colors on a glass palette with flake white, cadmium red light and deep, old Dutch yellow, yellow ochre, burnt sienna, burnt umber, raw umber, ultramarine blue, and ivory black. Since manufacturers' oils vary in hue, he may use as many as four or five brands of the best colors available. What he can't buy, he will grind himself and place into empty tubes.

His medium, which he prepares himself, consists of two-thirds cold-pressed linseed oil and one-third damar varnish. Occasionally, a small amount of turpentine is added as he paints. Stern originally used the Maroger medium for a number of years. But, after experiencing non-drying problems with the medium, Stern turned to Uffizi-trained conservator Piero Manonni for an alternative vehicle. The close proximity of their studios in New York provided Stern with the opportunity of assisting Manonni during his search for a replacement for Stern's rejected Maroger medium. Using recipes discovered in 15th-century Italian art treatises, the conservator was able to remove the mucilage and fatty acids from cold-pressed linseed oil by washing it with water. Once the water was siphoned off, the purified oil was cooked with white lead powder in order to modify its slow-drying properties. With the addition of one-third damar varnish, Stern now had a faster drying but leaner medium of proven permanence. In order to assimilate the desired buttery quality of the Maroger medium, Stern first removes the excess oil from his flake white by squeezing it onto a blotter and then mixes the white with a portion of his new vehicle.

To begin a painting he draws directly with the brush and burnt sienna or raw umber, thinned with turpentine and medium, on a cool or warm ground. He works this way since he may only have a general idea in mind, and he works tonally rather than linearly. The drawing is merely suggestive. In describing his procedure, Stern says, "I have developed a way of working that allows the greatest flexibility of execution. Anything can happen at any time: masses are blocked in; values and color become interrelated; darks are kept thin, lights are kept opaque; an area may be built up, scumbled, glazed, and then wiped."

In referring to his *Casualties No. 1*, he described his method: "The leg belonging to the casualty being carried is an appendage growing out of the body of the figure carrying him—dual figures that were one figure—the head blending into the shoulder which blends into the head. The moment one was carrying the other, they weren't separate entities anymore. I also wanted an integration between the rib and the over-muscle and, without anything being clear, to create the tension of encompassing areas within the body."

Murray Stern's description of his creative process, makes it all too clear that, in his need to express his innermost thoughts and feelings, he had indeed transcended the subject of football. Instead of illustrating the obvious, he had raised the commonplace imagery of a sport to the level of high art. Perhaps he summed up himself and his art when, as he stood before the furnaces at Dachau, he became certain of one thing: "I will not be put into an oven quietly."

PHILIP WHITE

BY JOAN E. FISHER

NOT TOO DEEP into Thatcher Woods, just outside Chicago, is an old slough, secluded from the glances of passersby yet not hidden enough to escape the attention of neighborhood children. Here a small child in a brightly colored jacket plays contentedly at the pond's muddy edge. It is a peaceful moment that would probably pass unnoticed by the casual observer, but to an artist like Philip White, this everyday scene is raw material for a painting. With a clarity of vision he captures these qualities and brings them directly into his paintings, experimenting and then perfecting in whatever medium will best serve his purpose—egg tempera, oil, acrylic, or watercolor.

White has visited these woods many times, observing with his keen and sensitive eye. "I must have painted that old slough a thousand times," he remarks. He has painted it flecked with clumps of dirt, twigs, and plants, murky in the summer sun; mirroring barren trees, its autumn stillness unbroken save for an occasional floating leaf; covered in a thick blanket of snow, crisscrossed with sled tracks; and lined with trees newly clad in the yellow-green of early spring.

One who is familiar with the area can see that White's direct, nearly photographic paintings do not stray far from his subject matter. "I try to paint basically as I see things." Light, shadow, color, texture, right down to the finest detail are startlingly realistic. Many people, when viewing the paintings that line the walls of his home, are surprised to find that they are not photographs and are only convinced when a closer inspection reveals the numerous tiny, careful brushstrokes that are blended to create the effect. Indeed, his paintings can be so convincing that at times they are unsettling.

All of White's paintings seem to re-create a moment—nothing spectacular or extraordinary—that anyone may encounter or fantasize about from time to time. What could be more innocent and secure than a girl and her mother collecting stones together or a boy stretched lazily in the sun, waiting for a fish to bite? White often depicts these moments with one lonely distant figure, usually a child, who is performing a simple task but appears to be absorbed in

thought. White enhances this effect by using natural colors and soft edges. Often a pensive mood pervades the painting; this feeling is intensified by lighting a scene at a low angle, which in a winter picture would, for example, create long shadows.

An observer is acutely aware of the season in White's paintings. The distinct Midwestern seasons almost always play a major part in his work. How light strikes or reflects from an object and the endless nuances changing light creates are a constant fascination to White.

Only a short distance away from Thatcher Woods and the old slough are the quiet, tree-lined village of River Forest and White's home and studio. He was born and raised in this established community, and his interest in art developed casually: "I had no idea I was going to be an artist, but I enjoyed making pictures more than anything." His increasing fascination for painting and drawing persisted through high school and throughout his years at the University of Southern California. As an art major, he studied art history. He was taught traditional painting methods, design, drawing, oil, and watercolor. His best work was in sculpture.

After a stint in the army, where he managed to find time to paint, he returned home to River Forest and began exhibiting his work at many of the local art fairs and meeting artists of the region. These outdoor art exhibits—in towns like Oak Park, Evanston, Winnetka, Oakbrook, and Highland Park—were important in the development of his career. They gave him the exposure he needed to establish his painting among Midwestern audiences. He is now one of the best-known and respected Chicago area artists—even among other regional artists, with whom he maintains a constant dialogue.

Although White does not strive for an exact photographic likeness of his subject, his use of photography is instrumental in his work. His preliminary

Right: *Wildflowers*, 1976, oil, 24 x 18. White often bases his medium selection on his choice of subject matter: "Tempera is a natural choice for the kind of detail in this work: the minute brushstrokes required, the lack of blending, the natural buildup of texture."

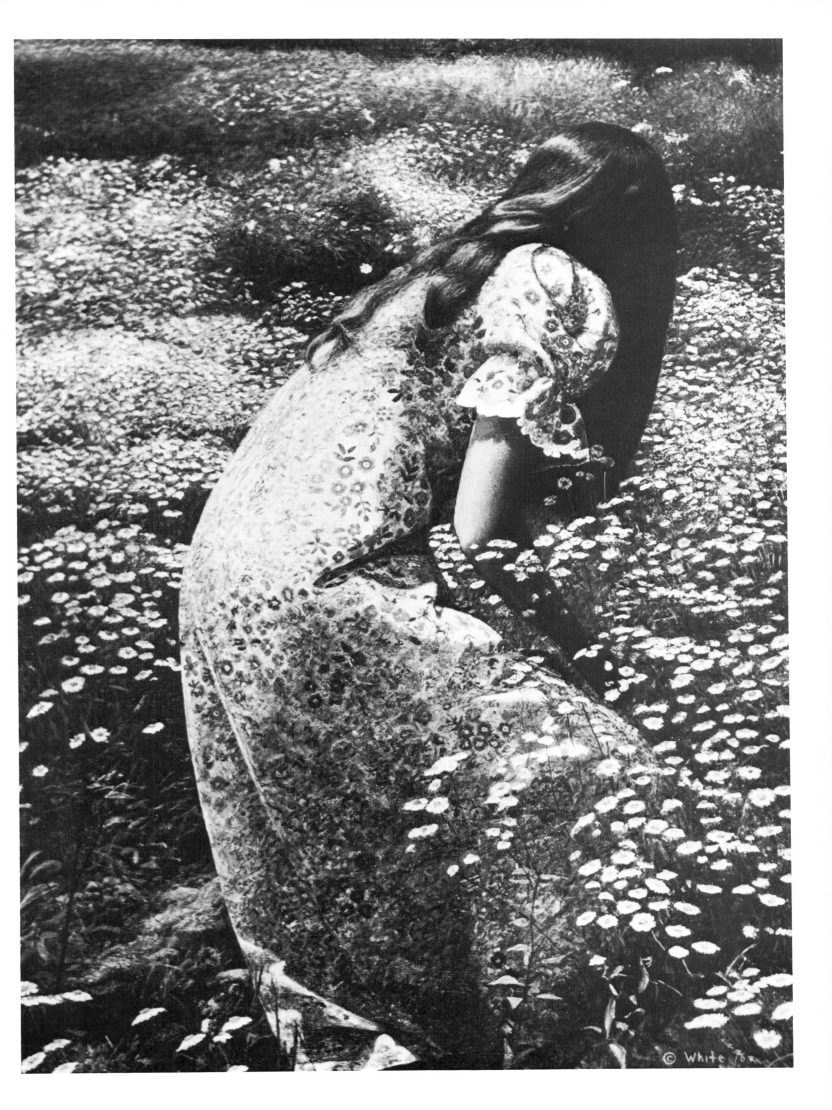

The Boulder Field, 1971, egg tempera, 24 x 35. Collection the artist. "This is Devil's Tower in Wyoming," White points out. "It's a volcano core where large pieces dropped off, so the painting is very blue-gray." He adds, "It's difficult to dress figures these days so that a painting of them doesn't look dated in a few years."

studies are done with a camera rather than a sketch-pad. "I think it's a tremendous aid for an artist. You can capture a moment that can in no way be done with sketching. The results are entirely different." He also uses photographs as a practical reference, preserving a moment for future study.

White has the unique ability to recognize a fleeting expression or scene that possesses what he wants to relay and, using his camera, to snap it. In this way he is able to capture candid facial expressions or stances of people without fear of their appearing posed. "I go into the woods and photograph people who don't even know I'm there. For example, I used to take a lot of pictures of people fishing. Because they were so intent on what they were doing, they didn't look posed. And because they would stay still, I had time to compose the photograph."

White prefers to do much of the composition that will appear in the finished painting in the photography stage. He then takes these photos into his studio and extracts part from one, part from another, until he comes up with a composite that he likes. From this point, however, White uses nothing beyond his own

skill and a few simple tools. "The excitement of painting, to me, is to see something and to just put it down freehand," he says. "I know that many artists project an image on canvas and trace around it—they certainly get the exact image better than I—but I wouldn't get satisfaction from that."

White's studio is a small room in the upstairs of his home, next to his two boys' rooms. Out of his window is the silent landscape found in many of his paintings. He has no fancy gadgets, no super-duper contraptions to aid him in his work. There are coffee cans packed with brushes, empty baby food jars for mixing egg tempera, and a table piled high with experimental sketches. An easel, a stool, and a glass palette on a stand are the only other pieces of furniture in the room. "I've always been very simple in my ways: when I started painting, I used a chair for an easel."

White is a perfectionist in his work and has high expectations for himself. If he is not satisfied with a painting, he will persist until he is. This may be part of the reason he has learned to use various media so proficiently. Many artists tend to specialize in one medium, but White uses the one that he feels will

Wintertime, 1974, oil, 24 x 35. Collection Dr. and Mrs. Boone Brackett. Here White has simplified shapes to enhance the drama of this winter scene, as a foil for the figure.

best fit what he is painting. For example, if he is painting a big sky or any large area with graduated tones, he will usually use oil, because it is easy to blend, or watercolor, because he can use a wash. With egg tempera, the graduated tones of such a subject are more difficult to achieve, because the medium demands that brushstrokes be applied side by side and one layer over another. White generally would not use acrylic for the same subject matter because a wash for tone and the sky is very difficult to repair if scratched, and color is hard to match.

When White decides to spend a long time working on a painting, he will often use egg tempera, but if he wants to do a painting quickly, he will use watercolor. Reworking, he finds, is easiest in egg tempera and oil and much more difficult in watercolor and acrylic. White finds acrylic easy to use in the preliminary stages, but it's not as satisfactory as the painting progresses because of the problems presented by the change of color between dry and wet paint. He feels that acrylic is least desirable for highly refined and precisely finished work. "What I'd like to do," he says, "is to start in one medium, take it as far as it goes, and then switch to another. But I never do it. It's not approved practice."

In all the different media, White uses small sable brushes, rags, and sponges to apply paint and knives and razor blades to remove it. He does a tremendous amount of drawing and paint-splattering to soften and diffuse areas that become too hard-looking.

It was not until much after art school that White began to experiment with egg tempera, now the medium he uses the most and likes the best. Knowing that Andrew Wyeth used egg tempera caused White to read up on it. Although it sounded complicated and tedious, he was encouraged by some friends' success with it. He experimented and was surprised by how fast he was able to pick up the technique and how well it suited his work: "There's really nothing to it. I find egg tempera easy to work with, especially when I want to stress drawing and detail. The finished paintings seem to have a delicacy that is not easily achieved in other media. Although the paint dries so rapidly that it cannot be blended, there is little change in color between dry and wet, so matching color and tone is easy."

Sand and Surf, oil, 24 x 36. Private collection. White used his two sons as models for this work. He comments, "I was inspired by the idea of two boys exploring: one, the older, testing the water, with the other watching from the sand, ready to follow along."

Right: *Collecting,* 1970-71, egg tempera, 24 x36. Collection the artist. White has made photomechanical reproductions of several paintings, which he sells at a nominal price. This is one of those paintings. "Many people ask me about a particular painting, then find they can't afford it. For some, having a reproduction of it fulfills part of that wish."

Below:*Two Little Girls,* 1977, oil, 14¾ x 22¼. Collection the artist. White's meticulous method and the fact that his subjects are usually children do not permit him to use live models. Instead, he takes many photographs of his subjects—in this case, neighborhood children he knows well.

© White 77

White takes advantage of egg tempera's unique qualities. The medium's luminosity and the way in which it enables him to render details and textures precisely add life and depth to his paintings. White's perfectionist method of working—and reworking— also lends itself well to the qualities of egg tempera. Because it dries almost instantly, he can keep working without waiting for layers to dry. He can labor over an area that he feels isn't quite right until he is satisifed with it. And if he still is not pleased—which he says happens far too often—he can simply scrape it off with a razor blade and try again.

White finds the more traditional techniques of egg tempera most satisfactory, although he hardly conforms to the rigid method prescribed 600 years ago by the masters who first began to use it. He has no compunction about breaking any of the age-old "laws" of egg tempera, which banned any correcting or techniques such as splattering, both of which he uses frequently. He often works quite loosely, making numerous changes, and if an unorthodox technique seems appropriate, he will try it.

Ordinarily, when beginning an egg tempera, White makes a charcoal drawing on a Masonite panel covered with gesso. Atop this he adds more details with an India ink wash. By doing this he establishes a solid structure, a composition that requires few changes as the painting progresses. He follows no rules of composition other than to keep the center of interest away from the edges and to maintain a balance that is pleasing to him: "I try to keep the scale and proportions of things natural, simple, and logical without distortions." After this careful drawing he quickly puts in the basic background with a larger brush, working to get down the essential colors. He then begins working on the figure or center of interest, now using very small brushes. From here he makes very slight changes until he gets what he wants. White, unassuming and soft-spoken, says, "It's really a matter of time and effort, as far as I'm concerned. It's simple."

Oil is also a favorite medium, and he uses it almost as much as egg tempera: "I enjoy oil paint especially when it is thinned down. To me the best feature of oil paint is its workability: its ability to be blended, the slow drying time." When beginning an oil painting, he generally does not make use of preliminary drawings on the canvas but starts with a "foggy" kind of a picture made by taking a rag and wiping in the basic colors. Then he gradually makes it sharper, changing it as he goes along. He seldom uses a palette knife.

In deciding which medium to use for his subject, White usually weighs all the aforementioned considerations before he begins to paint—but not always. There are many times when he chucks all his considerations out the window and begins to experiment: "Sometimes I am excited by a new discovery and use it extensively until a new approach presents itself." Or he may switch to something different simply for a change of pace. White has no rigidly established pattern to his working methods, and this easygoing approach allows him to continually investigate different media, new subject matter, etc. Recently he has been shifting his range of color. In the past he relied mainly on earth tones—muted blues and greens, soft browns and grays—and emphasized them in his compositions. But lately he has departed from this and has been using primary colors.

Although White chooses to paint mostly local scenes of the town he grew up and resides in, he and his family travel extensively—South America, Europe, Mexico—and he always has his camera, sketchpad, and tennis racket with him. He is an avid reader and collector of books and magazines on art—from how-to's to tips on technique to the latest controversy on copyrighting of paintings and government funding of the arts.

With such an active career and with the increasing popularity of his work, it would not seem unlikely that White might move to another part of the country to expand his range. Midwestern artists, he feels, are passed by far too often in favor of other artists, especially those from the East. However, White is comfortable in River Forest. He enjoys the freedom of knowing he could live—and work—anywhere but has no intention of moving. So chances are great that he will remain where he is, but his art will continue to grow and change just as the seasons in the woods he paints.

INDEX

Designed by Bob Fillie
Set in 10 point Medallion